RuPaul's Drag Race and the Cultural Politics of Fame

This book explores the connections between drag stardom and contemporary sexual and cultural politics in the *RuPaul's Drag Race* franchise. With Drag Race alumni achieving fame in fields such as music, fashion, theatre and beyond, this edited collection interrogates the relationships between gender, sexuality, performance, identity, and celebrity culture that lie at the very heart of the show.

RuPaul's Drag Race has recently completed its 15th season after having won 26 Emmys. The show is a popular culture phenomenon, broadcasting drag into the homes of middle America, spawning spin off shows and an ever-expanding international franchise. Its success has made global stars of its host, guest judges, and contestants alike. This edited collection explores the connections between drag stardom and contemporary sexual and cultural politics that *RuPaul's Drag Race* stages and dramatizes. Alumni of Drag Race have gone on to become globally famous. Adore Delano and Sharon Needles have launched music careers. Violet Chachki is the first drag model to become the face of Bettie Page Lingerie whilst Jinkx Monsoon has achieved success as a Broadway star. In 2017, RuPaul was named as one of *Time Magazine*'s 100 Most Influential People. Above everything else *RuPaul's Drag Race* is a show about celebrating the glamour, artifice, and the labour of fame. Whilst Drag Race has already attracted scholarly attention, the relationships between gender, sexuality, performance, identity, and celebrity culture that lie at the heart of its dynamic and appeal remain to be explored.

RuPaul's Drag Race and the Cultural Politics of Fame will be a key resource for academics, researchers and advanced students of Media and Cultural Studies, Gender Studies, Performing Arts, Media and Film Studies, Communication Studies and Sociology. The chapters included in this book were originally published as a special issue of *Celebrity Studies*.

John Mercer is Professor of Gender and Sexuality at Birmingham City University, UK.

Charlie Sarson completed his PhD at Birmingham City University, UK and researches representations of gender and sexuality.

Jamie Hakim is a lecturer in culture, media, and creative industries at King's College, London, UK and researches digital media and queer cultures of embodiment, intimacy, and care.

RuPaul's Drag Race and the Cultural Politics of Fame

Edited by
John Mercer, Charlie Sarson and Jamie Hakim

LONDON AND NEW YORK

First published 2024
by Routledge
4 Park Square, Milton Park, Abingdon, Oxon OX14 4RN

and by Routledge
605 Third Avenue, New York, NY 10158

Routledge is an imprint of the Taylor & Francis Group, an informa business

© 2024 Taylor & Francis

All rights reserved. No part of this book may be reprinted or reproduced or utilised in any form or by any electronic, mechanical, or other means, now known or hereafter invented, including photocopying and recording, or in any information storage or retrieval system, without permission in writing from the publishers.

Trademark notice: Product or corporate names may be trademarks or registered trademarks, and are used only for identification and explanation without intent to infringe.

British Library Cataloguing in Publication Data
A catalogue record for this book is available from the British Library

ISBN13: 978-1-032-57317-5 (hbk)
ISBN13: 978-1-032-57318-2 (pbk)
ISBN13: 978-1-003-43885-4 (ebk)

DOI: 10.4324/9781003438854

Typeset in Myriad Pro
by Newgen Publishing UK

Publisher's Note
The publisher accepts responsibility for any inconsistencies that may have arisen during the conversion of this book from journal articles to book chapters, namely the inclusion of journal terminology.

Disclaimer
Every effort has been made to contact copyright holders for their permission to reprint material in this book. The publishers would be grateful to hear from any copyright holder who is not here acknowledged and will undertake to rectify any errors or omissions in future editions of this book.

Contents

	Citation Information	vi
	Notes on Contributors	viii
1	'Charisma, uniqueness, nerve and talent': *RuPaul's Drag Race* and the cultural politics of fame *John Mercer, Charlie Sarson and Jamie Hakim*	1
2	From *Paris is Burning* to #dragrace: social media and the celebrification of drag culture *Zeena Feldman and Jamie Hakim*	4
3	'Assume the position: two queens stand before me' – RuPaul as ultimate queen *Hazel Collie and Gemma Commane*	20
4	Drag celebrity impersonation as queer caricature in The Snatch Game *Hannah Andrews*	35
5	Rewriting 'herstory': Sasha Velour's drag as art and activism *Renee Middlemost*	49
6	'Labouring in the image': celebrity, femininity, and the fully commodified self in the drag of Willam Belli *Rachel O'Connell*	65
7	'No one is trash, no one is garbage, no one is cancelled': the cultural politics of trauma, recovery and rage in *RuPaul's Drag Race* *Debra Ferreday*	82
8	Fifteen Seconds of Fame: RuPaul's drag race, camp and 'memeability' *John Mercer and Charlie Sarson*	97
	Index	111

Citation Information

The chapters in this book were originally published in the journal *Celebrity Studies*, volume 11, issue 4 (2020). When citing this material, please use the original page numbering for each article, as follows:

Chapter 1
'Charisma, uniqueness, nerve and talent': RuPaul's Drag Race *and the cultural politics of fame*
John Mercer, Charlie Sarson and Jamie Hakim
Celebrity Studies, volume 11, issue 4 (2020), pp. 383–385

Chapter 2
From Paris is Burning *to #dragrace: social media and the celebrification of drag culture*
Zeena Feldman and Jamie Hakim
Celebrity Studies, volume 11, issue 4 (2020), pp. 386–401

Chapter 3
'Assume the position: two queens stand before me': RuPaul as ultimate queen
Hazel Collie and Gemma Commane
Celebrity Studies, volume 11, issue 4 (2020), pp. 402–416

Chapter 4
Drag celebrity impersonation as queer caricature in The Snatch Game
Hannah Andrews
Celebrity Studies, volume 11, issue 4 (2020), pp. 417–430

Chapter 5
Rewriting 'herstory': Sasha Velour's drag as art and activism
Renee Middlemost
Celebrity Studies, volume 11, issue 4 (2020), pp. 431–446

Chapter 6
'Labouring in the image': celebrity, femininity, and the fully commodified self in the drag of Willam Belli
Rachel O'Connell
Celebrity Studies, volume 11, issue 4 (2020), pp. 447–463

Chapter 7

'No one is trash, no one is garbage, no one is cancelled': the cultural politics of trauma, recovery and rage in RuPaul's Drag Race
Debra Ferreday
Celebrity Studies, volume 11, issue 4 (2020), pp. 464–478

Chapter 8

Fifteen seconds of fame: RuPaul's drag race, camp and 'memeability'
John Mercer and Charlie Sarson
Celebrity Studies, volume 11, issue 4 (2020), pp. 479–492

For any permission-related enquiries please visit:
www.tandfonline.com/page/help/permissions

Notes on Contributors

Hannah Andrews is Associate Professor at Lincoln School of Film, Media and Journalism, University of Lincoln, UK. Her research focuses on representations of real people in popular culture, including biographical drama and caricature.

Hazel Collie is Course Leader in Media and Communication at Birmingham City University, UK, and a researcher in television audience identities, cultural studies and gender. Her research focuses on backfilling audience histories and feminine cultures.

Gemma Commane is Senior Lecturer in Media and Communications, and an active researcher in the fields of media and cultural studies, and gender and sexuality. Her research interests focus on contemporary cultural studies, gender and sexuality, bad girls and dirty bodies, entrepreneurship at the margins, and researcher positionality.

Zeena Feldman is Senior Lecturer in Digital Culture at King's College London, UK. Her research examines how digital communication technologies interface with analogue concepts and everyday life.

Debra Ferreday is Senior Lecturer in Sociology and Director of the Institute for Gender and Women's Studies at Lancaster University, UK. Her work explores the interconnections of feminist cultural studies, queer theory, and digital media theory; she has published widely on issues of representation, embodiment, and mediation.

Jamie Hakim is a lecturer in culture, media, and creative industries at King's College, London, UK and researches digital media and queer cultures of embodiment, intimacy, and care.

John Mercer is Professor of Gender and Sexuality at Birmingham City University, UK.

Renee Middlemost is Lecturer in Global Communication and Media at the University of Wollongong, Australia. Her research interests include cult film, fans, celebrity, film, television, and popular culture, with a central focus on audiences, and how they engage with, and create media products.

Rachel O'Connell is Lecturer at the School of Media, Arts and Humanities, University of Sussex, UK. She has published research on late nineteenth century British literature in relation to middlebrow culture, prose genres, ethics, sexuality, and disability

Charlie Sarson completed his PhD at Birmingham City University, UK and researches representations of gender and sexuality.

'Charisma, uniqueness, nerve and talent': *RuPaul's Drag Race* and the cultural politics of fame

John Mercer ⓘ, Charlie Sarson and Jamie Hakim

When the ceaselessly industrious RuPaul Charles eventually decides to write the next volume of his autobiography, the chapter devoted to the final year of the 2010s will no doubt be narrated as the point at which his triumph as an international media personality was assured; Photographed by Annie Leibovitz for *Vogue* (an outlet where RuPaul is now routinely a topic for fashion and beauty features) the launch of his own daytime talk show, The *RuPaul Show* on the Fox Network, a comedy series, *AJ and the Queen*, commissioned by Netflix, a make-up line with Mally Cosmetics and in 2018 perhaps the most symbolically significant of all, a star on the Hollywood Walk of Fame. All of these developments transpire alongside the launch of season 11 of *RuPaul's Drag Race*, the associated DragCon events, the *Werq the World* drag tour and the internationalisation of the TV franchise with versions launching in Australia and Canada as well as the surprise success of *RuPaul's Drag Race UK*. RuPaul and the polished, glossy vision of drag that he embodies has been a resounding international success. The pillar product in RuPaul's empire remains, for the time being at least, the reality TV competition show *RuPaul's Drag Race* a show designed as a campy satire of *America's Next Top Model* conceived as the search for 'America's next drag superstar' predicated on the premise that the ultimate dream of any aspiring drag queen must inevitably be the attainment of celebrity status, indeed that fame is the sine qua non measure of success.

As editors of this special edition we all agreed that the particularities of *RuPaul's Drag Race* as a format, organised around the star power of its eponymous host and its roster of celebrity judges and memorable contestants to its conditions of distribution and consumption provide extravagant riches from which we can mine an understanding about the workings of celebrity across media platforms in the 21st century.

The international appeal of *RuPaul's Drag Race* that reaches far beyond its cable and pay-per-view audience on channels such as LogoTV and VH1 has fostered a passionate and invested audience base which in turn has resulted in a growing body of work around the Drag Race phenomenon and drag culture more broadly in the past 5 years. For instance, in 2017 David Gudelunas and Niall Patrick Brennan's substantial edited collection *RuPaul's Drag Race and the Shifting Visibility of Drag Culture: The Boundaries of Reality TV* described the parameters of debate within this nascent subdiscipline. We note though that the connections between this specific iteration of drag culture and contemporary celebrity culture have until now been implicitly drawn rather than explicitly explored.

This then is a special edition of *Celebrity Studies* that aims to do two things simultaneously; to point to the textual and cultural specifics of *RuPaul's Drag Race* as an internationally popular phenomenon and consider the ways in which the show can be regarded as an instructive vehicle to explore a set of debates around contemporary celebrity; questions of gender and sexuality, the use of social media in framing and promulgating fame, the relations between mainstream and marginal celebrity status, fandom and fan practices, and the discourses of celebrity connected as they so often are to enactments of gendered glamour as well as histories of personal adversity, pain and trauma.

We have tried in this special edition to present essays that explore the intersections of celebrity and drag culture as it is represented in *RuPaul's Drag Race* and we have therefore aimed to gather together essays with a diversity of voices, perspectives, objects of study and concerns. It was also important to complicate easy assumptions about the assumed majority gay male audience and their investments in the programme and we are delighted that so many of our authors are female as *RuPaul's Drag Race* provides a space to consider performances of gender and identity that are not confined to expressions of gay male sexuality alone. We also felt very keenly that given the importance of fandom, communality and the pleasures of sharing that are central to the success of *RuPaul's Drag Race* that it was important not only to include essays that celebrate as well as criticise RuPaul's vision of drag culture but also that so many of the essays in this collection are co-authored.

We open this special edition with an essay by Jamie Hakim and Zeena Feldman, 'From Paris is Burning to #dragrace: Social Media and the Celebrification of Drag Culture' that contextualises and situates many of the debates that follow on in subsequent chapters. This includes the so-called mainstreaming of drag culture, the use of social media as a mechanism for self-promotion and self -branding and a critique of the politics that implicitly and explicitly undergird the discourses of *RuPaul's Drag Race*.

In "Assume the position: two queens stand before me': RuPaul as Ultimate Queen' Hazel Collie and Gemma Commane tackle the connections between the matrilineal discourse of RuPaul as 'Mama Ru' and the promotion and commodification of RuPaul as a brand head on. The authors argue that we should understand RuPaul as the 'ultimate queen' rather than as Mama Ru and therefore as the epitome of this very particular iteration of contemporary drag culture.

As *RuPaul's Drag Race* has evolved from season to season and grown in popularity it's possible to argue that the show's satirical intentions have been superseded by the therapeutic discourses of transformation and self-realisation that RuPaul extols in the publication of the self-help manual *GuRu* for instance. However campy satire remains a pervasive element of the programme's style and format and this is a subject that Hannah Andrews addresses. In 'Drag celebrity impersonation as queer caricature in The Snatch Game' Andrews discusses the interplay between the transgressive and the subversive and the reactionary and the conservative that is dramatised through the mainstreaming of drag in *RuPaul's Drag Race*. By focusing on one of the most popular challenges that are staples of the show's format, the 'Snatch Game', Andrews point to the potential that the caricature of celebrities offers as a camp strategy. As she observes, 'if camp can be defined as "queer parody" drag impersonations may be looked at as queer caricature.'

Fandom and fan investment has been one of the distinguishing characteristics and core to the reception and circulation of the *RuPaul's Drag Race* franchise. We felt therefore that an essay grounded in an appreciation of at least one of the queens was an essential contribution in terms of representing current drag culture scholarship. Renee Middlemost's essay 'Rewriting "Herstory": Sasha Velour's Drag as Art and Activism' wittily uses the *RDPR* 'virtues' (charisma, uniqueness, nerve and talent) to conduct a star study of one of the most distinctive winners of the drag race crown, Sasha Velour.

Rachel O'Connell also focuses on a specific queen but with altogether different intentions. In '"Labouring in the Image": Celebrity, Femininity, and the Fully Commodified Self in the Drag of Willam Belli' O'Connell discusses the self-proclaimed 'bad girl' of *RuPaul's Drag Race*, Willam. As a queen whose persona and signification resisted the constraining discourses of the programme, O'Connell sees Willam's drag femininity as one that is fixated with the acquisition of fame and also crucially about labour ('werk' being the fundamental injunction that RuPaul makes to her girls.) and considers the extent to which this can be understood as a comment on the construction of contemporary femininity in the digital age.

In "No One is Trash, No One is Garbage, No One is Cancelled': The Cultural Politics of Trauma, Recovery and Rage in *RuPaul's Drag Race*' Deborah Ferreday also focuses on a divisive queen through an exploration of The Vixen who courted controversy and suffered a fan backlash by questioning the racial politics of her fellow contestants and the programme more broadly. Ferreday's essay which breaks new ground in the field of celebrity studies, sees The Vixen's post *RPDR* celebrity via social media as illustrative of the ways in which trauma, rage and pain can be enacted (tropes central to the persona of the reality TV star). These performative acts Ferreday argues, resonate with a queer politics of vulnerability.

The final essay in this special edition returns to the issues that Hakim and Feldman set up in their opening essay and like Ferreday's essay points to the ways in which aspects of social media use deployed by the queens of *RuPaul's Drag Race* can be seen as indicative of the contemporary context of celebrity. Exploiting social media has been core to the success of the programme and to the development of the careers of the queens before and after they have appeared on *RuPaul's Drag Race*. John Mercer and Charlie Sarson's essay '15 Seconds of Fame: Rupaul's Drag Race, Camp, and 'Memeability" considers one aspect of the ways in which celebrity status is articulated in the social media age; the meme and 'memeability' and the extent to which the textual specifics of social media have become integral to the construction of a celebrity persona in the 21st century.

Disclosure statement

No potential conflict of interest was reported by the authors.

ORCID

John Mercer ⓘ http://orcid.org/0000-0002-8969-2626

From *Paris is Burning* to #dragrace: social media and the celebrification of drag culture

Zeena Feldman and Jamie Hakim

ABSTRACT

This article examines the celebrification of drag culture in the USA, and reflects on social media's role therein. This transformation is contextualised historically by charting the evolution of drag media representation from the subversive drag collectives immortalised in arthouse documentaries like *The Cockettes* (2002) to the emergence of highly-polished, brand-conscious celebrity drag entrepreneurs propelled to fame by the reality television programme *RuPaul's Drag Race* (2009–). The success of *RuPaul's Drag Race* (RPDR) has lent drag unprecedented levels of mainstream visibility. In so doing, we argue that RPDR has facilitated drag culture's move from the fringes to the mainstream, and contributed to drag's celebrification. In the second half of the article, we draw on celebrity studies and self-branding literatures to outline the central role that social media have played in the celebrification of drag culture. We also critique the politics this celebrification props up. Through analysis of queen-generated content on social media platforms, and of RPDR transcripts, we home in on the ethics of drag's celebrification – specifically the ways it supports homo-normative narratives of the 'good queer', and delimits the sorts of queer bodies and politics that are acceptable in the mainstream.

Introduction

Focusing on the American media ecosystem and the *RuPaul's Drag Race* franchise, this article argues that today's drag culture is 'celebrified': professionalised, commercially-viable, brand-oriented and mainstream. This 'celebrification', we demonstrate, is intimately connected to the rise of contemporary social media. To advance our argument, we bring the transformation of drag culture into dialogue with historic changes in media production, from the era of broadcast dominance to the current hegemony of user-generated online content. How has the shift from television and cinema to Instagram and YouTube affected the ways that drag queens understand and perform themselves? To what extent has the social media production context impacted drag's progressive identity and subversive politics? How does the emergence of multi-platform, celebrity drag queens connect with drag's history of critique?

Academic interest in the links between celebrity and politics is long-standing (e.g. Marshall 1997, Drake and Higgins 2006, McKernan 2011, Becker 2013). Some of this literature focuses on how established celebrities leverage their fame in support of political causes (Anderson 2008, Farrell 2012, Dejmanee 2013). But what happens to the relationship between celebrity and politics when the newly-minted star – in this case, the drag queen – is one who has traditionally been marginalised, stigmatised and an object of socio-economic exclusion? What becomes of the politics of subversion and opposition that are so intimately linked to an outsider subjectivity when that outsider is suddenly welcomed into the world of mainstream celebrity?

We examine these questions through attention to the celebrification of drag and social media's role therein. One of our aims is to contextualise drag's transformation historically by charting the evolution of drag media representation from the subversive drag collectives immortalised in arthouse documentaries like *The Cockettes* (2002) and *Paris is Burning* (1990), to the emergence of the highly polished, brand-conscious celebrity drag entrepreneur propelled to fame by the reality television programme *RuPaul's Drag Race* (2009–). The success of *RuPaul's Drag Race* (RPDR)[1] has lent drag unprecedented levels of mainstream visibility (Oliver 2018). It has also launched a bevy of celebrity careers with multimedia derivatives, and in so doing, we argue that RPDR has facilitated drag culture's move from the fringes to the mainstream, and contributed to drag's celebrification.

The article's second aim is to draw on celebrity studies, social media and self-branding literatures (e.g. Hearn 2014, Abidin 2018) in order to highlight the central role that social media platforms have played in the celebrification of drag culture. We also locate and critique the politics this celebrification props up (and disincentivises). Through analysis of queen-generated content across social media platforms, and of RPDR transcripts, we home in on the ethics of drag's celebrification – specifically the ways it supports homonormative narratives of the 'good queer' (Duggan 2003) and delimits the sorts of queer bodies and politics that are acceptable in the mainstream. Ultimately, analysis of the RPDR media empire and its social media footprint demonstrates that the celebrification of drag is today girdled by neoliberal imperatives and commercialised online platforms, wherein the transgressive drag collectivities captured in earlier media epochs have been displaced by the logic of individualism, competition and the market.

This article proceeds in two parts. First, we show how social media and drag have, individually, evolved along a similar trajectory. Both began as landscapes of non-commercial niche amateurism. Over the last decade, however, both have transformed into spaces of and for commercial enterprise. With these parallel chronologies mapped out, the second portion of the article reflects on what this dual commercialisation means for how we think about drag in the social media age. Here, we show that drag – as an identity and a politics – is increasingly read through the lens of celebrity and as a branded commercial endeavour, where 'authenticity' is legitimate only insofar as a coherent persona is consistently performed (Fry 2019). Our analysis suggests that social media's ubiquity in everyday life, and its centrality to the economics of drag celebrity, have further upped the ante.

One result of this is a dampening of drag's subversive potential – a constraining of its politics of critique. Less a project of subverting gender norms, or anti-capitalist politics, today's commercialised drag signals, results in and endorses 'a privatized, depoliticized gay culture anchored in … consumption' (Duggan 2003, p. 179), where drag has become

a vehicle for enterprise as opposed to a means through which dominant power structures might be mocked, queried or dismantled.

Internet, professionalisation, capital

The initial domestication of the internet, and later the World Wide Web, in the 1980s and 1990s, produced vibrant spaces of self-expression and information sharing. From early bulletin board systems (BBS) and proto-social networking sites like The WELL (Rheingold 1993 [2000]), Usenet (Hauben and Hauben 1997) and Internet Relay Chat (Burnett and Bonnici 2003) to the eclecticism of personal webpages and blogs (Lindemann 2005, Milligan 2017), the early Web was fertile ground for non-commercial socialisation and knowledge production. They were also spaces where stigmatised and disenfranchised subjects could connect with likeminded peers from all over the connected world (e.g. O'Riordan 2005).[2] This is not to suggest that the early Web was a utopia of inclusivity and acceptance. Indeed, it is important to note the rich scholarship that attends to online reproduction of offline racism, misogyny and homophobia (e.g. Silver 2000, Nakamura 2002). But equally, it is important to note that queer cultures did benefit from these newly networked spaces as they provided a means through which queer people, many of whom could not access the physical spaces of metropolitan gay neighbourhoods, were able to socialise (Campbell 2004).[3]

Things began to change at the start of the 21st century. There, sharp growth in internet penetration rates coincides with the emergence of brand names now associated with today's version of social media. LinkedIn and MySpace launch in 2003; Facebook and Flickr in 2004; Reddit and YouTube in 2005; Twitter in 2006 (Boyd and Ellison 2007). As the social media ecosystem began to take shape in the mid-2000s, we saw an accompanying lexicon emerge. Most notably, Tim O'Reilly (2005) furnishes the 'Web 2.0' buzzword. Originally a framework for understanding trends in software production, the term soon became shorthand for a participatory online media system of prosumers and their user-generated content (Bruns 2006, Ritzer and Jurgenson 2010, Paltrinieri and Degli Esposti 2013). The language of Web 2.0 gestured to the (alleged) defeat of traditional media gatekeepers and celebrates the (alleged) 'democratisation' of the means of production (Shirky 2008). Herein, the web was no longer the exclusive property of tech-savvy experts; it was now a terrain open – at least rhetorically – to everyone.

As platform access and content production became 'democratised', social media also became increasingly commercial and commercialised. In 2005, for instance, Rupert Murdoch's News Corporation bought MySpace for 580 USD million (Saga 2011). Less than a decade later, Facebook raised 16 USD billion in its initial public offering and achieved a market capitalisation of 104 USD billion (Rusli and Eavis May 2012). Suddenly, there was a lot of money to be made from social platforms and their users.

Despite the veritable gold rush, social media continued to offer spaces to hobbyists, amateurs and the non-commercially minded (e.g. Fulton 2009, Fuchs and Sandoval 2015). But as social media user counts grew, so too did the business of social media. Today's industry is complex and sophisticated, with myriad ad revenue models including affiliate programmes and brand ambassadorships (Enders et al. 2008, Holton and Coddington 2012, Miller 2013); digital agencies specialising in microtargeting and audience profiling (Barbu 2014); and a content marketing industry set to exceed 412 USD billion by 2021

(Technavio 2017). This commercialisation has impacted social media use and users, affecting motivations for participating and specific practices and forms of content-generation (nb. Paasonen 2016). With social media now captured by the language, materiality and incentive structures of the market, online self-presentation has increasingly become a conduit for profit. It is in this context that we can understand the rise of micro-celebrities and social media influencers (Khamis *et al.* 2017, Raun 2018, Djafarova and Trofimenko 2019). Likewise, this helps explain the emergence of the professional YouTuber – a figure starkly in contrast with that platform's early amateurism (Burgess *et al.* 2012). Indeed, many scholars have previously shown that as platforms of self-expression become commodified, so too do the practices of self-production (e.g. Thumim 2012, Banet-Weiser 2012, van Dijck 2013, Jarrett 2015, Iqani and Schroeder 2016).

What started out as non-commercial spaces of and for niche audiences have, in the last decade, emerged as spaces of and for professional content producers and enterprising subjects (Gill et al. 2017). This transformation of social media's political economy helps anchor our analysis of *RuPaul's Drag Race* in the final portion of this article, allowing us to map social media's commercialisation onto the mainstreaming, professionalisation and celebrification of drag.

Before that, the following section charts the shift in drag culture from earlier amateur media and forms to the emergence of today's professionalised, platformed queens. This shift mimics what we describe above in regard to social media platforms. With drag, however, this transformation can be articulated as a move away from the drag balls shown in the iconic documentary *Paris Is Burning* (1990) to the celebrity queens who have emerged from RPDR. What does this shift tell us about the evolution of drag culture? How does it map onto web culture's own mainstreaming and commercialisation? And what does this reveal about contemporary social mores and norms more widely?

Drag of yesteryear: from anti-capitalism to ambivalence

To be able to answer these questions, we first examine the relationship between drag and notions of professionalism that preceded *RuPaul's Drag Race* and its considerable social media footprint. Our analysis of pre-digital drag foregrounds more 'traditional' media forms: live performance and film. Within these, we find two general modes of drag represented. Firstly, drag which is intentionally un-professional and as such, functions as a means of anti-capitalist critique. Secondly, drag whose relationship to professionalism, and subsequently capitalism, is more ambivalent. We explore these in turn.

In the United States, there have been iterations of anti-capitalist drag since at least the 1960s. This mode of drag coincided with the period's feminist, gay and civil rights liberation movements and their critiques of gender, sexuality and race oppression. The drag troupe The Cockettes – arguably the most iconic exemplar of anti-capitalist drag – was forged in this progressive political moment. The Cockettes emerged as key players in San Francisco's hippy scene at the end of the 1960s (*The Cockettes 2002[The Cockettes 2002*). Living in a commune amongst a network of similarly organised anti-capitalist collectives, in the city's Haight Ashbury district, The Cockettes were the drag embodiment of Timothy Leary (1966) invitation to 'Turn On, Tune In, Drop Out'. They put on free performances, shoplifted costumes and props, ate free food provided by neighbouring

commune, and lived off state welfare (*The Cockettes The Cockettes 2002*). Ultimately, they defined themselves directly against and deliberately outside of America's capitalist norms.

The Cockettes' performances playfully subverted gender expression and offered free-wheeling, bawdy yet utopian visions of how social, economic and gender relations might be organised differently. Shows like *Tinsel Tarts in a Hot Coma* (1971) and *Journey to the Centre of Uranus* (1972) were deliberately amateurish in style in ways that worked to critique the formulaic predictability and professionalism of capitalist cultural production. Some of their work explicitly challenged capitalism, for instance their short film *Elevator Girls in Bondage* (1972) in which drag queen elevator girls gather beneath a portrait of Karl Marx and try to organise against their economic exploitation. The Cockettes were emblematic of the West Coast counterculture (Turner 2006) and the influence of their politics and transgressive style influenced a whole thread of subsequent drag culture, from the Radical Faeries (Lecker 2015) to Vaginal Crème Davis (Muñoz 1997) to the UK-based performance artist David Hoyle (Oliver 2014). As ideological descendants of The Cockettes, these artists use avant-garde drag aesthetics in ways that set out to undermine the gender norms and consumerist orientations of capitalist societies.

While anti-capitalist drag offers moments of important, culturally resonant critique, it was, and it remains, a fringe activity. With few exceptions (e.g. the Australian drag queen-cum-TV star Dame Edna Everage), Anglo-American drag culture has had an ambivalent relationship to professionalism and mainstream success. For decades, drag artists existed outside of the cultural conditions that might have enabled and supported the development of professional careers. Drag queens were outsiders, and within American capitalism, this 'otherness' extended beyond the cultural to the economic. As such, drag performers have long had a necessarily ambivalent relationship to capitalism.

This ambivalence is best captured by the Harlem ball scene of the 1980s, as represented in the cult documentary *Paris is Burning* (1990) and later, in Ryan Murphy's television series *Pose* (2018–2019). This drag scene has its roots in the late 19th century and is comprised of mostly African-American and Latinx queer people competing in balls. Here, competition involved convincingly dressing up – or in the language of the balls, 'passing' – as a particular type of person, often of the opposite gender. In its 1980s iteration this frequently meant 'passing' as a recognisable, prominent archetype of the time: a yuppie, a stockbroker, a runway model.

That *Paris Is Burning* takes place in Reagan's America (1981–1989) is not insignificant. Indeed, the above archetypes reflect the political economy of the historical moment in which they are performed. Reagan's America is a template of late capitalism and its contradictions: a systemic attack on the social safety net; conspicuous consumption; tax cuts; union-busting and deregulation; and a booming stock market (Anderson 1990, Wills 2017). Here, Madonna (1984) song 'Material Girl' enjoys *Billboard* success (Caulfield 2017) at the same time that state welfare cuts reduce (some) people's access to the 'material world' the song fetishes (Stoesz and Karger 1993). While media culture celebrated consumption, government policy foreclosed on the material subsistence available to society's neediest – to those, like drag queens and people of colour, who were systemically excluded from capitalism's warm embrace. This historic assault on the welfare state thus posed a fundamental challenge to the very viability of the anti-consumerist drag performed and articulated by The Cockettes and their anti-capitalist compatriots.

Paris Is Burning is also situated in Cold War America, with its rigid understandings of 'right' and 'wrong' (Stuckey 1995). 'Good' citizenship in this context is associated with virulent capitalism, heteronormativity and individualism. Conversely, the 'bad' subject is one who advocates for the collectivism, the welfare state and gender/sexuality fluidity. Thus, the Black and Latinx queens represented in *Paris is Burning* (and later, in *Pose*) are living on the fringes of society in multiple ways. They attend drag balls because these are among the few safe spaces to which they have access in an otherwise hostile America. And while the queens' ball ensembles often emulate the aesthetics of America's luxury consumer culture, the performances are essentially play-acting. In the Harlem balls, the aesthetics of wealth are recreated with stolen, found, handmade and second-hand goods precisely because drag does not yet offer a viable career, much less mainstream fame. Indeed, the protagonists of *Paris is Burning* discuss their 'mopping' (i.e. stealing) practice as the only way they can access the culture's fixation with brand names and consumerism. They also refer to the fact that they sometimes do not eat for days so that they can save enough money for their ball looks. The balls, then, function as spaces for self-expression, self-actualisation and communality set against a backdrop of economic marginalisation. Thus, when ball emcees and attendees express their approval of a queen's look by proclaiming 'You own everything', the phrase does complex conceptual work: it signals a convincing embodiment of luxury while also gesturing to its temporariness and artifice. Where the simulacrum of abundance successfully 'passes' for the 'real thing', it remains inextricably linked to the *fantasy* of economic power and drag queens' historic exclusion therefrom. This analysis provides an interesting lens through which to understand the RPDR contestant Mercedes' repeated inability to pronounce the word 'opulence' (S11E2).

The drag balls offered a temporary escape from the era's heteronormative capitalism. But they also reflect a profoundly ambivalent relationship with capitalism: the performances mimic its norms and articulate its aspirations while simultaneously providing a brief respite from systemic marginalisation. Desire sits alongside rejection, and critique alongside incorporation/interpellation.

The economic reality of other drag performers, as detailed in Esther Newton's landmark ethnography *Mother Camp* (1972), adds flesh to these bones. It is here that we begin to see a cleavage in the drag community, between performers interested in challenging capitalist hetero-patriarchy and those interested in a paying job. Where 'stage queens' *did* try to make a living, the working conditions were difficult. Newton explains that drag queens 'work long hours for little pay' (p. 4), noting

The highest weekly salary I ever heard of for a single female impersonator in a gay bar was 200 USD a week, and this is exceptional. The average is closer to 75 USD a week, with some salaries as low as 40 USD (p. 116).

The weekly average Newton cites equates to an annual income of 3,900, USD if the performer works 52 weeks a year. To put this in perspective, in the US, the average annual salary in 1979 was 11,479.46 USD (Social Security Administration 2019 61) – approximately 295% of a stage queen's yearly income.

Alongside low earnings, Newton also points to the high costs of doing drag work. Much of this work occurs in gay bars, where customers are often regulars and thus expect to see new looks from repeat performers. The bar tab also adds up. With high costs and low wages, self-promotion becomes increasingly necessary for the enterprising queen and so we see the emergence of publicity flyers – another cost of doing business.

Ultimately, this mode of working relied on individual perseverance. There were no contracts, no unions, no other structures of formal organisation. Queens were often out of work or 'between jobs'. Where paying gigs did exist, they typically required performers to move from city to city, shuffling between collective living arrangements with others queens. Further complicating these conditions of production was a legal-political context in which police had impunity to harass and close down gay bars, thus making a precarious living all the more so. 'Like the majority of Americans [...] [drag queens] have no control at all over the conditions of their work; no job security, no collective strength' (Newton 1972, p. xx).

Then in the early-to-mid 1990s, we see the rare drag success story: RuPaul. In 1993, two singles from her *Supermodel of the World* album reach number 1 on Billboard's Hot Dance Music/Club Play chart. The self-pronounced 'Supermodel' then signs a modelling contract with MAC Cosmetics and in 1994, becomes the face of their Viva Glam campaign. After publishing the 1995 autobiography, *Lettin' It All Hang Out*, RuPaul co-hosts a morning radio programme in New York and from 1996 to 1998, co-hosts a late-night talk show on the national cable television network VH1 (RuPaul 1998).

This has all the trappings of the American dream: the individual from humble beginnings who worked hard and made a success of him/herself. It is a classic rags-to-riches Horatio Alger story, with a drag queen as its central character.[4] While RuPaul's rise foreshadowed elements of today's drag moment, this success narrative also coincided with the rise of the World Wide Web: a communication medium that allowed (certain) marginalised audiences unprecedented access to voice and self-representation. Between the fledgling world of professional 'female impersonators' that Newton documents and the early career achievements of RuPaul, we begin to see potent parallels with contemporary drag norms, as exhibited in RPDR. We turn our attention to these parallels below.

Enter RuPaul's Drag Race: drag and social media convergence

RuPaul's Drag Race first aired in 2009, on Logo TV – an American LGBT-focused cable television channel (Ng 2013). Following the enormous commercial success of talent shows like *Big Brother* and *Pop Idol*, RPDR funnelled some aspects of the drag cultures described above into the traditional competition reality show format. In weekly episodes, drag queens compete in a task and a runway challenge. The two 'worst performers' of each episode then compete against each other in a lipsync performance, with the loser sent home. The weekly eliminations culminated in the last queen standing being crowned 'American's Next Drag Superstar' and in the first season, winning a cash prize of 20,000, USD 5,000 USD worth of MAC cosmetics, a spot in an LA Eyeworks advertising campaign and a job touring with the Logo Drag Race tour.[5]

As with many reality television programmes, social media has played an instrumental part in the show's success, as well as in the business model the show's production company, World of Wonder, built around it. RuPaul routinely directs viewers to 'participate' in Drag Race through a hashtag: #dragrace. In later seasons, audiences are also encouraged to express their support for their favourite finalist via hashtag. Here, social media platforms are positioned as proxies for community but they also work to enlarge RDPR's cultural-cum-economic footprint. Social media participation produces metrics, which act as evidence of user 'engagement' while also facilitating the monetisation of

that engagement (nb. Beer 2016). Where fans live-tweet episodes or post #TeamMonetXchange content on Instagram, for example, they are extending the franchise's cultural and economic reach. (They are also adding to Twitter and Instagram's data inventories.) Indeed, Drag Race's social media footprint is massive. As of 8 October 2019, the show had 2.8 M Instagram followers; 2.29 M Facebook followers; 969 K Twitter followers; and 1.35 M subscribers to World of Wonder's YouTube channel. Yet these figures reflect only official RPDR social channels – a sliver of the show's broader social media presence, populated by extensive fan-generated content and the individual accounts of featured queens and judges. Indeed, many of the show's alumni have amassed considerable social media followings (detailed below).

According to the media industries scholarship on reality television, the success of the current format depends almost entirely upon its enmeshment with the professionalised social media infrastructures we outline above (e.g. Deery 2014). In this sense *RuPaul's Drag Race* is a representative case of a broader logic. What this means for the production of celebrity within reality television is cogently addressed by the work of Alison Hearn (2008, 2014, 2017)). Hearn argues that reality television contains too many types of television to be understood as a single genre in its own right and instead is best conceived of as 'a series of cost-cutting measures in mainstream television production enacted by management as a response to the economic pressures faced by the television industry transnationally in the late 1980s and 1990s' (2014, p. 439) One of the major costs cut was personnel: instead of unionised writers and actors, reality television shows employed low-cost producers and no-cost 'real people'(Williamson 2016).

The rationale offered to these 'real people' for providing free labour is that the television programme gives them a 'free' platform on which to launch their celebrity personae. Subsequently, social media affordances could be harnessed to grow their nascent brands. As Hearn (2014) suggests, this method of 'self-branding' is located at the intersection of reality television and social media communication. With self-branding now characteristic of the contemporary production of celebrity, social media platforms become increasingly central to these practices. Indeed, it is within this context that we can make sense of what Crystal Abidin (2018) dubs 'internet celebrity' – a form of entrepreneurial self-branding enabled by social media's ability to facilitate direct communication between a star and their fans. Social media platforms are thus essential to making possible both contemporary celebrity and contemporary fandom.

RuPaul's Drag Race, as a reality television show with a considerable social media presence, is informed by the industrial logic Hearn outlines. It is unsurprising then that the show's most 'successful' participants become celebrities within the terms of this logic: the show provides them with a platform to launch themselves as media personalities, and then social media savvy enables them to further market themselves, to grow their fanbase and ultimately, to become drag entrepreneurs. The remainder of this article will provide evidence from the show itself as well its social media content to demonstrate how *RPDR* drag queens explicitly construct themselves as professional, entrepreneurial self-brands. It will then consider the figure of drag queen as self-brand within the longer history of drag outlined earlier, so as to understand the ethical implications of the pre-eminence of this sort of drag celebrity within the current historical conjuncture.

The queens of drag race: competitive, hard-'werqing' self-brands

For the contestants of *RuPaul's Drag Race*, a social media presence is all but compulsory. Instagram is currently the dominant platform for drag queens, arguably because its emphasis on imagery supports drag's long-standing connection to visual culture and is particularly well-suited to showcasing a queen's distinctive looks. Twenty-two former Drag Race contestants have now surpassed 1 million Instagram followers (RuPaul's Drag Race Wiki). Such social media popularity often gestures to the accountholder's offline success, and indeed, of the twenty-two queens in the 'million follower club', many have developed prolific multimedia careers that include touring but also extend to YouTube, film, television and music production (Turchiano 2018).

Drag Race queens frequently frame their social media participation through the discourse of celebrity and entrepreneurial self-branding. For instance, Jasmine Masters (S7 and All Stars S3) has said:

> Yeah, cause once you're on [social media], you are a reality celebrity. You are a brand from that point, you know, so you have to treat yourself as a market, as a business So you have to think, company-wise, you have to think of yourself as a brand because you are a brand now (in Schotmiller 2017, p. 283).

Masters has in fact mastered the use of social media to self-brand. Despite performing poorly on both of her RPDR seasons she has achieved the status of fan favourite largely through the virality of memes that are produced from videos she uploads onto her YouTube channel.

Indeed, an active social media presence is increasingly regarded as essential to the making of a contemporary drag career. West Hollywood based drag queen Cake Moss aspires to be a RPDR contestant and is keenly aware of the importance of social media to achieving RPDR levels of success.

> You have to like at least post one or two photos a day on social media and post in general just to keep your place. It's weird, it's interesting. Cause I've noticed that of the older queens that aren't really savvy with technology and social media and all that, they're just being swept under the rug (in Schotmiller 2017, p. 268).

Social media engagement is presented here as both necessary and central to today's drag profession. Yet Drag Race contestants who are seen as too closely affiliated with social media are routinely dismissed by competing queens. Silky Nutmeg Ganache, for example, rejects the idea that her Season 11 colleague Ariel poses meaningful competition precisely because

> Ariel is a social media girl. So I think it's a difference for her being in a situation where she's with real entertainers. She's one note. She don't really have a personality. She's an Instagram ho. Nobody care, *nobody* care (S11E3, emphasis original).

For Ariel, being seen as a *primarily* social media queen raise scepticism about her charisma, uniqueness, nerve and talent. Yet we also see, through Jasmine Masters and Cake Moss, that social media is nonetheless regarded as necessary to the viability of a successful drag career.

Indeed, social media self-branding is understood by many Drag Race contestants as central to their post-show careers. The topic has even formed the basis of discussion

panels held at the thrice annual *RuPaul's Drag Race* fan convention 'RuPaul's Drag Con'. One such panel called 'Brand Me!' (2016) featured Drag Race contestant Laganja Estranja reflecting on how her appearance on the show and audience's social media responses to this informed her post-show entrepreneurial self-branding strategy and social media usage. Laganja explained that the show launched her as a 'character' that was built around her 'catchphrases', her 'meltdowns' and her drag style's incorporation of cannabis references. On Twitter, Instagram and elsewhere, this character was one that many of the show's fans loved to hate, so on the panel Laganja explained how she set about 'rebranding herself' by leveraging this negative audience reaction: 'Oh girl, you think I'm too much, now I'm #teamtoomuch, and now you can see me on tour'. She claimed that social media hashtags are key to her self-branding, not only hashtagging her catch-phrases, which have become iconic to the Drag Race audience, but also giving nomen-clature to her fanbase: #buds (referring to the buds of a cannabis plant).[6] Most social media commentators agreed that Laganja gave a middling performance on RPDR, includ-ing her turn on the show's talent contest 'Snatch Game'. As such, a carefully cultivated, social media-based self-branding strategy has been crucial to the professional construc-tion of her celebrity and post-show career. For both Laganja and Jasmine Masters, their celebrity stems more from their social media self-branding than from the more traditional ingredients of a drag persona: the drag look and performance style.

The purpose of branding is to make a product – in this case, one's self – distinctive within a competitive marketplace. In today's drag, much of that branding takes place within increasingly accessible but also increasingly crowded social media feeds. One result of this has been intensification of the competitiveness that Newton (1972) found to be an everyday feature of a drag queen's working life. This competitiveness is, of course, compounded by the fact that RPDR is itself a competition. Yet we can also chart how, over time, the explicit values and stakes of competition impacted the show's content and affective texture. The early seasons of RPDR feature queens who are rough around the edges – for instance, in their makeup application, hair and wig skills, fashion acumen and padding. But as the show progresses, we see fewer unpolished queens. The increased gloss brings with it a change in the discussion topics among contestants and also their narratives of self-presentation. Earlier seasons routinely feature heart-warming stories of individual struggle and perseverance-against-all-odds. Later seasons foreground queens discussing their social media followers, their brands, their careers. The (sympathetic) figure of the social outcast is slowly replaced by the professional and hungry entrepre-neur – exemplified in All Stars 3 when contestant Morgan McMichaels notoriously announced 'I'm here to win; [I] will get rid of my competition'. As discussed above, this displacement of the amateur by the professional/enterprising subject coincides with and maps onto a similar move in social media production.

A definitive aspect of the drag entrepreneur as self-brand that characterises successful contestants of *RuPaul's Drag Race* is the embrace of the imperative to 'work', or in the parlance of the show, 'werq'. This extraordinary emphasis on working is where the culture of drag that the show privileges departs most clearly from the radical forms of drag discussed at the beginning of this article and that we have exemplified using *The Cockettes*. The term 'werq' is used across drag as well as LGBTQ+ cultures in the US (and elsewhere) as an affirmation of something that someone has said or done. The term is constantly used in the show as well as in its various spin-offs and associated content. The

significance and ontological centrality of the term is perhaps most vividly illuminated in fan favourite Shangela's song *Werqin' Girl* (2012). In contrast to RuPaul's *Supermodel (You Better Work)*, which is largely about the fantasy of the glamorous life of a supermodel (regular fayre in US drag queen and ball culture, which often aspires to the aesthetics of hyper-femininity), *Werqin' Girl* is a braggodocio track in which Shangela boasts about her status as a paid professional. The lyrics begin with the line 'Move aside amateurs!' and continue into the chorus:

I'm a pro
Pro
I'm a pro
Uh I am a professional
Pro
I'm a pro
I'm a pro
Uh I'm a professional
Work (work work)
I came to work (work work)
I'm here to work (work work)
I told y'all I was a professional

The song fetishes hard work and tenacity. In reference to her tireless work ethic, Shangela explains that her work is:

No 9 to 5
Around the clock
Overtime
Haters cannot touch my drive

The discursive insistence on professionalism and hard work is reinforced affectively through the song's intense and abrasive sound as well as the music video's choreography, which can best be described as frenetic. Indeed, Shangela's construction of herself as a hard-working queen has paid off and her celebrity profile now extends well beyond the Drag Race universe. In addition to several music singles, she has many film and TV credits to her name, including on *Glee* (2012); *Broad City* (2019); and the Lady Gaga vehicle *A Star is Born* (2018). In the celebrity persona that is Shangela, exemplified by her single *Werqin' Girl* and its explicit celebration of the hard working, professional, self-branded drag entrepreneur, we are a world away from the free-wheeling, anti-establishment, anti-capitalist drag that preceded *RuPaul's Drag Race*. That earlier drag – less professional but more political – has been all but eclipsed by the genre's mainstream success. Indeed, in a Drag Con panel titled 'The Business of Drag' (2016), Latrice Royale makes clear that today, 'Drag is not hobby, it's a career'.

Conclusion

RuPaul's Drag Race represents the high watermark of mainstream success for drag culture in the US (and elsewhere). This success has been enabled in large part by the ways that

World of Wonder has funnelled key aspects of US drag culture into the reality TV format. As previously stated, this format is dependent on a complex, commercialised social media infrastructure designed to increase audience engagement and maximise revenue in an ever-more-competitive media ecology. The effect that this has had on the celebrification of the show's drag queens and therefore the type of drag that achieves visibility in the mainstream is significant.

Whereas prior to the show's success, US drag cultures existed either in opposition to, or were side-lined by, American capitalism, the drag culture that most people consume now, both inside and outside LGBTQ+ communities, is thoroughly imbued with the logic and mechanics of capitalism. *RPDR* drag queens routinely frame their drag and their social media engagement as forms of professional self-branding. In the process, relations between the drag queens have become more competitive and drag's articulated values far more work-oriented than in previous iterations of the art form. That this transformation has paralleled similar shifts in social media practice and organisation is not coincidental; it is, we are arguing, precisely because of the opportunities proffered by the highly capitalist arrangement of contemporary social media that this neoliberal, professional version of drag has become hegemonic.

What does all this mean for US drag? As fans of the show and of drag culture more generally, we find much to celebrate about the proliferation of social media drag content and its increased visibility in the mainstream. But we are also left wondering what has been gained and lost by *this version of drag in particular* becoming hegemonic over the forms outlined in the first half of this article. Of course, all performers – drag or otherwise – should receive fair recompense for their labour and should be able to carry out their work in full-time capacities should they so desire. A professionalised and capitalist form of social media has, to some degree, enabled this for a handful of US drag queens, in ways that were simply not possible before its emergence.[7] As LaTrice Royale marvelled at 'The Business of Drag'(2016) Drag Con panel: 'When has it ever been possible for drag to be a viable career? Who knew?'.

Of course, there remain other ways of doing drag, and other reasons for doing it. As mentioned above UK based drag artist David Hoyle remains active and deliberately uses drag performance to articulate anti-capitalist and other progressive political positions. But the polished, professional, multi-platform queen celebrated on RPDR is the hegemonic model today. Likewise, there are many ways of using social media (and many reasons for doing so). But the professionalised, entrepreneurial content creator is the subject position that currently has the greatest visibility, legitimacy and cultural purchase. This parallel professionalisation of drag and social media tells us something about the contemporary world and its values. What's valorised is entrepreneurial individualism and competitiveness, beauty/polish, hard work and a clearly articulated identity: the brand needs to be immediately apparent and consistently performed (nb. Hearn).

All of this takes a lot of work. It arguably requires a lot more work than the early Cockettes shows, where the commune just showed up at the theatre, got on stage, and let whatever happened happen. The spontaneity and artistic anarchism of The Cockettes has been replaced by the extensive planning and staging required by the contemporary content industries.

Yet we contend that as an art form, drag is at its most powerful when it questions dominant arrangements of power and dominant frameworks of social reproduction. As

Paris is Burning shows, it is possible to critique power whilst simultaneously seeking access to it. Or in the case of The Cockettes, we see drag used as a means of more forcefully disrupting existing power structures. While *RuPaul's Drag Race* puts forward a far less confrontational and transgressive style of drag, its capacity to challenge the status quo remains. Our culture has yet to reach a stage where 'a man dressed as a woman' is a normative act. However, in achieving celebrity and mainstream success through professionalised, commercialised forms of social media, drag queens are increasingly becoming willing agents of the hegemonic power that was previously denied them.

Disclosure statement

No potential conflict of interest was reported by the authors.

References

Anderson, E., 2008. Treacherous Pin-ups, politicized prostitutes, and activist betrayals: Jane Fonda's body in hollywood and Hanoi. *Quarterly review of film and video*, 25 (4), 315–333. doi:10.1080/10509200601105308

Anderson, M., 1990. The Reagan Boom - greatest ever. *The New York Times*, 17 Jan, p. 25.

Banet-Weiser, S., 2012. *Authentic^{TM}: the politics of ambivalence in a brand culture*. New York and London: New York University Press.

Barbu, O., 2014. Advertising, microtargeting and social media. *Procedia, social and behavioral sciences*, 163, 44–49.

Becker, A.B., 2013. Star power? Advocacy, receptivity, and viewpoints on celebrity involvement in issue politics. *Atlantic journal of communication*, 21 (1), 1–16. doi:10.1080/15456870.2013.743310

Beer, D., 2016. *Metric Power*. London: Palgrave Macmillan.

Boyd, D.M. and Ellison, N.B., 2007. Social network sites: definition, history, and scholarship. *Journal of computer-mediated communication*, 13 (1), 210–230. doi:10.1111/j.1083-6101.2007.00393.x

"Brand Me!" featuring Manila Luzon, Laganja Estranja, AB Soto and Jackie Huba at DragCon 2016. 2016. Available from: https://www.youtube.com/watch?v=sXxeG5aWToQ [Accessed 14 Oct 2019]

Bruns, A., 2006. Towards produsage: futures for user-led content production. *In*: F. Sudweeks, H. Hrachovec, and C. Ess, eds. *Proceedings of cultural attitudes towards communication and technology 2006*. 28 June - 1 July 2006. Tartu: Estonia, 275–284.

Burgess, J.E., *et al.*, 2012. YouTube and the formalisation of amateur media. *In*: D. Hunter, ed. *Amateur media: social, cultural and legal perspectives*. Oxon: Routledge, 53–58.

Burnett, G. and Bonnici, L., 2003. Beyond the FAQ: explicit and implicit norms in usenet newsgroups. *Library & information science research*, 25 (3), 333–351. doi:10.1016/S0740-8188(03)00033-1

Campbell, J.E., 2004. *Getting it on online: cyberspace, gay male sexuality, and embodied identity*. London: Routledge.

Caulfield, K., 2017. Madonna's 40 biggest billboard hits [online]. Available from: https://www.billboard.com/articles/list/499398/madonnas-40-biggest-billboard-hits [Accessed 13 Sep 2019].

Cockettes, The. 2002. London: Tartan DVD. DVD.

Deery, J., 2014. Mapping commercialisation in reality television. *In*: L. Oullette, ed. *A companion to reality television*. Chichester: John Wiley & Sons, 11–28.

Dejmanee, T., 2013. The burdens of caring. *Australian feminist studies*, 28 (77), 311–322. doi:10.1080/08164649.2013.821726

Djafarova, E. and Trofimenko, O., 2019. 'Instafamous': credibility and self-presentation of micro-celebrities on social media. *Information, communication & society*, 22 (10), 1432–1446. doi:10.1080/1369118X.2018.1438491

Drake, P. and Higgins, M., 2006. 'I'm a celebrity, get me into politics': the political celebrity and the celebrity politician. *In*: S. Holmes and S. Redmond, eds. *Framing celebrity: new directions in celebrity culture*. London and New York: Routledge, 87–100.

Duggan, L., 2003. *The twilight of equality? Neoliberalism, cultural politics and the attack on democracy*. Boston: Beacon Press.

Enders, A., *et al*., 2008. The long tail of social networking: revenue models of social networking sites. *European management journal*, 26 (3), 199–211. doi:10.1016/j.emj.2008.02.002

Farrell, N., 2012. Celebrity politics: bono, product (RED) and the legitimising of philanthrocapitalism. *The british journal of politics and international relations*, 14 (3), 392–406. doi:10.1111/j.1467-856X.2011.00499.x

Fry, N., 2019. Just be yourself. *The new yorker*, 1 (Apr), 28–31.

Fuchs, C. and Sandoval, M., 2015. The political economy of capitalist and alternative social media. *In*: C. Atton, ed. *The routledge companion to alternative and community media*. Oxon and New York: Routledge, 165–176.

Fulton, C., 2009. Quid pro quo: information sharing in leisure activities. *Library trends*, 57 (4), 753–768. doi:10.1353/lib.0.0056

Gill, R., Kelan, E.K., and Scharff, C.M., 2017. A postfeminist sensibility at work. *Gender, work & organization*, 24 (3), 226-244. doi:10.1111/gwao.12132

Hauben, M. and Hauben, R., 1997. *Netizens: on the history and impact of usenet and the internet*. Los Alamitos, CA: IEEE Computer Society Press.

Hearn, A., 2008. Insecure: narratives and economies of the branded self in transformation television. *Continuum: journal of media & cultural studies*, 22 (4), 495–504. doi:10.1080/10304310802189972

Hearn, A., 2014. Producing "reality" branded content, branded selves, precarious futures. *In*: L. Oullette, ed. *A companion to reality television*. Chichester: John Wiley & Sons, 437–456.

Hearn, A., 2017. Verified: self-presentation, identity management, and selfhood in the age of big data. *Popular communication*, 15 (2), 62–77. doi:10.1080/15405702.2016.1269909

Holton, A. and Coddington, M., 2012. Recasting social media users as brand ambassadors: opening the doors to the first 'social suite. *Case studies in strategic communication*, 1, 4–24.

Iqani, M. and Schroeder, J.E., 2016. #selfie: digital self-portraits as commodity form and consumption practice. *Consumption markets & culture*, 19 (5), 405–415. doi:10.1080/10253866.2015.1116784

Jarrett, K., 2015. *Feminism, labour and digital media: the digital housewife*. New York: Routledge.

Khamis, S., Ang, L., and Welling, R., 2017. Self-branding, 'micro-celebrity' and the rise of social media influencers. *Celebrity studies*, 8 (2), 191–208. doi:10.1080/19392397.2016.1218292

Leary, T., 1966. *Turn on, tune in, drop out*. Oakland, CA: Ronin Publishing.

Lecker, M., 2015. *Welcome home: radical faeries and queer worldmaking*. Thesis (PhD). George Mason University.

Lindemann, K., 2005. Live(s) online: narrative performance, presence, and community in livejournal. com. *Text and performance quarterly*, 25 (4), 354–372. doi:10.1080/10462930500362494

Madonna, 1984. Material girl. Like a virgin. Sire Records/Warner Bros.

Marshall, P.D., 1997. *Celebrity and power: fame in contemporary culture*. Minneapolis and London: University of Minnesota Press.

McKernan, B., 2011. Politics and celebrity: a sociological understanding. *Sociology compass*, 5 (3), 190–202. doi:10.1111/j.1751-9020.2011.00359.x

Miller, P., 2013. Social media marketing. *In*: A.B. Albarran, ed. *The social media industries*. New York and London: Routledge, 86–104.

Milligan, I., 2017. Welcome to the web: the online community of GeoCities during the early years of the world wide web. *In*: N. Brügger and R. Schroeder, eds. *The web as history*. London: UCL Press, 137–158.

Muñoz, J.E., 1997. "The white to be angry": vaginal Davis's terrorist drag. *Social Text*, 52/53, 80–103. doi:10.2307/466735

Nakamura, K., 2002. *Cybertypes: race, ethnicity, and identity on the internet*. New York and London: Routledge.

Newton, E., 1972. *Mother camp: female impersonators in America*. Chicago: University of Chicago Press.

Ng, E., 2013. A 'post-gay' era? Media gaystreaming, homonormativity, and the politics of LGBT integration. *Communication, culture & critique*, 6 (2), 258–283. doi:10.1111/cccr.12013

O'Reilly, T., 2005. What is Web 2.0: design patterns and business models for the next generation of software [online]. Available from: https://www.oreilly.com/pub/a/web2/archive/what-is-web-20.html [Accessed 21 Sep 2019].

O'Riordan, K., 2005. From usenet to gaydar: a comment on queer online community. *ACM siggroup bulletin*, 25 (2), 28–32. doi:10.1145/1067721.1067727

Oliver, D., 2014. You're funnier when you're angry. *Performance research*, 19 (2), 109–115. doi:10.1080/13528165.2014.928526

Oliver, I., 2018. Is this the golden age of drag? Yes and no. *The New York Times* [online] Available from: https://www.nytimes.com/2018/01/17/arts/drag-queens-rupaul-drag-race.html [Accessed 3 May 2019].

Paasonen, S., 2016. Fickle focus: distraction, affect and the production of value in social media [online], *First monday*, 21 (10). [Accessed 20 Sep 2019]. doi:10.5210/fm.v21i10.6949

Paltrinieri, R. and Degli Esposti, P., 2013. Processes of inclusion and exclusion in the sphere of prosumerism. *Future internet*, 5 (1), 21–33. doi:10.3390/fi5010021

Raun, T., 2018. Capitalizing intimacy: new subcultural forms of micro-celebrity strategies and affective labour on YouTube. *Convergence: the international journal of research into new media technologies*, 24 (1), 99–113. doi:10.1177/1354856517736983

Rheingold, H., 1993 [2000]. *The virtual community: homesteading on the electronic frontier*. Cambridge: Addison Wesley and MIT Press.

Ritzer, G. and Jurgenson, N., 2010. Production, consumption, prosumption: the nature of capitalism in the age of the digital 'prosumer'. *Journal of consumer culture*, 10 (1), 13–36. doi:10.1177/1469540509354673

RuPaul, 1998. *Lettin in all hang out: an autobiography*. London: Warner Books.

RuPaul's Drag Race Wiki, *Queens with 1 millions followers of more on Instagram* [online]. Available from: https://rupaulsdragrace.fandom.com/wiki/Category:Queens_with_1_Million_Followers_or_More_on_Instagram. [Accessed 5 June 2019].

Rusli, E. and Eavis May, P., 2012. Facebook raises $16 billion in I.P.O. *The New York Times* [online]. Available from: https://dealbook.nytimes.com/2012/05/17/facebook-raises-16-billion-in-i-p-o/?hp

Saga, J., 2011. News corp sells myspace, ending six-year saga [online]. Available from: http://uk.reuters.com/article/2011/06/29/us-newscorp-myspace-idUSTRE75S6D720110629 [Accessed 22 June 2019].

Schotmiller, C., 2017. *Reading RuPaul's Drag Race: queer memory, camp capitalism, and RuPaul's drag empire*. Thesis (PhD). UCLA.

Shirky, C., 2008. *Here comes everybody: the power of organizing without organizations*. New York: Penguin Press.

Silver, D., 2000. Margins in the wires: looking for race, gender, and sexuality in the blackburg electronic village. *In*: B.E. Kolko, L. Nakamura, and G.B. Rodman, eds. *Race in cyberspace*. New York and London: Routledge, 133–150.

Social Security Administration, National average wage index [online]. Available from: https://www.ssa.gov/oact/COLA/AWI.html [Accessed 14 Oct 2019].

Stoesz, D. and Karger, H.J., 1993. Deconstructing welfare: the reagan legacy and the welfare state. *Social work*, 38 (5), 619–628.

Stuckey, M.E., 1995. Competing foreign policy visions: rhetorical hybrids after the cold war. *Western journal of communication*, 59 (3), 214–227. doi:10.1080/10570319509374518

Technavio, 2017. Global content marketing market 2017-2021 report [online] Available from https://www.technavio.com/report/global-content-marketing-market [Accessed 14 Oct 2019].

"The Business of Drag" featuring Latrice Royale and Mimi Imfurst at DragCon. 2016. Available from: https://www.youtube.com/watch?v=MFS45z_jvTw/ [Accessed 14 Oct 2019] Abidin, C., 2018. *Internet celebrity: understanding fame online*. United Kingdom: Emerald Publishing.

Thumim, N., 2012. *Self-representation and digital culture*. Basingstoke and New York: Palgrave Macmillan.

Turchiano, D., 2018. 'RuPaul's Drag Race' at 10: launching the next wave of drag superstars. *Variety* [online]. Available from: https://variety.com/2018/tv/news/rupaul-drag-race-most-successful-queens-1202715507. [Accessed 14 Oct 2019].

Turner, F., 2006. *From counterculture to cyberculture: stewart brand, the whole earth network, and the rise of digital utopianism*. Chicago: University of Chicago Press.

van Dijck, J., 2013. *The culture of connectivity: a critical history of social media*. Oxford and New York: Oxford University Press.

Williamson, M., 2016. *Celebrity: capitalism and the making of fame*. Cambridge: Polity.

Wills, G., 2017. *Reagan's America: innocents at home*. New York: Open Road Media.

Wood, A.J., *et al.*, 2019. Networked but commodified: the (Dis)embeddedness of digital labour in the gig economy. *Sociology*, 53 (5), 931–950. doi:10.1177/0038038519828906

'Assume the position: two queens stand before me'–RuPaul as ultimate queen

Hazel Collie and Gemma Commane

ABSTRACT

Season 10 marked a decade of RPDR, with RuPaul and other celebrities framing the show as a worldwide phenomenon promoting love, inclusivity, acceptance and Drag. This aspect of RPDR is foregrounded in much existing scholarship on the reality show which considers the inclusivity and visibility that it offers. Although RPDR brings an area of gay culture and history into the mainstream, we argue that the Queen and Herstory that is promoted and validated is RuPaul Herself. Within the show, contestants often refer to RuPaul as 'Mama Ru', in reference to historical drag family relationships. In this article, we argue that RuPaul is positioned as the Ultimate Queen rather than Drag Mother, reflecting the more transactional relationship between head judge and contestants that we argue is constructed in the show. RuPaul as Ultimate Queen is achieved through using the themes of history and authenticity to support a commodification of RuPaul which reinforces celebrity, cultural capital and authority. From Queens lip-syncing to RuPaul's back catalogue to the central place RuPaul places herself as drag pioneer; we explore 'RuPaul as commodity' and the possible implications on the presentation and marketability of gay/drag culture through the format of *Drag Race* and RuPaul as ultimate Queen.

Introduction

RuPaul's Drag Race (*RPDR*, Logo TV, 2009–2016; VH1, 2017-present) has gained substantial academic attention in recent years, with a wealth of work emerging in response to the phenomenon. This academic work is diverse in focus, taking in questions of gender, ethnicity, identity, the drag community, mainstreaming, authenticity and commodification to name but a few. While there is an increasing body of work on *RPDR*, the figure of RuPaul is often peripheral to these academic discussions. Despite her looming celebrity presence in the show, discussion instead gathers around the presentation and format of the show and the experiences and behaviours of the drag contestants. Season 10 marked a decade of *RPDR*, with RuPaul and other celebrities framing the show as a worldwide phenomenon promoting love, inclusivity, acceptance and drag. This aspect of *RPDR* is foregrounded in much of the existing scholarship on the reality show which considers the inclusivity and visibility that it offers (Edgar 2011, Goldmark 2015).

In this article we have drawn upon data collected through emergent and repeated themes arising from a textual analysis of Seasons 1–11. What interests us is that academically absent figure of RuPaul and how the performer positions herself as the central commodity of the show and 'Ultimate Queen'. The role of the drag mother has been significant in drag history, where drag mothers create drag families to fulfil the emotional support which might otherwise be missing in drag queen's lives. Drag mothers also enable the fame and success of their drag daughters within their own micro-cultural contexts. Within the show, contestants often refer to RuPaul as 'Mama Ru', in direct reference to this drag family relationship. We have used the term Ultimate Queen rather than Drag Mother in this piece to reflect a more transactional (rather than emotional) relationship. RuPaul as Ultimate Queen is achieved through strategically using the themes of history and authenticity to support a commodification of RuPaul which reinforces celebrity, cultural capital and authority. At the heart of *RPDR* lies a tension between hierarchies of celebrity, in which an established celebrity (RuPaul) oversees and uses the programme's competition format to also extend their own celebrity status. We argue that RuPaul uses the programme to establish an overlap of both achieved and attributed celebrity (Rojek 2001, p. 18), using it as a vehicle to promote and extend a back catalogue of work which establishes her previous achievements. The show may purport to find 'America's next drag superstar' but is structured to ultimately support RuPaul as 'America's pre-eminent drag superstar'.

The search for America's next drag superstar: discussions of format and celebrity

The reality television genre is often criticised as a mainstream and conservative genre. It is academically viewed as one in which artifice and manufacture is key (Berns 2014) and in which only emotion provides authenticity (Grindstaff and Murray 2015). *RPDR*, however, is seen by some to occupy a more complex position as a reality format.

Existing work positions *RPDR* as belonging to both the mainstream of reality TV and the subversive world of drag and the tensions which arise from this in relation to issues of authenticity (Edgar 2011, Brennan 2017). Brennan and Edgar, for example, both point to the way that reality TV generally, and *RPDR* particularly, can maintain authenticity through the legitimacy of relationships established between audience and performer (Brennan 2017, p. 32). Both authors attribute this relationship to the programme's production network. Logo TV is a queer network and through its legitimate and knowing interaction with queer audiences RPDR is granted legitimacy. However, with the programme's presence on the Netflix platform for several years and its move to the more commercially mainstream broadcaster VH1 in 2017 these assumptions begin to erode.

Aspects of the relationship between reality television, celebrity and authenticity are sometimes explored, but not often at the same time. Hannah Hamad indicates how the increasing prominence of reality television as a form of media has been significant in enabling formations of contemporary celebrity to flourish in the contemporary media environment (Hamad 2018). The relationship between celebrity and authenticity is better understood. While avoiding a detailed definition of the term, Lionel Trilling suggests that authenticity involves finding and expressing the true inner self and evaluating relationships in terms of it. Trilling suggests that when authenticity is

invoked, it usually refers to an object with a defined history and story of origin (Trilling 1972). Discussion of celebrity includes strong connections made between perceived authenticity, private lives and self-branding of micro-celebrities (Jerslev 2014, Khamis *et al.* 2017) and the production and sustenance of celebrity through exposure and disclosure (Marshall 2010). This type of discussion assumes that reality celebrities are 'ordinary' people thrust into the world of celebrity (Turner 2006, Collins 2008, Curnutt 2009, Bell 2010), often emphasising celebrity as a question of manufacture rather than achievement or merit. While recognising the role of reality television in the creation of celebrity, Marwick and boyd explore the shift in traditional understanding of what they call 'celebrity management' and suggest that the perception of authenticity is essential to achieve intimacy between participant and follower in contemporary celebrity (Marwick and boyd 2011). *RPDR* belongs to a smaller subset of reality television which offers a platform to existing celebrities to rekindle their career. The role and significance of authenticity in this rekindling is less clearly explored in existing literature on celebrity, reality formats and the interplay between them.

Questions around subversive potential and authenticity in the mainstream are important in relation to commodification. Alyxandra Vesey speaks of the 'tethering' of success in *RPDR* to pop music performance and personal branding (Vesey 2017). Pop music is inherently linked to mass consumption and commodification. It is often associated with young female and LGBTQ+ audiences, positioned as 'less authentic' than other, more explicitly 'masculine' forms of music (Coates 1997, Whiteley 2013). What we see in *RPDR* is a layering up of inauthenticity and artifice; a reality format, combined with drag, combined with pop music. Against these expected areas of commodification, the programme also commodifies and trivialises the political significance of other aspects of drag/LGBTQ+ cultures, including race (Strings and Bui 2014), HIV (Hargraves 2011) and histories (Parsemain 2019).

Much of the work outlined here focuses on narrow examples, participants and their interaction with the host without making explicit RuPaul's changing role over the course of the series. However, ultimately its key commodity is RuPaul herself through advertising images, the name and her celebrity. The foregrounding of RuPaul's experience and persona as central to the programme and the authority that is conferred upon her by judges and contestants alike (the consumer's representatives within the programme) positions her as the Ultimate Queen and trades upon her capital.

(Re)making HERStory: the importance of history and self-commemoration

Perhaps more than any other similar show, *RPDR* develops to promote the history of the show itself. The role of history is significant in drawing together wider LGBTQ+ histories with RuPaul's own positioning as a legitimate and central figure to those events within the context of the show and wider popular culture. History is manipulated as the format of the show matures and begins to engage with a more mainstream audience. This raises important questions about RuPaul as the filter for interpretation of those narratives, her own place within them and her motivation for doing so.

The relationship between celebrity and reality television has been given significant attention in terms of 'ordinary' people who achieve fame (Turner 2006, Collins 2008), or what Rojek would call 'celetoids' (2001, p. 20). Although reality television has a history of

giving existing celebrities a platform from which to revitalise and expand their persona in a variety of national settings, this intersection of such celebrity and reality television is given less attention. Ensemble reality shows such as *Strictly Come Dancing* (BBC, 2004-present) and *I'm A Celebrity: Get Me Out of Here*(ITV1, 2002-present)among many others, offer an opportunity for minor celebrities or those with a waning public profile to remind fans of their existence, rekindle those relationships and create new ones. Other reality shows which focus on particular celebrities offer a similar platform to extend market share to established celebrities, such as *The Osbornes* (MTV, 2002–2005) and *Rock of Love with Bret Michaels* (VH1, 2007–2009). *RPDR* can be read as part of the same tradition, as the format of the show repackaged RuPaul for a new generation of viewers and, through its move from Logo TV(an LGBT channel) to VH1 and availability on Netflix, to a mainstream non-LGBTQ+ audience.

One of the ways that celebrity reality formats allow celebrities to do this is through the reiteration of individual's histories which imbues them with legitimacy as real celebrities in a world populated by celetoids who lack this credibility. In their discussion of history on television, Erin Bell and Ann Gray highlight how historical events may be manipulated through representation and narration. They point to the significance of this for a television audience who may not have access to other versions of history which gives them importance as an authoritative narrative (Bell and Gray 2007, p. 116). The political and cultural implications of this power to select and pre-interpret historical narratives are obvious when thought of through the lens of what is available to the viewing public. Although Bell and Gray's focus is on the traditional historical documentary, the significance of this selection and presentation is also present in the case of *RPDR*, a programme which is credited with increasing the visibility of drag culture.

In her discussion of Series 1, Eir-Anne Edgar suggests that RuPaul uses her successful history as a drag performer to position herself as the quintessential drag spokesperson and that references to historically situated drag cultures and icons gives the show queer legitimacy(Edgar 2011, p. 135). Edgar argues that these references hail queer viewers in such a way that allows interpellation of both the legitimated positions of the show as well as themselves as audience members. These references to the history of drag and its place in the LGBTQ+ story continue throughout the show, during contestant's werk room conversation, while they make up, in the background given to challenges and in judges critiques. Josh Morrison picks up this elision in his own discussion of camp and homo-normative politics, arguing that 'Part of the larger project of homonormative politics is rewriting the history of queer activism to fit a civil rights narrative of "things were bad, then we resisted, we were misunderstood, but now we've nearly reached the systemic equality we deserve."' (Morrison 2014, p. 136). He proposes that this narrative strips queer histories of their radical politics and allows only limited queer subjects access to the capital and political privilege which visibility allows.

Woven through this is RuPaul's own role in these histories, creating a narrative which chimes well with Morrison's concerns about the limited queer subjectivities which are allowed access to such capital and privilege. In her consideration of RuPaul's connections with Foucauldian work on transformations and discursive change, Megan Metzger surveys RuPaul's professional history, making connections between her pre- and post-*RPDR* professional persona. For Metzger, the show, and RuPaul's own history, offers an insight

into how visibility relies upon the political background of a particular time which allows people to engage with marginalised cultures (Metzger 2016). However, this presentation of RuPaul's' history fulfils another purpose, which is to provide the head judge with the authority to pass judgement on different forms of drag that are commercially suitable. This questions the extent to which *RPDR* offers a radical queer space.

Throughout the seasons RuPaul makes professional connections between her own working life and the wider history of drag and LGBTQ+ cultures. Particular moments and causes form the basis of challenges, which RuPaul ties into her own history and branding. In Season 1, Episode 4 the contestants were required to create a commercial for Mac's Viva Glam makeup which would inform the public of Viva Glam's help for those living with HIV. RuPaul presents the challenge to the contestants, stating 'I was fortunate enough to be the first face of MAC cosmetics Viva Glam. See it there?' At this point the Werk Room floor is dominated by the original Viva Glam poster featuring RuPaul, making a strong statement that she was there at the beginning of a campaign linked to HIV (Hargraves 2011). On other occasions this collision of histories occurs at a personal level. In Season 5's Snatch Game (Episode 5) during RuPaul's walk through of the Werk Room, Alaska tells him that she will be impersonating Lady Bunny, a significant figure in the US drag scene. RuPaul's response is 'Bunny is hilar ... I think she is actually the funniest person I've ever met'. While seemingly innocuous, the comment suggests that RuPaul has a familiarity with this legend ('Bunny' rather than Lady Bunny). In doing so, RuPaul aligns himself with this icon, reminding Alaska and the audience of RuPaul's longevity and status in the field. During judge's critiques, too, RuPaul frequently uses personal experience to frame criticism of attitudes and performance. This foregrounds RuPaul's experience and age.

The contestants are typically significantly younger than RuPaul. While they can talk about the history of drag and LGBTQ+ rights, they do not have the same direct personal experience that RuPaul has. Older queens such as Porkchop, Vivacious, Charlie Hides and Tempest DuJour 'wear' their age and experience as knowledge (Straw 1997), taking the opportunity to educate younger queens during their werk room transformations. In Season 9, Episode 3 Charlie Hides speaks emotively of the AIDS crisis of the 80s and 90s, 'None of my friends were playing safe. I buried all of my best friends.' The younger queens respond positively, with Cynthia Fontaine and Sasha Velour confirming the importance of remembering what happened. On other occasions this knowledge is presented as a power flex to younger queens. In Season 6, Episode 3, for example, Trinity K. Bonet and Vivacious have a Werk Room conversation about Vivacious' drag style. Vivacious namechecks a 'club kids Leigh Bowery style of drag'. When Trinity asks Vivacious if she feels the need to revamp her style, Vivacious responds to camera, 'The newer generation only know of the fishy look. But when I walk into a club all eyes are on me. *You're* still that little girl in the corner trying to look like a lady'. Although the significance of history is indicated through the inclusion of contestants who can open up and address its past, to have directly participated in this past is not enough. These older queens occupy a fragile space and are typically eliminated within the first few episodes, often criticised for their 'datedness' and inability to move beyond their comfort zones. This is the critique that follows Vivacious' style defence. In comparison, RuPaul has cemented her position in the history of drag but, through adaptability and the cultural capital which this offers, is also the future of drag. Even though RuPaul's style of drag

could be argued as belonging to a particular time, RuPaul is in a position where she can never be eliminated.

Alongside this manipulation of wider LGBTQ+ history the show also begins to portray its own history. By Season 5, the format is well established. The competing queens enter the competition with an expectation of certain challenges. At this point of the series' development, the history of the show is apparent in the queen's discussions and pieces to camera. In Season 6 Episode 5, Ben De La Crème speaks to camera about The Snatch Game, noting it as 'a really important challenge. It's one that everyone knows is coming and everyone's kind of waiting all season to see what you're gonna pull out'. From Season 7 when Max impersonates Season 4 winner Sharon Needles and Violet Chachki performs as Season 5 contestant Alyssa Edwards, previous season's queens also become a staple impersonation of the challenge and the history of the show is reprised, or commemorated, by contestants.

As the series matures the historical element of *RPDR* involves commemoration of the show through production and editorial choices. The first episode of Season 8, for example, opens with a one-minute montage celebrating its 100[th]episode. This montage of key moments is accompanied by an episode clock which flicks through episodes to 100. The key moments are ones that regular viewers will recognise, and newer viewers might be familiar with some of them through social media. Moments such as RuPaul's admonishment 'drag is not a contact sport' to Mimi Imfurst (Season 3), Latrice Royale's 'Get those nuts away from my face' (Season 4) and Bianca Del Rio's 'Not today Satan' (Season 6) are all included. While avoiding discussion of the reality genre, in her work on televisual memory Amy Holdsworth uses analysis of montage sequences from a variety of television shows as evidence of 'televisual memory'. She argues that these montage sequences act as commemoration texts, designed of televisual commemoration and reflection. When television memorialises itself in this way, it makes a statement about its position and status (Holdsworth 2010). This montage sequence from Season 8 serves to make a statement about the show's longevity and significance to popular culture and drag visibility, drawing attention to key pop culture moments that have arisen in the show. RuPaul is central to the programme and is implicitly included in this statement regarding position and status.

The first episode of Season 10 undertakes commemoration in a different way. To celebrate ten years of *RPDR*, at the outset RuPaul announces 'Let's start with a mini challenge that's been a decade in the making. And ladies ... I expect tens, tens, tens across the board'. The challenge involves a catwalk runway for each competing queen, and RuPaul is aided in her judging by numerous queens from previous seasons. The main challenge in this episode comprises a re-run of the dime store challenge, the very first challenge that the Season 1 queens undertook. This commemoration continues throughout the season as previous queens appear in each episode to help mentor contestants through the challenges. Bianca Del Rio (Season 6) accompanies RP on her pre-Snatch Game work room walk through to talk contestants through their performance. Alyssa Edwards (Season 5) coaches the queens through their performances for the PharmaRusical challenge. This serves not only to remind us of the history of the show, but also its significant role in moulding and giving a platform to drag queens who have gone on to have successful and lucrative careers, implicitly tying their success into RuPaul. This subtle weaving of RuPaul's own experience into both drag history (through

experience stories) and contemporary memory (through *RPDR* and its self-memorialisation) places her centrally to those wider historical narratives. Through her knowledge and experience of these histories she places herself as the Ultimate Queen in the context of the show and in the history of LGBTQ+ struggles, as the other queens do not have this capital to trade on. Through the commemoration of the show, RuPaul again positions herself as Ultimate Queen in a contemporary setting by placing *RPDR* as a significant part of the recent history.

You better work!: commodification, brand and exposure

Commodity culture links with branding and marketability to ensure the longevity of a brand, company or institution. Alyxandra Vesey (2017) and José Esteban Muñoz (1999) both criticise RuPaul in relation to the commodification of gay culture and RuPaul's celebrity being far removed from queer radical politics. The maintenance of fame and success is continually negotiated by and through templates. These templates are set by RuPaul within the context of community culture, celebrity and pop stardom, and are measured by success, as well as the challenges presented by queens, as key milestones. Within these templates of success, queens often compromise their own drag styles to satisfy standards which are marketable to a wider, non-queer audience. For Vesey the template for pop stardom is something queens must adhere to for success, which means that queens 'must distance themselves from these origins to comply with pop music's and reality television's prizing of individual achievement and marketable cultural difference' (2016, p. 591). The maintenance of fame relies upon queens being part of RuPaul's Herstory, which coincides with the mediated re-telling of gay history discussed earlier. Commodification, therefore, has implications for how success is articulated and embodied, as well what histories and struggles are included to validate fame, authenticity and history.

The longevity of the RuPaul brand is reinforced by its commercial appeal and quality. For Khamis, Ang and Welling, 'brand signifies a certain quality or idea associated with a commodity which ostensibly simplifies the consumer's decision-making. Ideally, a brand must be seen to possess strong, favourable, unique and relevant mental associations, which helps differentiate the brand in an otherwise crowded and cacophonous market' (2017, p. 192). Queens often talk about certain points in the series which they feel are milestones, which are part of the expected format of *RPDR* as set by RuPaul herself. These key milestones include the Snatch Game, the final five and the final three. Exposure is a central strategy for all queens on *RPDR*, whether they sashay away during the first episode or make it to the final three. However, the format of the reality game show offers different levels of exposure dependent on success in the show. The further a queen progresses through the competition, the closer their perceived association with RuPaul which provides a greater level of exposure and validity as a contender. This is perhaps most acutely apparent in the final competitive episode of each season where the three remaining queens perform in RuPaul's next music video. The music video has been a feature of *RPDR* since its inception, when the final three queens (BeBe Zahara Benet, Nina Flowers and Rebecca Glasscock) recorded a verse for and performed in the video for *Cover Girl (Put the Bass in Your Walk)*. Featuring in the video is a signifier of success and a stepping-stone to possible superstardom. The release of the video on social media

platforms outlasts the broadcast life of the show and commemorates their relationship with RuPaul, cementing their association with the ultimate queen. For queens who make it that far the video becomes a platform for maintaining fame. *RPDR* frames success and achievement as marketable, with pop stardom and reality television elevating the value of the show, the queens and RuPaul as ultimate queen. This includes endorsing products, and the promotion of RuPaul's back catalogue.

However, it is not only the contestants who benefit from this association. The show exists as a machine that works to promote a version of RuPaul through the efforts of the contestants both in the show *and* its afterlife. The music video acts as another form of promotion for RuPaul's own professional output and exposure. For RuPaul the videos become part of a back catalogue that can be promoted in future series, via name dropping or direct inclusion (e.g. *Cover Girl*, 2009) in catwalks. In the Season 10 finale, a selection of queens from all seasons sang along to a RuPaul medley of songs from all 10 seasons. Most significantly the video ensures that Ru does not have to tour or undertake other traditional marketing activities to promote her own records. Instead she has an ever-expanding team of queens who lip-sync her songs in venues around the world on her behalf. Through their inclusion in the video and the work they must undertake after the show to maintain their celebrity, the queens are constantly performing labour that also creates value for RuPaul.

Exposure links to the wider contexts of celebrity culture, where it is essential for gaining followers and fans. This is particularly pertinent in relation to social media use and promotion through social media channels, fan interaction and endorsement. Anne Jerslev (2014) discusses the growing interest the media has in the private lives of celebrities which means that celebrities must be aware of how they 'do' celebrity and the work they need to undertake to perform a 'marketable' persona. P. David Marshall discusses the climate surrounding celebrity which encourages celebrities to 'expose their lives further in order to gain a following and audience' (2010, p. 41). The level of perceived disclosure over eleven seasons and the exposure of RuPaul as ultimate queen is a clever PR strategy for RuPaul's continued success and maintenance of fame. Maintenance of fame, therefore, relies upon celebrity being viewed as a 'media cultural practice, whereby the celebrity is commodity, commodity produced at one and the same time' (Jerslev 2014, p. 174). For Jerslev, 'doing celebrity is strategic work. Practicing celebrity is performing a marketable persona, which has to be unique and irreplaceable' (2014, p. 174). This work can be found directly in the format of *RPDR* and the strategies employed to elevate and maintain the cultural/commodity value of RuPaul as Ultimate Queen through the television show, tour and associated media texts. This includes the queens themselves, RuPaul's music videos, RPDR brand endorsements, memes, and so on.

There are different levels of maintaining fame for the queens, with the audience being reminded of the final three transitions from normal queen (e.g. their entrance in episode one) to possible drag superstardom. For example, in Season 3, Episode 15 (grand finale) there is a mini presentation of the final three queens and their journey to the finale. This reinforces the value of embodying charisma, uniqueness, nerve and talent as a means of success through the show and on to the RuPaul tour. In the same episode RuPaul reminds queens that they are already stars, reinforcing success as commodity form through the format of the show and RuPaul as ultimate queen. RuPaul's assumed position gives her the legitimacy to affirm their stardom. Success through commodification is found through

past queens talking about their achievements post-show, such as Detox who appears in Season 5, Episode 14 where she tells RuPaul and the audience about touring the world, including Dubai. Past contestants are framed as RuPaul's girls and part of the *RPDR* family. The 'family' operates to show solidarity as a collective as well as enabling RuPaul to be positioned front and centre, frequently referred to as Mama Ru. Individual queens sustain the *RPDR* experience and RuPaul's notoriety as being the Ultimate Queen through queen's name dropping RuPaul on tours (both RuPaul affiliated tours and solo tours, etc.) and *RPDR* appears in various queens' biographies on their professional websites (such as Bianca Del Rio, Jinkx Monsoon, Bob the Drag Queen and so on).

As the show format has matured, the machine which surrounds it has expanded to create additional connected texts and events, including spin-off shows (*RPDR All Stars*, VH1; *RPDR UK*, BBC3) and tours. In its current form, the show exists as part of the promotion of the tour and the RuPaul experience. The show's finale has become a stepping stone towards the tour, as well as an event in itself, where an audience watches queens in an opulent theatre. Earlier seasons did not have an audience and the finale was conducted in-house, contained within the series structure and within a studio setting. The finale experience has developed from that to a theatre space welcoming back previous queens and celebrity guest judges, as well as including an audience. The finale offers other touring and programme opportunities, not just for the queens but also for the portability of RuPaul's own fame, cultural capital and superiority.

If you can't love yourself, how in the hell you gonna love somebody else?: Illusion, authenticity and disclosure

So far, we have considered how the RuPaul brand appropriates wider drag histories and commodifies the brands of other queens. Here we turn our attention to authenticity through disclosure, which is another way in which the labour of others is used to further the RuPaul brand. Whilst 'authenticity' can refer to discussions of the self, we instead apply authenticity in our exploration of RuPaul as Ultimate Queen through the lens of self-promotion, celebrity and consumer capital. Authenticity has a dual meaning on the show, established within the contexts of RuPaul's brand and aligned with 'realness'. As gender illusionists, the queens often describe their catwalk looks as 'realness' to indicate that their feminine looks are authentic. However, the programme also seeks to promote 'realness' to connect audiences with cast members through their authentic, emotional disclosure (Grindstaff and Murray 2015). The show's narrative encourages this authentic disclosure and aligns it with success. For example, Bianca Del Rio (special guest in Season 10, Episode 7) gives advice to Aquaria on authenticity stating that, 'the thing is, when you watch *Drag Race*, the realest people are really the ones you gravitate to. When you take a Latrice, everybody's like "I love her!" Adore [Delano] is another one. It's these people that are really their true selves. But you just need to trust your own instincts.' Celebrity culture, commodities and industrial capitalism position authenticity as something to consume, perform and embody as means to obtain success. Although commodity culture engages with critiques of taste (what is 'non' authentic versus the authentic), we are more interested in the strategies employed to illustrate RuPaul's celebrity and status as the authentically Ultimate Queen.

Academic discussions centring on the production of celebrity consider how it has, as Marshall argues, 'taught generations how to engage and use celebrity culture to "make" oneself' (2010, p. 36). The transformational narratives promoted by neoliberalism and its connections with consumer culture (the commodities used and selected by individuals to express their 'true self'), reinforce the need to continually work on identity/brand/self. Transformational narratives are used in the show as a promotional strategy for RuPaul as Ultimate Queen, and for contestants to validate their presence on the show. Here authenticity is a project encouraged by RuPaul where contestants' work can demonstrate charisma, uniqueness, nerve and talent, all of which correlate to the production of self (see Marshall 2010, but also Franssen 2019 on the star being real and genuine). The perceived success of this performance of authenticity is always within RuPaul's judgement. Authenticity and serenity are valued as a central feature of celebrity culture, which individuals strive to achieve (see Dyer 1991, Franssen 2019) through image control, staged authenticity and audiences seeing queens grow in authenticity as they disclose the personal. This connects to discussions on self-branding, self-improvement and unique selling points of micro-celebrities developing a distinct identity and personal brand (Khamis *et al.* 2017).

Disclosure is carefully placed in episodes and across seasons to allow audiences to get to know the queens and for queens to stand-out as identifiable amid other contestants. Disclosure connoting an authentic self is reserved for certain segments in each episode, with different spaces and segments in the show offering opportunities to disclose in different modes. During RuPaul's werk room walk through he pushes queens to authentically disclose to him and to the audiences. The segment where the queens make themselves up is a key space for this personal disclosure to the other queens. Inserts of queens talking directly to camera is the space where queens disclose directly to the audience. During judge's critiques, disclosure incorporates RuPaul, other queens and the audience. As the season progresses and the number of contestants is whittled down, remaining queens are prompted to give life advice to photographs of themselves as children and to reveal their true selves to RuPaul over a Tic-Tac lunch. Alongside the 'commodification of the self, individuals are locked into a mode of constant promotion' (Khamis *et al.* 2017, p. 201), and in the foregrounding of the importance of authenticity we can see that disclosure operates as a means of self-branding. Being identifiable is important for queens to demonstrate an authentic self, which is further clarified through how stories are told, the place these stories occupy within the format of RPDR and the portability of these affective moments beyond the programme into popular culture.

In the context of micro-celebrity and self-branding through social media, Khamis *et al.* (2017, p. 196) argue that celebrity disclosure potentially attracts 'audiences for a multitude of reasons – they could be inspirational, relatable, instructive, cautionary, and so on'. Realness also connects to celebrity public self and values, with RuPaul positioning herself as a mentor to help queens succeed. To perform effectively as a queen is not enough to maintain celebrity. Disclosure of their true selves out of drag is also a requirement. Not all queens see RuPaul as performing the mentor role with former contestants, such as Pearl, commenting on RuPaul only performing the mentor role when the cameras rolling (Jezebel 2018). However, more often this opportunity is recognised and worked upon in the show. In Season 4, Episode 5 following a push from the judges to show emotion, the previously emotionless Willam cries on stage. The other queens view this as a cynical push

for authenticity, which demonstrates their understanding that this is expected. As the format matures, this understanding develops further. In Season 9 Eureka O'Hara performs emotional disclosure in the first episode when she meets her idol Lady Gaga, tearfully thanking her for the role that she has played in her life struggles and ultimate wellbeing. When she returns in Season 10, Eureka reminds the other queens of the importance of being strategic, smart and playing the game: 'RuPaul has mentioned that he wants to see us pushing strategy, making decisions that push us to the frontline'. Mentoring plays a part in this drive, specifically in the later seasons where queens are aware of the opportunities being on Drag Race can bring. In turn, by mentoring queens over eleven seasons RuPaul reminds viewers of her (brand) authenticity and acts as a tool for maintaining her image as a professional. On one level, being your authentic self is one of the expected generic conventions of reality TV, with the format relying on authentic stories and disclosure (coming out stories, rejection, HIV status). On a deeper level disclosure is mined within the format of *RPDR* not only for viewer pleasure, but to promote and reinforce RuPaul's status as community ambassador, expert and a caring Drag Mother.

Disclosure is not always prompted by RuPaul's presence with queens. The format and longevity of the show has enabled queens to learn the importance of disclosure and to mobilise it at strategic moments. It has become a trope of the show that the queens reiterate how important *RPDR* is for identification and belonging. This disclosure often operates in the absence of RuPaul, but is framed by the head judge's expectations and the wider narrative she creates around love, acceptance and her own place within that narrative. For example, in Season 7, Episode 8 Tempest DuJour discusses the importance of tolerance with Drag Race enabling queens to tell struggling audience members that they are not alone. She states that 'being able to talk about our personal issues and talk about our disastrous upbringings gives us an opportunity to show those kids who are struggling themselves that there is someone who can emphasise (with) what you are going through.'

Placement also connects to self-branding, specifically as queens in later seasons utilise their introductions as 'pitches' in the first moments of each season. In Season 5, Episode 10 we see the queens make-over veterans, and emotions are heightened when Detox discloses a story about being involved in a car crash resulting in reconstructive plastic surgery. Detox, the Plastic Queen, explained that *Drag Race* helped her recovery, a familiar story for other queens too. Disclosure acts as a reminder of the importance of *RPDR* and RuPaul herself as enabling space to showcase realness and authenticity. Identification is equally important for audiences who want to follow specific queens on social media and to see certain queens live on Drag Race tours. There is commercial gain for both queens and RuPaul alike, although being connected or in reference to the RuPaul brand further builds RuPaul's cultural capital. Private experiences shared between queens, and then distributed through consuming the programme builds and heightens the intimacy felt between celebrity and audience (Marshall 2010, Marwick and boyd 2011). This affective connection is built over time, with narratives carefully constructed to fit the format. Consumption and distribution of affective connections includes memes and audience interaction during the programme through hashtags. This active interaction highlights that online media is both a 'consumer-centric space' (Khamis *et al.* 2017, p. 194) and a space where the performance of authenticity transcends the confines of the show/format.

The queens on *RPDR* are always in the position of seeking stardom, whilst RuPaul is established. Authenticity is also about embodying the successful attributes of a star (charisma, uniqueness, nerve and talent), but also using an established name (appearing on *RPDR* and becoming one of RuPauls 'girls') and online platforms, such as Twitter and Instagram, as a means of maintaining/cultivating/building a career and fan base in and beyond the gay community. In the context of cultural workers, Karen Patel's (2017) critique of expertise, relational labour, competence and signalling expertise can be applied here in relation to queens from the show and RuPaul. For Patel, cultural workers' social media activity is more than self-promotion and self-branding due to artists being invested with other artists within their communities through collaboration and mutual aid. Patel states that 'while of course the artists in my sample are performing expertise for their own benefit, they are often raising the profile of other artists at the same time,' (2017, p. 172). To build on this, RuPaul is a powerhouse and does not need to raise her profile, however mutual endorsement, praise and even criticism continues her visibility in popular culture, through social media and within *RPDR* activities.

RuPaul's Herstory is an ongoing subtext within the series, such as references to her back catalogue and professional life. Unlike the contestants RuPaul can choose what she reveals, enabling her to maintain her professional self. While RuPaul pushes the contestants hard to perform their authentic selves through disclosure at various points in the series, she discloses little. There has never been a RuPaul-based 'money shot' (Grindstaff 2002) in the way that disclosure and emotional breakdown has formed the focus of contestants' narratives (such as Rebecca Glasscock, Yara Sofia and Roxxxy Andrews). This is interesting in the context of celebrity, where disclosure's role in maintaining intimacy between celebrity and audience has been highlighted (Marwick and boyd 2011). There are moments where Ru's personal life is allowed to break the façade, but this is always highly controlled and well-guarded. For example, in the introduction to the lip-sync for your life in Season 2 Episode 5, RuPaul breaks from form to explain the significance of Martha Wash's *Carry On* in her life after the death of her mother. However, this disclosure is delivered without the emotional outpouring which is expected of the contestants. By performing the minimum of disclosure herself against a backdrop of the importance of authenticity, RuPaul creates the impression of 'realness' beyond gender illusion. RuPaul uses her role as Ultimate Queen to trade upon contestant's performances of disclosure and authenticity. In encouraging their own disclosure, RuPaul manages to align herself with authenticity without engaging in it herself.

She owns everything: concluding thoughts

Through an analysis of RuPaul's Drag Race (Seasons 1 to 11) we identified three key recurring themes: history, authenticity and commodification. We have established that these three themes are important in identifying RuPaul herself as the central commodity and Ultimate Queen, through strategically using *RPDR*, Herstory and success as ways to reinforce celebrity, cultural capital and authority. Although the queens on *RPDR* achieve different levels of success and exposure through their appearance, achieving certain milestones and becoming part of the *RPDR* Family; the real winner will always be RuPaul's drag empire. Success and visibility are always mediated by and through the format of *RPDR* and association with RuPaul's celebrity and the attributes she judges to

equal superstardom. Superstardom, however, is harder for queens to achieve because they are either standing before (when being judged) or behind (on the finale stage) RuPaul. We have outlined that although there are various academic discussions engaging with *RPDR*, what is absent is an analysis of the figure of RuPaul herself as a central commodity and Ultimate Queen. RuPaul as a central commodity and Ultimate Queen is carefully achieved through embodying charisma, uniqueness, nerve and talent, the weaving of drag history according to Ru through the show, how the show celebrates its own success, and how the queens owe their success to the space RuPaul has created

Through exploring history, we have argued that the weaving of RuPaul's own experience and authority enables her to place herself within wider historical narratives. This is significant as the show has become mainstream and framed as a significant aspect of pop culture. In this context, the value and importance of *RPDR* is not just about celebrating diversity but also how the success of this phenomenon is down to RuPaul herself. This is achieved through commemoration (e.g. celebrating 10 years of *RPDR*) but also through RuPaul embodying authenticity and success. Authenticity is about showing charisma, uniqueness, nerve and talent as decided by RuPaul and the key milestones some queens achieve. Exposure depends on how far queens make it but addressing all queens as daughters and family ensures that routes to success come by, through and because of Ru. Success is also measured and calculated by the commodification of success through the value placed on RuPaul's next musical release and each series acting as an advertising strategy for the tour.

RPDR is indeed a phenomenon and should be celebrated in terms of its success on the global stage. However, this article positions itself as a key intervention in the debates of *RDPR* through turning the critical lens on to RuPaul herself as both subject and object of study. The critical turn of the article and its spotlight on RuPaul herself brings RuPaul out of the periphery of arguments and into the centre. The blending of a cultural studies approach to the analysis of RuPaul as commodity is essential in exploring further implications of her celebrity through how she uses history, authenticity and commodification.

Disclosure statement

No potential conflict of interest was reported by the authors.

References

Bell, C.E., 2010. *American idolatry: celebrity, commodity and reality television*. Jefferson, NC: McFarland.

Bell, E. and Gray, A., 2007. History on television: charisma, narrative and knowledge. *European journal of cultural studies*, 10 (1), 113–133. doi:10.1177/1367549407072973

Berns, F.G.P., 2014. "For your next drag challenge," you must do something: playfulness without rules. *In*: J. Daems, ed. *The makeup of RuPaul's drag race: essays on the queen of reality shows*. Jefferson, NC: McFarland & Company Inc, 88–105.

Brennan, N., 2017. Contradictions between the subversive and the mainstream: drag cultures and RuPaul's drag race. *In*: N. Brennan and D. Gudelunas, eds. *RuPaul's drag race and the shifting visibility of drag culture*. Cham: Palgrave Macmillan, 29–43.

Coates, N., 1997. (R)evolution now?: rock and the political potential of gender. *In*: S. Whiteley, ed. *Sexing the groove: popular music and gender*. Abingdon, Oxon: Routledge, 50–64.

Collins, S., 2008. Making the most out of 15 minutes: reality TV's dispensable celebrity. *Television & new media*, 9 (2), 87–110. doi:10.1177/1527476407313814

Curnutt, H., 2009. "A fan crashing the party" exploring reality-celebrity in MTV's real world franchise. *Television & new media*, 10 (3), 251–266. doi:10.1177/1527476409334017

Dyer, R., 1991. A star is born and the construction of authenticity. *In*: C. Gledhill, ed.. *Stardom: industry of desire*. London: Routledge, 136–144.

Edgar, E., 2011. "Xtravaganza!": drag representation and articulation in RuPaul's drag race. *Studies in popular culture*, 34 (1), 133–146.

Franssen, G., 2019. Sincerity and authenticity in celebrity culture: introduction. *Celebrity studies*, 10 (3), 315–319. doi:10.1080/19392397.2019.1630117

Goldmark, M., 2015. National drag: the language of inclusion in RuPaul's drag race. *GLQ: a journal of lesbian and gay studies*, 21 (4), 501–520. doi:10.1215/10642684-3123665

Grindstaff, L., 2002. *The money shot: trash, class and the making of TV talk shows*. Chicago: University of Chicago Press.

Grindstaff, L. and Murray, S., 2015. Reality celebrity: branded affect and the emotion economy. *Public culture*, 27 (1 (75)), 109–135. doi:10.1215/08992363-2798367

Hamad, H., 2018. Celebrity in the contemporary era. *In*: A. Elliott, ed. *Routledge handbook of celebrity studies*. London: Routledge, 44–57.

Hargraves, H., 2011. "You better work:" the commodification of HIV in RuPaul's drag race. *Spectator*, 31 (2), 24–34.

Holdsworth, A., 2010. Televisual memory. *Screen*, 51 (2), 129–142. doi:10.1093/screen/hjq007

Jerslev, A., 2014. Celebrification, authenticity, gossip: the celebrity humanitarian. *Nordicom review: nordic research on media and communication,* 35 (s1), 171–186.

Jezebel, (2018) *Pearl claims she was banned from RuPaul's drag race: all stars in retribution for interview comments*. Available from: https://themuse.jezebel.com/pearl-claims-shes-been-banned-from-rupauls-drag-race-a-1828601089 [Accessed 5 Nov 2019].

Khamis, S., Ang, L., and Welling, R., 2017. Self-branding, 'micro-celebrity 'and the rise of social media influencers. *Celebrity studies*, 8 (2), 191–208. doi:10.1080/19392397.2016.1218292

Marshall, P.D., 2010. The promotion and presentation of the self: celebrity as marker of presentational media. *Celebrity studies*, 1 (1), 35–48. doi:10.1080/19392390903519057

Marwick, A. and boyd, D., 2011. To see and be seen: celebrity practice on Twitter. *Convergence: the international journal of research into new media technologies*, 17 (2), 139–158. doi:10.1177/1354856510394539

Metzger, M., 2016. "Sometimes you have to break it down for a Motherf*!ker": RuPaul as foucauldian mystic. *In*: *Console-ing passions conference*, 16-18 June 2016 Indiana.

Morrison, J., 2014. Draguating to normal: camp and homonormative politics. *In*: J. Daems, ed. *The makeup of RuPaul's drag race: essays on the queen of reality shows*. Jefferson, NC: McFarland & Company Inc, 124–147.

Muñoz, J.E., 1999. *Disidentifications: queers of color and the performance of politics*. Minneapolis: University of Minnesota Press.

Parsemain, A.L., 2019. *The pedagogy of queer TV*. Cham: Palgrave Macmillan.

Patel, K., 2017. Expertise and collaboration: cultural workers' performance on social media. *In*: J. Graham and A. Gandini, eds. *Collaborative production in the creative industries*. London: University of Westminster Press, 157–176.

Rojek, C., 2001. *Celebrity*. London: Reaktion Books.

Straw, W., 1997. Sizing up record collections: gender and connoisseurship in rock music culture. *In*: S. Whiteley, ed. *Sexing the groove: popular music and gender*. London: Routledge, 3–16.

Strings, S. and Bui, L.T., 2014. "She is not acting, she is" the conflict between gender and racial realness on RuPaul's drag race. *Feminist media studies*, 14 (5), 822–836. doi:10.1080/14680777.2013.829861

Trilling, L., 1972. *Sincerity and authenticity*. Cambridge,MA: Harvard University Press.

Turner, G., 2006. The mass production of celebrity: 'celetoids', reality TV and the 'demotic turn'. *International journal of cultural studies*, 9 (2), 153–165. doi:10.1177/1367877906064028

Vesey, A., 2017. "A way to sell your records": pop stardom and the politics of drag professionalization on RuPaul's drag race. *Television & new media*, 18 (7), 589–604. doi:10.1177/1527476416680889

Whiteley, S., 2013. *Women and popular music: sexuality, identity and subjectivity*. Abingdon, Oxon: Routledge.

Drag celebrity impersonation as queer caricature in The Snatch Game

Hannah Andrews

ABSTRACT

The Snatch Game episodes of *RuPaul's Drag Race* are hugely popular and highly anticipated. A test of their make-up and acting skills, the game requires competitors to impersonate celebrities and answer outrageous questions in-character. The hyperbolic nature of these impersonations, consistent with the culture and affective resonance of drag and camp, invites us to read them as performed caricatures. Caricature, like camp, can be critical and transgressive. It can also depend on gendered, classed, ableist or racialised stereotypes as part of its implied critique of its subject. This article will consider how Snatch Game caricatures manifest this play of subversion and conservatism in relation to the selection of celebrity subjects and the modes of performance applied to the impersonation of them. This article will analyse the relationship between drag, caricature and celebrity as it plays out in The Snatch Game, by considering how the celebrity impersonation draws on and subverts a celebrity's persona. If camp can be defined as 'queer parody', drag impersonations may be looked at as queer caricature.

I don't dress up as a woman, I dress up as a caricature of a caricature of a woman – Trixie Mattel (Weaver 2017)

Introduction

Picture a television studio set, reminiscent of, though noticeably of lower budget than, the long-running game show *The Match Game* (NBC 1962, -). Seated behind bright blue booths are a striking group of famous women. Reality television stars Anna Nicole Smith, Judge Judy Sheindlin and Teresa Giudice mingle with celebrity chefs Paula Deen and Julia Child. Nicki Minaj shares a desk with esteemed character actor Maggie Smith, who has elected to appear in costume as her character from *Downton Abbey* (ITV 2010-2015). What strange alchemy has brought together these famous women, two of whom are deceased? And, though we may recognise these faces, why is there something a little 'off' about them?

This is the Snatch Game segment of season six of *RuPaul's Drag Race* (Logo/VH1 2009 -). A recurring challenge since season two, Snatch Game has become highly anticipated and much scrutinised by the international viewership of the hugely popular reality TV competition. In these episodes, competing drag queens are challenged to perform in-character as

a celebrity in a skit modelled on a quintessentially televisual form: the panel game show. This is a test not only of their make-up, costuming and acting skills, but also their ability to maintain a character and improvise wittily, much as the famous participants on the original *Match Game* would. The Snatch Game thus demands a combination of the skillsets of the conventional television personality (Bennett 2010) and the drag queen (Newton 1972, Taylor and Rupp 2004, Hopkins 2004, Berkowitz and Belgrave 2010). As a popular alumna and season five winner Jinkx Monsoon puts it, 'without [improvisation, wit and impersonation skills], a drag queen might as well not call herself a drag queen' (S5, E5).

Scholarship on drag tradition supports Jinkx's assertion. Esther Newton's seminal study of drag culture in the 1960s, *Mother Camp*, suggested that 'verbal facility and wit, a sense of camp ... and the ability to do both "glamorous" and comic drag' (1972, p. 3) were highly prized in the gay community at the time, and the popularity of the Snatch Game suggests that this has not changed entirely. Indeed, Snatch Game, in its demand for the funny impersonation of a celebrity figure, is well placed to enable queens to demonstrate glamour and comedy simultaneously: glamour purloined from the impersonated celebrity, and humour in the impersonation itself. While some of the comedy of these performances undoubtedly arises from camp irony, from the sheer incongruity of (mostly) male bodies emulating famous women, much is deliberately executed within the performance through grotesque distortions of the celebrity personae, or through exaggerations of their best-known attributes.[1] These impersonations thus share commonalities with a representational form that creates recognition, meaning and comedy through such distortions – the caricature.

Caricatures offer a paradox. They are deliberately exaggerated, simplified and distorted images that are nevertheless instantly recognisable provided the perceiver is armed with sufficient knowledge of the original face. In its preference for exaggeration and distortion to comment ironically on the status quo, caricature also overlaps with camp as a sensibility and mode of address. If, as Core (1999) suggests, camp is a 'lie that tells the truth', so too is a caricature. Performed caricature shares with camp a predilection for 'exaggeration, theatricality, parody and bitching' (Medhurst 1997, p. 276). Therefore, here I want to take caricatures seriously and consider what the intersection between caricature, camp and drag performance can reveal about celebrity culture and identity. Following Moe Meyer's (1994) definition of camp as 'queer parody', we might see the drag celebrity impersonation as 'queer caricature'.

I discuss four prominent intersections between caricature and drag culture as portrayed on *RuPaul's Drag Race*. I begin with an analysis of the concept of 'character' in both caricature and celebrity more broadly. To be able to identify the portrayed celebrity in an impersonation or caricature, there must be a basic cultural understanding of the meaning(s) of that persona. How these meanings are presented lies at the heart of both caricature and of celebrity. Next, I consider caricature and drag as parodies of both gender identity and celebrity, via an analysis of the drag celebrity impersonation as satire. While there is the potential for transgressive subversion here, there is also often a conservative undercurrent to this parody of celebrity identity, especially in the engagement of stereotype. This oscillation between radical critique and discriminatory ridicule, a feature of both camp and caricature, will be examined. Following this is a detailed analysis of the Snatch Game episodes, looking not only at the 'challenge' segment but also the 'behind-the-scenes' portion in the workroom, and the judging sequence to determine the ways in

which caricature is used by judges as a – sometimes explicit – criterion on which the success of a performance is assessed. Here, the obligation to 'make us laugh' aligns these impersonations with the comedic function of caricature, its use of humour to ridicule the celebrities that are represented. Caricatures do this in a similar manner to camp, by drawing on incongruous contrasts and absurd exaggerations. Finally, I analyse the performative mode of impersonation in these episodes, considering how these seemingly simplified, silly performances reveal complex layers of identity between drag queen and celebrity.

Celebrity, caricature and character

Caricature works on a principle that I have elsewhere (Andrews 2019) termed 'distorted recognition' – an exaggeration of the most culturally well-known aspect of a person whose image, gesture and voice is reimagined in such a way as ironically to enable faster recall. Rhodes (1996, p. 13) offers this useful summary of how (pictorial) caricature has historically been defined:

> The essential features of caricature … appear to be *exaggeration* and *individuation*: a caricature differs from a *realistic portrait* by its deliberate distortion, and from a *grotesque* by its representation of a known individual. Other features also commonly associated with the concept of are a caricature's power to reveal true character or personality, its focus on defects, its humour and simplification.[2]

Each of these aspects of caricature – individuation, the power to reveal character, the focus on defects, humour and simplification – is present in Snatch Game impersonations. I focus initially on individuation and revelation of character. I will move on to discuss flaws, comedy and simplification in subsequent sections.

Celebrities are specimens of individuation; marked out from the rest of society with special status. More, though, as Marshall (2014a, 2014b) argues, celebrity is a representative system that illuminates processes of individualisation in contemporary societies. Part of the celebrity skillset is the presentation and modelling of personas, which are an articulation of the relationship between the individual and the social (Marshall and Barbour 2015). This requires celebrities to personify a set series of characteristics which circulate and construct their meaning and social value, turning them into 'signs' (Dyer 1979). Caricatures work best when they amplify these relatively simple, culturally accepted 'facts' about a famous person's image or personality. In season three's Snatch Game, for instance, Manila Luzon's interpretation of Filipina First Lady Imelda Marcos centred on her controversial collection of hundreds of pairs of shoes (S3, E6). Manila draws upon the best-known feature of Marcos as part of a gentle critique of her subject. She makes oblique reference to another wife of a corrupt dictator, Eva Perón, via a misquote from *Evita* – 'don't cry for me, Filipinos', hinting at the connection between these women in profiting from the misdeeds of their husbands. Her caricature, then, uses Marcos' shoe collection as a cipher for her greed and complicity in a brutal regime. In simplifying the person to their key attribute, the caricature draws on a cultural consensus about that person.

By contrast, the lack of knowable personality traits can be an impediment to a successful Snatch Game appearance. Phi Phi O'Hara was the second queen to unsuccessfully attempt a Lady Gaga impersonation, because, as RuPaul pointed out to her, she

has no recognisable personality and is, as Michelle Visage put it in judging, 'all visual' (S4, E5). Phi Phi's is not a failure of image, but a lack of both caricature's individuation and camp's exaggeration. This may be surprising given Gaga's place in the pantheon of contemporary queer icons. Susan Sontag (1999) notes in her seminal work on camp that 'character is understood as a state of continual incandescence – a person being one, very intense thing'. Since Gaga is not one but many 'intense things', she is a tricky character to convey in the minimal available time for a Snatch Game performance. Both Phi Phi and Sonique (S2, E4) denuded Gaga of her intensity and of specificity, a failure of camp and of caricature.

Caricature's use of semiotic coding and dependence on shared knowledge of the individual portrayed has lent it an ephemeral quality. As Weschler (1983, p. 317) notes, 'it loses impact when we no longer know the code and have nothing at stake'. Here there is an overlap with celebrity, which scholars have sought to analyse as part of a culture which apparently 'privileges the momentary, the visual and the sensational over the enduring, the written and the rational' (Turner 2004, p. 4). The need for a knowledge and understanding of cultural codes makes the caricature a sophisticated form of communication but also renders it temporally and culturally specific. Caricatures require recognition to function, since, as Gombrich and Kris point out 'a caricature reveals its true sense to us only if we can compare it with the sitter, and thus appreciate the witty play of "like in unlike"' (1940, p. 13). It is for this reason that one of the main anxieties queens express in the preparation segment of the show is that their subject is not well known enough. A 'not-famous-enough' character is not always an impediment to success; for instance Jinkx Monsoon won her episode with an impersonation of Edith 'Little Edie' Beale, who many of the other queens had never encountered before (S5, E5). However, in this case, there are clear-cut aspects of personality and character – particularly Beale's distinctive voice – which could be exaggerated to create a recognisable, funny and camp character. Although recognition is important to Snatch Game appearances, the more successful caricatures draw on camp modes of address, incorporating to varying degrees parody, irony, theatricality, ostentation and subversion (Shugart and Egley Waggoner 2008). Little Edie's adoption into the canon of camp appreciation renders her a doubly appropriate subject for The Snatch Game (Vogt 2018). A fuller appreciation of the caricature can be garnered with the requisite queer cultural capital, which the judges of The Snatch Game can be assumed to have. In combination with her obvious talents as a 'comedy queen', this made Jinkx's victory in this game all but inevitable.

Caricatures are not simply amusingly exaggerated images of human beings; they are grotesque portraits which express personality through the distortion of notable and/or 'flawed' physical attributes. In the Snatch Game, many queens have utilised this aspect of caricature to support their celebrity impersonation. Kameron Michaels' Chyna emphasises her large biceps and pectoral muscles (S10, E7), and Pearl's Angela 'Big Ang' Raiola from *Mob Wives* (VH1 2011 – 2016) exaggerates her surgically enhanced lips and breasts and gaudy, excessive make-up (S7, E7), as does Trinity Taylor's Amanda Lepore (S9, E6). Grotesquery can extend to performance as well, such as when Sharon Needles turns Michelle Visage's enthusiastic laugh into a guttural squawk (S4, E5), or Eureka O'Hara, in character as child reality television star Alana 'Honey Boo Boo' Thompson (S10, E7), pulls up her frilly pink dress to reveal she has drawn over her large belly in permanent marker. These performances adopt caricature's traditional function of physiognomic critique,

centred on the idea that bodily imperfection reflects or reveals moral or intellectual failures beneath the surface: Chyna and 'Big Ang' are improperly feminine, Honey Boo Boo is literally marked as stupid. Grotesque exaggerations render the caricatured body an abject site of personal attack.

Caricature uses deformations to ridicule and thus symbolically denude its subject of power, capitalising on comedy's function of asserting temporary superiority of the powerless over the dominant (Stott 2005). In this sense, it is a transgressive form. This effect is negated when caricature's critical eye is trained on subjects without political or social power, especially marginalised communities or disempowered people. Similarly, caricature's tendency to use hackneyed tropes of disfigurement, disability or non-normative bodily features as indicative of immorality or malice endow it a reactionary flavour. In its invocation of power relations as part of its representational strategy, the caricature is an unassailably political form of communication, even when used in absurd contexts like the Snatch Game. Its uses of surface appearance to articulate critical judgement in this way align it with the modes and aims of camp, and of drag.

Customary subversion in caricature, camp and drag

Caricature can be aligned with the potential of drag to be, as RuPaul himself has said, 'punk rock' – an instrument of resistance or a 'political statement'. (Kornhaber 2017, p. 22). Drag's claim to subversive affect has been discussed by feminist and queer scholars, most notably Butler 1990a, (p. 146) who acknowledged its value for deconstructing gender in its 'parodic repetitions' which expose 'the illusion of gender identity as an intractable depth and inner substance'. Butler follows the general understanding of the meaning and value of parody, summarised by Simon Dentith (2000, p. 9) as 'any cultural practice which provides a relatively polemical allusive imitation of another cultural production or practice'. While drag certainly fulfils the criterion of allusive imitation, its position within the entertainment industry may qualify the extent in which this is read as overtly polemical. Butler later denied an intrinsic relation between drag and subversion, noting that drag can be 'used in the service of both the denaturalization and reidealization of hyperbolic heterosexual gender norms' (1990b, p. 338). Drag can, like other forms of parody (including camp and caricature), manifest a conservative or 'customary' undercurrent (Underwood and Schacht, 2004). Caricature works through a sometimes problematic cultural consensus about the semiotic meaning of the famous figure portrayed and about what constitute bodily and moral flaws. Similarly, much drag performance depends on assumptions about the meanings of femininity which need to be agreed before they can be subverted – and the subversion does not necessarily arrive.

The clearest examples from Snatch Game of the play of conservatism and subversion in these performed caricatures lie not in the parody of gender identity, but in the invocation of racial stereotypes. Two prominent examples of this manifest in the Snatch Game. Stacey Laine Matthews' Mo'Nique (S3, E6) was essentially a revisiting of a character from *Precious* (Lee Daniels, *Precious* (Lee Daniels, 2009) which was itself deemed dangerously close to minstrelsy by film critics (Strings and Bui 2014). Stereotypical associations with impoverished African American communities, such as a hatred for 'skinny bitches' or a hunger for fried chicken are deployed in Stacey's caricature. In a similar vein, Gia Gunn's choice of social media celebrity and nail artist Jenny Bui (*All Stars* S4, E3) was explicitly

based not on any actual facet of Bui's personality or biography, but on Gia's conviction that she can authentically portray an East Asian person, since she is of Japanese heritage. She states: 'I don't know much about her, but I do know how to impersonate someone who's fresh off the boat.' In both cases, these performances seem to 'punch down', targeting representatives of marginalised communities, rather than satirising elites. Both Gia and Stacey found themselves under scrutiny from some fans for their casual deployment of stereotype (Denby 2018). These are not subversive critiques of social stereotypes, but their invocation for the purposes of a hollow laugh.

Caricatures and stereotypes are both cultural shorthand, or 'a simple, striking, easily-grasped form of representation [that] are none the less capable of condensing a great deal of complex information and a host of connotations' (Dyer 2002, p. 2). The negative reputation of caricature and stereotype derives from the reduction of the humanity of the subject(s) portrayed to a small number of unflattering tropes or characteristics. The two terms are sometimes conflated in common usage, but the main difference between them is intention and individuation: a caricature is a deliberate representation of a recognisable individual rather than a social grouping. The confusion is exacerbated by the fact that caricatures often draw on stereotypical associations of the social groupings from which the individual derives, as is the case of Gia and Stacey's Snatch Game performances. The failure to critique and, indeed, the tendency to encourage the performance of stereotype in *Drag Race* has been critiqued by scholars (Strings and Bui 2014). Stacey's victory in her Snatch Game, where stereotype underpinned and, ironically, validated her impersonation, supports this claim. The Snatch Game's quick editing offers minimal time for the queens to perform their celebrity. Drawing on the shorthand of stereotype is a convenient means of drawing both recognition and comedic impact out of a celebrity impersonation, even if the accuracy and sensitivity of the portrayal suffers as a result.

In many Snatch Game episodes, there is a recognition of the political or emotional risk at the heart of the caricature. Queens, who often have sincere – or at least, performatively sincere – emotional connections to their icons, demonstrate in the preparation portion of the show their anxiety about performing as them. Raja (S3, E6) and Detox (S5, E5) both claim real-world friendships with their chosen celebrities (Tyra Banks and Ke$ha), which impede rather than aid their impersonations. RuPaul points out to Detox the inherent problem with this: 'You gotta be willing to make a fool out of the person you're doing.' Milan explicitly states that she wants to avoid performing a 'true caricature' of Diana Ross (S4, E5). Alexis Michelle describes her version of Liza Minelli as a 'loving tribute' as opposed to an offensive distillation of the key tropes of her idol (S9, E6). Alexis' successful performance demonstrates the potential for Snatch Game caricatures to be affectionate lampoon rather than unforgiving character assassination. Nevertheless, for a caricature to be effective, we must recognise the parodied figure as a simplified set of characteristics rather than a rounded human being. In a sense, this mirrors the general cultural status of celebrities: a lack of public acknowledgement of their complexity is the price paid for stardom. Some queens' reluctance to move beyond a 'loving tribute' suggests an appeal to the humanity of their icons that speaks to a less cruel and ambivalent relation to celebrity than is superficially understood from camp and drag culture as portrayed in *Drag Race*.

Caricature and comedy as critical framework

Unfortunately for those queens reluctant to insult their chosen celebrity, caricature is explicitly set up in Snatch Game episodes as an evaluative framework through which the success of performances will be judged. In his introductory video for season five's Snatch Game, for example, RuPaul says 'stars aren't born. They're made. Then we destroy them'. As with caricature, the aim is to traduce through comedic ridicule. RuPaul concludes the video by entreating the competitors to 'be fabulous, be a star and most importantly, be funny'. Comedy is frequently reiterated in the pre-challenge segments of the show as the key criterion for success in the Snatch Game. A typical example is RuPaul's exchange with Sasha Velour from season nine; he surveys her costume of tuxedo and top hat and correctly surmises that Sasha will appear as Marlene Dietrich. He suggests to Sasha that this could be a problematic choice since, 'Germans aren't known for being funny' (S9, E6). Over the course of the series, competitors have become self-regulating, offering each other judgements in the workroom of the potential for chosen celebrities to be sufficiently funny. This can sometimes be achieved simply by the selection of an inherently amusing personage, as in the case of Eureka O'Hara's Honey Boo Boo (S10, E7), Pandora Boxx's (S2, E4) and Bob the Drag Queen's (S8, E5) Carol Channing or Alaska's Lady Bunny (S5, E5) and Mae West (*All Stars* S2, E2). More often, though, the humour of the impersonation must be achieved through the means of caricature and of camp: hyperbolic distortion.

The fast-paced editing of Snatch Game episodes compels queens to turn their chosen celebrity into caricatures. Since, as RuPaul notes, 'you have thirty seconds from the waist up to make it happen' (S5, E5), queens must be selective and overt in their personifications of their chosen celebrity to create humorous 'distorted recognition'. Gopnik (1983, p. 373) suggests that the source of comedy in caricatures is the recognition that 'an artist has somehow tapped into the tendency of the mind to exaggerate, generalize and simplify, and has made these tendencies explicit'. Successful Snatch Game performances support this suggestion, since they tend to select and amplify simplistic character traits associated with their personality for comedic purposes. The Snatch Game described at the beginning of this essay, from season six (S6, E5), provides an illustration of this. Much like the 'real thing', Bianca del Rio's Judge Judy is intimidating, forthright and barks scathing aphorisms, such as 'beauty fades, dumb is forever', with precise timing. Adore Delano emphasises Anna Nicole Smith's slow and deliberate southern drawl in combination with disorderly bodily movements which insinuate her permanent intoxication. Maggie Smith is performed by Bendelacreme with startling precision: she adopts an affectedly formal speaking voice and haughty mannerisms, pursing her lips and literally looking down her nose at the camera. These performances are funny partly because they are witty and because of their impeccable comic timing. But a significant source of the comedy also derives from the identification of simple, recognisable and satirisable character traits.

Comedic drag performance has historically been highly valued and relatively well remunerated, based on some combination of slapstick, grotesquery and camp irony (Netwon 1972). Comedy is also an important means for the drag queen to express her power over the audience. Berkowitz and Belgrave (2010, p. 177) identify this as a 'situational power' that is 'tied to the stage, to the setting and the scene'. A drag queen's ability to improvise is usually contingent on the relationship with her audience. As with

camp humour, comedy derives in this context from a power dynamic in which the ordinarily marginalised person establishes temporary social authority (Medhurst 1997). This can result in drag queens achieving ephemeral, localised or self-identified celebrity status (Hopkins 2004), helping to explain why Aquaria's appraisal of her Snatch Game performance highlights that she is 'amazing at being herself' *and* doing a 'silly stupid job of being *another* great celebrity' (S10, E7). The theatrical pause and winked addendum 'catch that?' indicates that she is aware of the pomposity of this statement without a hint that it will be rolled back, producing a moment of self-aware high camp which encapsulates the complex relationship between drag queen and celebrity.

Season six's game (S6, E5) demonstrates how televisual cues (Mills 2009) are used to construct the comedy of these performances. Music is used to aid both recognition of the star portrayed and comedic comprehension. As RuPaul introduces each contestant, a snippet of relevant music is played to illustrate the personality. Jaunty clarinet-led jazz underscores Adore/Anna Nicole Smith, emphasising her silly traits and counteracting audience knowledge of her troubled life and tragic death, rendering her a more palatable figure for caricature. Maggie Smith is accompanied by string quartet music, underlining the caricature of her elite status and stuffy Englishness. Here, editing and mise en scene contribute to the performed caricature by adding extra contextual clues to aid quick recognition, in a manner analogous to the presentation of caricature in other televisual contexts (Andrews 2019). Canned laughter is added to performances in post-production to compensate for the lack of diegetic audience. The laugh track is added to jokes or amusing statements to cue the viewer to a comedic moment, for instance, when Darienne Lake/Paula Deen quips 'She's a real keeper. As in keep 'er in a cage!'. The absence of canned laughter is equally used as a demerit for jokes that fall flat in the room, such as Milk/Julia Child's strange attempt at a double entendre around the term 'sausage truck'.

Editing plays a similar role in cueing the viewer to laughter: after the queens perform a 'bit' or provide an amusing answer to the Snatch Game question, the camera often cuts to either RuPaul or one of the guests appearing on the show performatively laughing at the joke. Editing can equally be used to exacerbate failing performances. For instance, in a brief reaction shot, guest judge Gillian Jacobs' eyes widen, embarrassed as Gia Gunn/Kim Kardashian fumbles her response to a question from RuPaul. Brief reaction shots from one of the other queens in the room can also be used for this function, such as Bianca del Rio's eyes noticeably rolling at LaGanja Estranja/Rachel Zoe's robotic voice and gestures. These shots often relate not to the immediate context of the Snatch Game, but to a wider story arc in the season of *Drag Race*, in this case a growing conflict between Bianca and LaGanja. Moments like these remind the viewer of the drag persona beneath the caricature, breaking any temporary pretence that they 'are' their celebrity counterpart. This is reinforced in short segments of competitors addressing camera in their non-drag personas, delivering a usually scathing verdict on another queen's performance, for instance Bianca's tongue-in-cheek one-liner 'Milk ain't no Meryl Streep'. The effect is to heighten the comedy of the episode and to undermine these ineffective impersonations.

In their critiques and evaluations, judges' comments tend to focus on the salient aspects of caricature performance that have been discussed so far in this essay: simplification, exaggeration and comedy. Guest judge Niecy Nash comments to contestant Jujubee in season two, 'when you do characters and you only have a short amount of time you want to do the biggest thing about them that makes people go "that's Kimora"' (S2, E4).

This observation demonstrates the extent to which the judges are explicitly looking for vulgar amplifications in Snatch Game from the outset. By contrast, critiques of queens whose acts underwhelmed tend to point out that they needed 'more' or that they did not read as 'funny'. Indeed, there are occasions, such as with Coco Montrese's Janet Jackson, where judges acknowledge the quality of the visual and vocal impersonation but note that it simply was not 'enough' (S5, E5). In cases like this where costuming and makeup provide a close mimesis with the subject, failure suggests that additional skills are required in the Snatch Game. Regular judge Michelle Visage has directly invoked caricature more than once, for example, praising Manila Luzon's performance: 'what I loved is that you were a caricature of a caricature of Barbra [Streisand]' (*All Stars 4*, E3). Accurate imitations are not the point of The Snatch Game. Impersonation hinges on exaggerated physical movements and vocalisation more than the make-up and costuming of the performers. While portrait caricature works through distorted iconicity, performed caricature depends on acting, improvised dialogue and movement, as well as image.

Impersonating celebrities, queering celebrity

The demand for competitors in Snatch Game challenges simultaneously to be recognisable as their celebrity and to be funny requires them to improvise in character. While there are clearly some elements of Snatch Game, such as the opening gambit, that queens plan and rehearse, the most striking moments arise from extemporisation. A good example is this exchange from season six:

Bendelacreme/Maggie Smith: [after a discussion of smartphones] Am I to understand that one yanks one's telephone right off the wall and carries it with them?

Trinity/Nicki Minaj: Ru, could you get people that speak normal English next time for the show?

Bendelacreme/Maggie Smith: Excuse me, we originated the language!

Improvisation skills tend to be highly valued in drag queens who, as Taylor and Rupp (2004) note need to embrace a 'theatrical identity'. Newton recognises that there is a theatrical structure and style to drag, arguing that 'there is no drag without an actor and his audience, and there is no drag without drama (or theatricality)' (1972, p. 37). The absence of audience in Snatch Game episodes creates a rather artificial scenario in which the theatrical skills of the queens play out. The regular theatrical frame in which professional drag queens have traditionally performed is replaced by a televisual frame which exchanges long-form theatricality with immediate visual and performative impact. Ferris and Harris note that such framing is present in the work of professional celebrity impersonators, but that they

> move back and forth between the type of sincere imitation that represents the traditional theatrical frame (in which all in the theatre agree that the performer has taken on a role) and the playful improvisation that complicates that traditional frame (in which a performer makes a "wink, wink, nudge, nudge" reference to his/her role-taking). (2011, p. 58)

There are occasions on Snatch Game when such a nod to the artificiality of impersonation is enabled; a good example is Sasha Velour/Marlene Dietrich's answer to a question about

a Snapchat filter: 'I found this question unfair, because as you know, I rarely know these new things, I rarely leave my house, and I died many decades ago' (S9, E6). Recognising the silliness of the pretence that she *is* Marlene Dietrich, Sasha's careful, mannered answer ironises the situation, a subversion of the form of Snatch Game which makes a mockery of its entire premise. Here Sasha draws on camp's tendency to 'see everything in quotation marks' (Sontag 1999, p. 56), to acknowledge the absurd contextual frame for her performance of Dietrich. In this example, Sasha parodies not only gender's performativity but the overt display of celebrity identity. This mirrors Ferris's (2011, p. 1191) claim that a celebrity impersonation is in fact a 'replication of the persona of a real individual'. In other words, the impersonating queens of the Snatch Game are not performing *as* a celebrity, rather, they are attempting to construct a character out of that celebrity's persona. It is possible to do this to greater or lesser degrees of credibility, because persona exists separately though not independently from the person of the celebrity (Hamilton 2009). Moreover, as Marshall (2014b, p. 166) notes, 'persona definitionally implies an outward appearance of the individual' which renders it possible for competing queens to emulate closely their chosen celebrity in terms of image and gestural range. The caricature format of Snatch Game means there is little need for the queens to have any interest in the celebrity person, able instead to reproduce and subvert the persona.

Drag queens have an instinctual relationship to the presentation of a persona, since that is the nature and format of drag performance. Most research on drag culture emphasises that the drag persona is separate even if interdependent from the drag performer (Hopkins 2004). In Snatch Game episodes, queens will often select their celebrity impersonation based on their perceived fit with their drag persona. Bianca chose Judge Judy because of overlaps between her drag character and the TV judge: loudness, abrasiveness and being a 'fucking bitch'. Adore states in out-of-drag talking head that her drag persona is actually inspired by Anna Nicole Smith, an idea assented to by the judges in deliberations, who argue that it is therefore not as great a challenge for Adore to perform in-character; in a sense, she is performing in-character as Adore, who happens to be dressed as Anna Nicole. This sense by which the drag personality is influenced or reflective of the (female) idols of the queen recollects Mark Booth's observation that 'a camp female impersonator may well continue to use the mannerisms of Bette Davies or Joan Crawford off-stage in a way which says as much about himself as it does the stars' (Booth 1999, p. 69).

When we observe a caricature performance on the Snatch Game, we are in the presence of three personae – the celebrity impersonated, the drag queen underneath, and the performer underneath her. This recollects Jean-Louis Comolli's (1978) assertion that when an actor portrays a real historical person on screen, there are two bodies in competition, one body too much. In the case of drag impersonation, there is an additional persona to contend with, another 'body' too many. This dynamic is at its most complex when queens chose a male celebrity for their Snatch Game performance. For example, when Kennedy Davenport chooses to perform as Little Richard, her colleagues Katya and Ginger Minj are horrified (S7, E7). Kennedy suggests Little Richard is appropriate, since he has been 'in drag' his entire life, implying that there is sufficient affinity between her drag persona and a male celebrity. Kennedy's Little Richard lends weight to Helene Shugart and Catherine Egley Waggoner's suggestion that the '"incongruous contrasts" that characterize camp irony are not limited to gender, even if that is its most common

manifestation' (2008, p. 32). Indeed, it suggests that it is not only gender identity but identity more broadly that is under scrutiny in these performances.

Hamilton (2009, p. 224) sees celebrities as 'persons in perpetual performance, as quintessential personae'. Moe Meyer suggests that 'queer' signals a similar challenge to 'bourgeois notions of the Self as unique, abiding and continuous while substituting instead a concept of the Self as performative, improvisational, discontinuous and proces- sually constituted by repetitive and stylized acts' (1994, p. 3). If celebrities can be seen as performative personas, this definition of queer opens a reading of Snatch Game carica- tures as queerings of celebrity identity along similar lines to Butler 1990b, (p. 137) formulation about drag as a parody of gender:

> In drag we are actually in the presence of three contingent dimensions of significant corporeality: anatomical sex, gender identity and gender performance ... *in imitating gender, drag implicitly reveals the imitative structure of gender itself – as well as its contingency.*

We might reframe this influential argument, via Hamilton's identification of celebrities as performative personas: 'in drag celebrity impersonation, we are in the presence of three contingent dimensions of celebrity: the person, the persona and celebrity performance ... In imitating celebrity, drag implicitly reveals the imitative structure of celebrity itself, as well as its contingency'. Celebrity is dependent upon the repetitive performance of knowable, individualised images and traits. The ability of drag queens to capture, subvert and capitalise on these traits via performed caricature suggests that they are imitable, contingent and only loosely constructed around the person. So, as drag and camp constitute queer parodies of gender relations under heterosexist patriarchy, drag celebrity impersonation is queer caricature.

Conclusion – why Beyoncé never works

In discussing the overlaps between caricature, camp and drag performance, this article has analysed four key features of performed caricatures as they manifest in the Snatch Game. These are the distortion of known character traits to aid viewer recognition of the subject; the use of these exaggerations as a means of satirising the celebrity figure; camp irony and comedy as the result of these absurd portrayals; and the queering of persona through performing 'in-character' as a celebrity. I conclude this analysis of Snatch Game performances by using this framework to analyse a frequently recurring trope in the Snatch Game: the failure of queens who attempt to personify Beyoncé.

A major problem for queens who choose Beyoncé is that, in the words of Monique Heart, 'Beyoncé doesn't really have a personality that we get to see' (S10, E7). Monique speaks to Beyoncé's success in releasing her private persona into the public eye on her own terms, which means her 'true' personality remains mysterious, and her meaning in popular culture becomes imagistic and theatrical. While her power and intensity in these terms makes her a fitting figure for camp appreciation, it also makes her a difficult celebrity to caricature. As with Lady Gaga, there is a lack of intense singular persona that can be identified and subverted. For caricature to work effectively, it must select prominent character features, such as Judge Judy's harsh tone and nasal voice, Anna Nicole Smith's drunken ditziness, Marlene Dietrich's androgyny. These are exaggerated to produce the distorted version which prompts immediate recognition. It is not possible to

do this with a persona as fundamentally unknowable as Beyoncé, who has no clearly identifiable personality traits, but is multiple characters in one.

Exaggerations in caricature do not only perform the function of aiding recognition. They also work as part of a critique of the person. Caricature tends to highlight its subject's defects as a means of denigration. While it is possible to do this with affection, the ironic distance required for both camp humour and caricature often tends towards the insult rather than the 'loving tribute'. *Drag Race* queens have been largely unwilling to perform an imperfect but recognisable version of Beyoncé. Instead, each time she is created, the version is either bland, like Tyra Sanchez (S2, E4) or fictional, as in Asia O'Hara's angry mean mother (S10, E7) or Kenya Michaels' narcoleptic IBS sufferer (S4, E5). The judges on this episode suggest that Kenya does not possess enough pop culture knowledge to draw on for her performance, but it is equally likely that she simply elected not to satirise a popular icon.

Kenya made the decision to humanise her version of Beyoncé by drawing attention to her failing body. Such corporeal humour is a common feature of the caricature, which uses abject imagery to satirise, to imply that flawed bodies represent human failings. This seems a poor fit with Beyoncé's persona. Again, she is an unusual celebrity inasmuch as she does not really represent the dichotomy of ordinary/extraordinary that Dyer (1979) identifies as central to traditional star-making. Beyoncé is framed in popular culture as beyond normality: 'universally loved, virtually unquestioned, and flawless' (Bennett 2014). Kenya was, however, searching for an answer to the largest problem with Beyoncé, which is how to make her funny. This is a recurrent theme with queens who attempt Beyoncé. They simply seem reluctant to make fun of her. Although she exudes the 'continual incandescence' (Sontag 1999) that may make her a figure of considerable camp, she seems not to possess the *failed* seriousness beloved of the camp sensibility. Her cultural power has the sheen of legitimacy derived of authentic talent rather than cheap self-promotion. This makes her an unlikely, though not impossible, figure to lampoon, and a weak candidate for the queer caricature of drag celebrity impersonation as displayed on *RuPaul's Drag Race*.

The Snatch Game challenge 'unleashes the dichotomy between lampoon and legitimacy' (Brennan 2017, p. 36) which is inherent to drag and to caricature. Its quickness of pace and reliance on visual and aural cues to aid recognition compels queens to caricature rather than impersonate their chosen celebrities. Queens must embody three personas in one, exuding and subverting the surface personality within seconds. Queer caricature parodies individual celebrities and, at another level of abstraction, the performance of celebrity itself. While bringing celebrity subjects down to Earth through distortion and physiognomic critique, nailing a Snatch Game performance can also help cement a celebrity's status as a star, since it confirms their persona either has enough (sub)cultural cachet or is unique and recognisable enough to support a caricatured version. The fact that so many Snatch Game performances have caricatured other *Drag Race* queens speaks to both the show's ability to create new celebrities and the instinctive ability of drag queens to model (celebrity) personas. Purloining, trashing and exposing the illusion behind celebrity 'charisma, uniqueness, nerve and talent' the queer caricature demonstrate the contingency and imitability of celebrity identity.

Notes

1. 'Mostly' because (a) some transwomen and non-binary people have competed in the Snatch Game, and (b) some competitors have performed as male celebrities.
2. 'Grotesque' is used in this context as a noun, to refer to the art historical category of portrait, sculpture or architectural feature which displays a deliberately gross, ugly or deformed figure springing from the artists' imagination, not based on a pre-existing subject.

Disclosure statement

No potential conflict of interest was reported by the author.

References

Andrews, H., 2019. Distorted recognition: the pleasures and uses of televisual historical caricature. *Screen*, 60 (2), 280–297. doi:10.1093/screen/hjz005

Bennett, J., 26 Aug 2014. How to reclaim the F-Word? Just call Beyoncé! *Time Online*. Available from: https://time.com/3181644/beyonce-reclaim-feminism-pop-star [Accessed 2 Oct 2019].

Bennett, J., 2010. *Television personalities: stardom and the small screen*. London: Routledge.

Berkowitz, D. and Belgrave, L., 2010. "She works hard for the money": drag queens and the management of their contradictory status of celebrity and marginality. *Journal of Contemporary Ethnography*, 39 (2), 159–186. doi:10.1177/0891241609342193

Booth, M., 1999. *Campe-toi!* On the origins and definitions of camp. *In*: F. Cleto, ed. *Camp: queer aesthetics and the performing subject: a reader*. Ann Arbor: University of Michigan Press, 66–79.

Brennan, N., 2017. Contradictions between the subversive and mainstream: drag cultures and *RuPaul's Drag Race*. *In*: N. Brennan and D. Gudelunas, eds. *RuPaul's Drag Race and the shifting visibility of drag culture*. Basingstoke: Palgrave, 29–43.

Butler, J., 1990a. *Gender trouble: feminism and the subversion of identity*. London: Routledge.

Butler, J., 1990b. Gender is burning: questions of appropriation and subversion. *In*: S. Thornham, ed. *Feminist film theory: a reader*. New York: New York University Press, 336–349.

Comolli, J., 1978. Historical fiction: a body too much. *Screen*, 19 (2), 41–54. doi:10.1093/screen/19.2.41

Core, P., 1999. From camp: the Lie that tells the truth. *In*: F. Cleto, ed.. *Camp: queer aesthetics and the performing subject: a reader*. Ann Arbor: University of Michigan Press, 80–87.

Denby, M., 2018. Jenny Bui claps back at Gia Gunn's shocking Drag Race portrayal. *Who Magazine online*. Available from: https://www.who.com.au/jenny-bui-gia-gunn [Accessed 17 Jul 2019].

Dentith, S. 2000. *Parody*. London: Routledge.

Downton Abbey, 2010-2015. TV, ITV.

Dyer, R., 1979. *Stars*. London: BFI.

Dyer, R., 2002. *The matter of images: essays on representations*. 2nd ed. London: Routledge.

Ferris, K. and Harris, S.R., 2011. *Stargazing: celebrity, fame and social interaction*. New York and London: Routledge.

Ferris, K.O., 2011. Building characters: the work of celebrity impersonators. *The journal of popular culture*, 44 (6), 1191–1208. doi:10.1111/j.1540-5931.2011.00895.x

Gombrich, E. and Kris, E., 1940. *Caricature*. Harmondsworth: King Penguin.

Gopnik, A., 1983. High and low: caricature, primitivism and the cubist portrait. *Art journal*, 43 (4), 371–376. doi:10.1080/00043249.1983.10792257

Hamilton, S., 2009. *Impersonations: troubling the person in law and culture*. Toronto: University of Toronto Press.

Hopkins, S., 2004. "Let the drag race begin!" The rewards of becoming a queen. *Journal of homosexuality*, 46 (3), 135–149. doi:10.1300/J082v46n03_08

Kornhaber, S., Jun 2017. RuPaul gets political. *The Atlantic*, 20–23.

Marshall, P., 2014a. *Celebrity and power: fame in contemporary culture*. Minneapolis and London: University of Minnesota Press.

Marshall, P., 2014b. Persona studies: mapping the proliferation of the public self. *Journalism*, 15 (2), 153–170. doi:10.1177/1464884913488720

Marshall, P. and Barbour, K., 2015. Making intellectual room for persona studies: a new consciousness and a shifted perspective. *Persona studies*, 1 (1), 1–12. doi:10.21153/ps2015vol1no1art464

Medhurst, A., 1997. Camp. *In*: A. Medhurst and S. Munt, eds. *Lesbian and gay studies: a critical introduction*. London and Washington: Cassell, 274–293.

Meyer, M., 1994. Introduction: reclaiming the discourse of camp. *In*: M. Meyer, ed. *The politics and poetics of camp*. London and New York: Routledge, 1–22.

Mills, B., 2009. *Sitcom*. Edinburgh: Edinburgh University Press.

Mob Wives, 2011 – 2016. TV, VH1.

Netwon, E., 1972. *Mother camp: female impersonators in America*. Chicago: University of Chicago Press.

Precious, 2009. Directed by Lee Daniels. USA: Lee Daniels Entertainment/Smokewood Entertainment/Harpo Films/34th Street Films

Rhodes, G., 1996. *Superportraits: caricatures and recognition*. Hove: The Psychology Press.

RuPaul's Drag Race, 2009. present. TV, Logo TV/VH1.

Schacht, S. and Underwood, L., 2004. The absolutely fabulous but flawlessly customary world of female impersonators. *Journal of homosexuality*, 46 (3), 1–17. doi:10.1300/J082v46n03_01

Shugart, H. and Egley Waggoner, C., 2008. *Making camp: rhetorics of Transgression in U.S. popular culture*. Tuscaloosa: University of Alabama Press.

Sontag, S., 1999. Notes on Camp. *In*: F. Cleto, ed. *Camp: queer aesthetics and the performing subject: a reader*. Ann Arbor: University of Michigan Press, 53–65.

Stott, A., 2005. *Comedy*. Abingdon: Routledge.

Strings, S. and Bui, L., 2014. "She's not acting, she is!" The conflict between gender and racial realness on *RuPaul's Drag Race*. *Feminist media studies*, 14 (5), 822–836. doi:10.1080/14680777.2013.829861

Taylor, V. and Rupp, L., 2004. Chicks with dicks, men in dresses: what it means to be a drag queen. *In*: S. Schacht and L. Underwood, eds.. *The drag queen anthology: the absolutely fabulous but flawlessly customary world of female impersonators*. New York and Oxford: Routledge, 113–133.

The Match Game, 1962. Present. TV, NBC/CBS/ABC.

Turner, G., 2004. *Understanding celebrity*. London: Sage.

Vogt, G., 2018. Malapropos desires: the cinematic Oikos of grey gardens. *In*: I. Hotz-Davies, G. Vogt, and F. Bergmann, eds.. *The dark side of camp aesthetics: queer economies of dirt, dust and patina*. New York and Abingdon: Routledge, 127–144.

Weaver, C., Nov 2017. Trixie mattel is for men (and women and kids). *GQ*. Available from: https://www.gq.com/story/trixie-mattel-is-for-men-and-women-and-kids [Accessed 24 Apr 2019].

Weschler, J., 1983. The issue of caricature. *Art journal*, 43 (4), 317–318.

Rewriting 'herstory': Sasha Velour's drag as art and activism

Renee Middlemost

ABSTRACT

Following its move to VH1 in 2017, Season 9 of *RuPaul's Drag Race (RPDR)* was positioned to capture a larger audience than ever before, boasting the strongest field of competitors in its 'herstory'. This article maps the career trajectory of Season 9 winner Sasha Velour to determine how she distinguishes herself from previous champions. While winners of *RPDR* are expected to possess the virtues of charisma, uniqueness, nerve, and talent, Velour's articulation of fame post *RPDR* has been informed by charisma and uniqueness, coupled with a consistent performance of an 'authentic' persona. Since winning Season 9, Velour has been an outspoken advocate for the transgender community and the need to diversify drag, in addition to drawing attention from the mainstream fashion industry for her art and style. Drawing inspiration from *RPDR's* virtues, I argue that the performance of charisma and uniqueness are essential to interpreting the success of the drag celebrity persona as part of the 'fame cycle' beyond *RPDR*. Velour's star image is distinctive for centring art and activist performance as vital to her public persona across transmedia platforms, allowing for the promotion of positive change for the LGBTQIA community worldwide.

Introduction

'The new thing is going to seem a little strange, and a little weird. And the new thing is definitely going to walk in with a scream. And that is me' (Velour, S9, E12).

Since the 2009 debut of *RuPaul's Drag Race*, sixteen queens[1] have 'snatched' the crown to become America's Next Drag Superstar. With past alumni of the show now numbering over one hundred, the ability to stand out from the crowd and maximise exposure as a former contestant is crucial. *RPDR* quickly gained a cult following for its combination of talented contestants, celebrity guest judges, viral catchphrases, and low budget production values. The appeal of the show grew beyond the queer community apace, with Season 4 (2012) (Bailey 2009)considered the point when the series infiltrated mainstream popular culture (Sim 2018). Indeed, the Season 4 triumph of Sharon Needles, a horror-drag performer may have sown the seeds for future 'alternative drag' winners, such as Sasha Velour. Academic studies of the series have focused on the use of transphobic language (Gudelunas 2016, O'Halloran 2017); commercialism (Vesey 2017); and race representation (Jenkins 2017, McIntyre and

Riggs 2017). In particular, RuPaul's 2018 remarks regarding the eligibility of transgender performers to compete were rejected by the queer community (Greenhalgh 2018); she had also previously claimed: 'Our show is not meant to be representing everybody' (Associated Press 2017). RuPaul later issued an apology that stated: 'In the 10 years we've been casting *Drag Race*, the only thing we've ever screened for is charisma uniqueness nerve and talent. And that will never change' (RuPaul 2018). RuPaul's statements in this instance prove her remarkable detachment from the community *RPDR* claims to represent. While the critiques of RuPaul, and *RPDR* are well founded, the impact of exposing drag to a mainstream audience has, as LeBesco (2004) contends of reality television: ' ... had a hand in changing images and perceptions of transgressive sexuality for better and worse'. The premiere of *RPDR* also coincided with the rise of Twitter and Instagram, and audiences' engagement with social TV (Selva 2016); thus *RPDR*'s transmedia presence has been integral to its devoted fan following. After a successful eight-year partnership, *RPDR* moved to VH1 in 2017. The move to VH1 (away from the niche, subscription based Logo TV channel) enabled access to a wider audience, and season 9 – the first season to be screened on the network – gained the highest audience share for the premiere of the series to date (Megarry 2017). Widely considered to be one of the strongest assembled fields (Hawkins 2017) the cast included Brooklyn based queen, Sasha Velour, an atypical choice for the series to date. As the following case study of Sasha Velour demonstrates, to win, and succeed beyond the title of America's Next Drag Superstar, the perception of authenticity must be balanced with RuPaul's intangible virtues of charisma, uniqueness, nerve, and talent. While these virtues are functional within the confines of *RPDR*, their intangible nature problematises use in academic analysis. RuPaul repeats these virtues as a type of mantra throughout the series, yet she never clarifies their features, even after the release of 'Charisma, Uniqueness, Nerve, and Talent' on her album *American* (2017). The chorus lyrics of the single offer little in the way of further explanation: 'Charisma. Uniqueness. Nerve and. Talent. Trust in the virtues, the rhythm within you. Let your body tell the truth'. The lyrics merely suggest that these qualities are innate to any winner of the series, and they will be recognised by RuPaul.

Drawing inspiration from these virtues, this article contends that Velour embodies charisma and uniqueness, presented as an 'authentic' transmedia persona that connects fans with her brand. While other winners and fan favourites have distinguished themselves post *RPDR*, this article focuses on Velour's strategic use of media platforms, and specific articulation and performance of star persona/brand. Both Reeves (1961) and Niu and Wang (2016) insist that a Unique Selling Proposition (USP) is central to any brand. Applying this concept to celebrity persona, this article questions how reality TV drag stars distinguish themselves, and how *RPDR* alumni are positioned in relation to the 'fame cycle' (Deller 2016). Since winning Season 9 of *RPDR* in 2017, Velour has proven she[2] is the 'new thing' influencing both drag, and mainstream popular culture. As I will argue, Velour operates as a distinctive brand by centring her public persona around art aesthetics and activism across transmedia platforms, and in so doing, promotes positive change not only for herself, but the LGBTQIA community worldwide.

Just being themselves? Framing America's next drag superstar as 'authentic celebrity'

Contemporary fame is undergoing rapid and continuous change, largely attributed to the uptake of social media, and the ability of fans to feel connected to celebrities. Marshall (2014, p. xii) claims these changes to celebrity presentation, and of our ideas of public/private has 'helped expand our comfort with public intimacy'. Reality television contestants exhibit public intimacy in both their onscreen performance of 'confessional address' (Redmond 2008), and their social media presence. In the case of *RPDR* contestants, the 'constructedness of persona' (Jerslev 2014) is visible both in the portrayal of the drag character, and the performer underneath. The reading of celebrity drag personas is further complicated as the queens appearing on *RPDR* are already active performers (unlike most other reality television contestants), with their own pre-existing brand (Gudelunas 2017, p. 236). Thus, *RPDR* contestants are at the forefront of debates regarding celebrity, microcelebrity, niche tastes, authenticity, personal branding, and the 'fame cycle' (Deller 2016)., The opportunity for queens to diverge from the traditional fame cycle grows alongside the *RPDR* franchise[3]; increasingly fan favourites, and winners such as Velour, Bianca Del Rio, Alaska, and Shangela are recognisable celebrities that cross into mainstream popular culture, such as Shangela and Willam's cameo appearance with Lady Gaga in *A Star is Born* (Cooper 2018) . For contestants of *RPDR*: 'performing a marketable persona, which has to be unique and irreplaceable' (Jerslev 2014, p. 174) is central to their post-show success – a message constantly reinforced by RuPaul's mantra, that to win, contestants must display the 'virtues' of charisma, uniqueness, nerve, and talent.

Social media platforms are essential to the public image management of celebrities and this persona is performed across multiple platforms. Although relationships between fans and celebrities are frequently parasocial, the desire for an authentic portrayal of 'realness' from celebrities, and the reassurance that they are 'just like us', remains. Dyer (1991) contends that 'sincerity and authenticity' is essential to the star persona; however the authenticity of celebrity personas is more convoluted. Holmes (2005, p. 9) explains that while 'celebrity' and 'star' are often used interchangeably, 'celebrity' is structured by: ' ... discourses of cultural value [and] used to indicate a more fleeting conception of fame, when fame rests predominantly on the private life of the person, as opposed to their performing presence'. How then to assess the authenticity of a drag performer appearing on reality television, when they are performing not just one, but two personas (their drag self, and their 'real' self)? Brennan (2017, p. 37) reflects on authenticity and performance in *RPDR*, pinpointing 'the contradictions of drag authenticity as determined by the judges' and ' ... the possibility of multiple, *authentic* drag cultures existing simultaneously' (original emphasis). Van Leeuwen (2001, p. 393) also describes the complexity of authenticity as a measure of truth:

> ... something can be called 'authentic' because it is thought to be true to the essence of something ... One such essence is the 'self', construed as a constant and unified 'character', which at best slowly 'evolves' or 'matures'. Another is an internalised conscience or life goal which is never altered or compromised. Yet another is the style of the artist or the voice of a singer.... if they seek distinction and are to be regarded as having their own authentic style or voice, they must adopt just one style and abandon the others (Van Leeuwen 2001, p. 393).

In *RPDR*, authenticity as the adoption of 'just one style' is problematised as queens can be both praised, and critiqued for performing a consistent persona (Brennan 2017). The

onscreen performance of queens is also judged for authenticity by fans against their pre-existing social media profile, highlighting the contentious nature of their public personas.

Direct social media communication informs fan impressions of celebrity authenticity. Of social media and celebrity persona, Ellcessor asserts: 'Often, what best cements the authenticity of online expression – of celebrities and everyday people alike – is the articulation and repetition of a core identity or value that speaks to the "kind" of person one is. This core, for celebrities, makes their persona culturally meaningful' (2018, pp. 259–260). By season 9, the series had begun to accept (if not always reward) drag from outside the pageant circuit due to the popularity of queens such as Sharon Needles and Alaska. This in turn allowed Velour's performance of a consistent, yet highly stylised art/drag performance, underpinned by her political beliefs; these features of her performance remain central to her drag and celebrity persona both on and offline.

Bennett and Holmes (2010, p. 66) contend: ' ... reality TV has been invoked to exemplify wider shifts in fame ... it reflects the fluid and pervasive circulation of contemporary media fame which does not respect media borders'. As I have outlined in this section, despite the historical separation of star/celebrity in terms of discursive 'value', both personae have a shared preoccupation with authenticity. 'Reality TV has established a new televisual realism in the digital age, founded on the concept of self-revelation and (often) personal development as a privileged signifier of authenticity' (Holmes 2006, p. 54). A convincing performance of authenticity on *RPDR* is essential for the queens as they attempt to secure their future career prospects, and negotiate the liminal space between the DIY creation of their drag persona *and* their online persona.

The remainder of this article argues that charisma and uniqueness, coupled with a persona perceived as authentic are central to understanding the career trajectory of Sasha Velour. The following case study aligns charisma and uniqueness with the features of contemporary celebrity identified by Dyer (1991), Bennett and Holmes (2010), and Ellcessor (2018). In sum, this case study shows how Velour personifies an 'authentic' transmedia persona that connects fans with her brand, and inspires their ongoing affective engagement with her post *RPDR* projects.

Category is: charisma

When considering the frequent attribution of charisma as an essential feature of celebrity, there is a striking lack of scholarly research that defines its substance. For Henricks, 'the permissive popular usage of the term "charisma" ... applies the label to whoever appears inspiring or magnetic toward larger groups of people which are often people in the media, including celebrities from the entertainment branch' (Hendriks 2017, p. 348). This type of charisma is exemplified in Sasha Velour's winning performance in the Season 9 finale of *RPDR*. Velour entered the finale as an underdog despite successfully showcasing her 'artsy, weird drag' throughout the season. Velour's lip sync to Whitney Houston's 'So Emotional' against front runner Shea Coulee captivated the live audience with an unexpected wig reveal of cascading rose petals at the climax of the song. For many fans of *RPDR*, this image of Sasha Velour (Alexander Hedges Steinberg), is the enduring representation of her drag persona, despite her already established career and subsequent post show success.

Sasha Velour was born in Berkeley, California, before spending the majority of her childhood in Urbana, Illinois, where her father worked as a University professor of Russian History. As Velour revealed during *RPDR*, and in subsequent interviews, even as a child she was drawn to the world of art, makeup, and costumes (Malice 2017). After studying undergraduate Literature and Queer theory, Velour moved to Russia to research LGBTQIA political protest art as a Fulbright scholar. The hostile Russian environment towards LGBTQIA people (The Council for Global Equality 2019) meant that she had to conceal her primary research, and began to consider:

> … what kind of work actually helps to change things for queer people. And I became really fascinated with drag because it's such an accessible and joyful art form. I wanted to create beautiful images in drag that would not just inspire queer people who need to see some beauty and need to experience some joy, but also would engage people politically (Hobson 2017).

Upon her return to the U.S., Velour embarked upon a Master of Fine Arts degree in Cartoon Studies; during this period her mother was also battling cancer. Velour frequently reflects upon the impact of her mother's death, and the inspiration she provides when performing as Sasha Velour, not only in fashion (Barsamian 2017) but her decision to perform as a bald queen (Bromwich 2017). Once she began experimenting with drag, Velour quickly established her own platforms to combine her interests. These include her magazine, *Velour*, dedicated to drag, art, and the promotion of other queer performers; and *Nightgowns*, a monthly review featuring an array of drag artists in a theatrical setting. Velour's fine art background continues to inspire her drag performance, with digital projections of her art appearing in live shows, social media channels, merchandise, and *Velour* magazine. The charisma hinted at in Velour's performance on *RPDR* has been one of the cornerstones of her success post appearance; through her political advocacy and activism she has begun to occupy the 'charismatic leader' persona.

Weber's (1968)) research informs the framework of charisma expanded upon by both Dyer (1998) and Marshall (2014). For Marshall (2014, p. 22) charisma is central 'to understanding the nature of celebrity power'. Weber defines charisma as a: 'certain quality of individual personality by virtue of which [s/]he is considered extraordinary and treated as endowed with supernatural, superhuman or at least specifically exceptional powers or qualities' (Weber 1968, p. 241)). Weber's definition of charisma is also seen in Dyer's theorisation of stars as imbued with a kind of 'magic' (another intangible quality). In his exploration of charisma, Weber underscores the innovative qualities of the charismatic leader, and their ability to initiate change: 'charismatic authority repudiates the past, and is in this sense a specifically revolutionary force' (1968, p. 244). Recent scholarship has also turned towards the impermanence of charisma:

> … once the task of creating and institutionalising new orders has been accomplished, quite often charisma can fade or become routinised. Charisma dissipates when the individual seeks out more permanent and formal structures or when various rules and institutions emerge to guide it (Cocker and Cronin 2017, p. 465)

Rather than framing charisma in terms of leadership, *RPDR* seems to imagine charisma as an embodiment of the star 'magic' Dyer (1998, p. 16) formulated – whereas modern celebrity allows for the performance of both types of charisma simultaneously. Velour's backstory emphasises personal impetus and studious application to learning, whereas her

star image aligns with the 'magic and talent', described by Dyer (1998, p. 16) where 'stars are stars because they are exceptional, gifted, wonderful'. Further, Dyer insists that the success myth relies on contradictory elements:

> that ordinariness is the hallmark of the star; that the system rewards talent and "specialness"; that luck, "breaks", which may happen to anyone typify the career of the star; and that hard work and professionalism are necessary for stardom (Dyer 1998, p. 42).

Yet as Holmes (2010, p. 74) contends, those performing on reality 'talent' shows 'continue to peddle more traditional myths of fame'. Holmes' depiction of reality TV fame allows 'ordinariness' and 'star magic' to exist side by side in a format that rewards performers 'just being themselves'.[4] Charisma in *RPDR* centres upon the ability of contestants to inspire affect, allowing them to become a marketable commodity and sell products to their fans (Vesey 2017). As I will demonstrate, the commodification of Sasha Velour as persona/brand, is distinctive for selling products alongside philanthropic causes.

Velour's activism illustrates the appeal of the charismatic leader persona 'in times of psychic, physical, economic, ethical, religious, political stress' (Eisenstadt and Weber 1968, p. xx), when 'the charismatic figure offers a value, order, or stability' (Dyer 1998, p. 31) to correct this imbalance. Velour's persona combines advocacy for LGBTQIA causes with a personal mode of address to encourage fan involvement across a variety of platforms. Velour began organising monthly drag review Nightgowns in 2015; the review features Velour performing alongside other drag artists, with a percentage of ticket sales donated to New York based LGBTQIA charities such as the Ali Forney Centre, and the Sylvia Riviera Law Resource. As someone who has risen to mainstream recognition from a position of renown in the LGBTQIA community, Velour has been vocal about her core value of advocacy for the community, rather than personal fame alone:

> I think the phenomenon of drag performers helping each other succeed as a community is far more significant historically, and it's way more interesting to me personally! ... I think I'm in a unique position where I can make positive change for many different people in the industry, and I want to do everything I can (Velour, quoted in Damshenas 2019a, p. 56).

In addition to advocacy for the queer community, Velour's onstage performances inspire the affective engagement of fans central to the popularity of other *RPDR* alumni such as Trixie Mattel and Katya. As Ellcessor observes: 'Online celebrity activism can act as connective tissue, reinforcing an "authentic" (cohesive) set of core values and disseminating them both via social media and through on – and off-line ventures' (2018, p. 264). Velour's activism can be viewed as both connective tissue, and 'revolutionary force' when coupled with her charismatic drag performances and high fashion looks. Velour has been recognised for her style, and has begun to appear in mainstream fashion publications such as *Vogue, Teen Vogue* and *Turkish Vogue*. She also curated fashion brand Open Ceremony's SS 2019 parade for New York Fashion Week, and starred as the face of Swatch's new 'Glam' watch range (Zane 2018). In forums such as the Teen Vogue Summit (Bergado 2018) and the annual 'Long Conversation' event at the Smithsonian, Velour uses her platform as a fashion icon to advocate for LGBTQIA causes. The fannish affect inspired by Velour can be observed across her social media platforms. She has one of the largest followings of past *RPDR* alumni on Instagram, at 1.6 million,[5] and appears to use Twitter to personally engage fans. Fan affect is not limited to 'ordinary fans', with U.S.

Senator Alexandria Ocasio-Cortez filmed 'fangirling' over Velour at a November 2019 meet and greet for Smoke and Mirrors in Washington D.C. (Dommu 2019). Velour gains a wide audience for her art/activist drag based in part upon her charisma encompassing 'star magic' and leadership, performed across multiple platforms. Despite RuPaul's frequent assertions that drag can 'never' be mainstream (Bernhardt 2018) it is clear that *RPDR* alumni now have a wide reach across media platforms – and the need to demonstrate the uniqueness of their brand and maintain fan interest is vital.

Uniqueness

'I'm committed to being uniquely Sasha, all the time' (S9, E1).

Reality television programmes such as *RPDR* place an emphasis on individuality; yet celebrity relies upon convincing audiences that stars are unique and special, but simultaneously ordinary and 'just like us'. The success of reality TV personalities depends on 'authentic' performances of individuality, which audiences read as contestants 'just being themselves' (Bennett and Holmes 2010). However in a competitive environment like *RPDR*, there is constant struggle to balance the impression of 'realness' with success, and to satisfy fans (Richards 2019). Recent fan favourites such as Vanessa 'Vanjie' Mateo (Season 10 and 11) show that fan desires (particularly in terms of 'talent' and 'authenticity') are complex and challenging to assess. Although Vanjie was eliminated in S10, E1, her seemingly 'authentic', 'unplanned' exit performance combining bravado and humour became a memeable viral sensation – resulting in her return for Season 11. Authenticity may appear at odds with a drag reality show emphasising performance; however as the popularity of the show has increased, fans have been quick to 'call out' queens seen to be inconsistent or hypocritical, such as Season 11's Silky Nutmeg Ganache[6] (Damshenas 2019b). Bennett and Holmes (2010, p. 66) maintain that:

> Canonical conceptions of television fame famously emphasise how the medium's rhetoric of familiarity and intimacy, and the domestic contexts of its reception … [create] "the personality effect". Such paradigms pivot on the notion of television fostering a close identification between persona and role – thus giving the impression that the TV personality is just being 'themselves'.

While 'being yourself' is officially encouraged within *RPDR*, contestants are also warned to 'stand out', particularly in challenges based on promoting their personal brand. In post *RPDR* interviews, Velour revealed that: 'I really wasn't sure I was a good fit for them …. I thought *Drag Race* was all about having a specific type of personality that I don't really think I have' (Spanos 2018).

During the early episodes of Season 9, Velour struggled to portray her drag persona in a way that was accessible to fans, yet unique enough to distinguish her from other contestants. Nevertheless, she performed well in the early challenges, landing in the 'safe' zone, until her breakthrough impersonation of Marlene Dietrich in E6, The Snatch Game. The Snatch Game involves the queens taking on yet another persona, by imitating a celebrity, and answering an array of questions in character. In conversation with Ru, Velour admitted she found comedy gruelling, as she is known for her intellectualism rather than her jokes. Her selection of Dietrich (over her first choice, Judith Butler) was praised as both a witty portrayal, and brave choice, as the judges speculated a younger

audience was (perhaps) unfamiliar with Dietrich. Despite the selection of Dietrich, a classic queer icon, Velour's character switch from Butler may also be read as a compromise. By modifying her academic credentials, and selecting Dietrich over Butler, Velour becomes more palatable to a mainstream television audience – - while still 'just being herself' (Malice 2017). As van Krieken (2018, p. n.p.) argues, individuality is central to 'the allocation and distribution of esteem and regard' that shapes the 'structure and dynamics of celebrity society'. Velour's participation in the competition was marked by her efforts to represent her unique persona outside of the mandated pop stardom template described by Vesey (2017), and articulate difference on the runway by merging punk, glamour, and art.

Velour's uniqueness as a contestant involved bending the challenges to her brand of drag, combining 'art and smarts'. Rather than race, or appearance, Velour's intellectual, artful drag was framed as potentially unpalatable to a wider audience (Nett 2017). Brusselaers (2017) also questions whether high art and drag can co-exist (at least on reality television), given the competing discourses of high (art) and low (drag/reality TV) culture. Velour's warm reception from the other queens, and the audience, provides a contrast to Brusselaers' case study of season 5's maligned art queen, Serena ChaCha. Despite appearing in just two episodes in season 5, ChaCha earned a reputation for elitist snobbery due to her incessant discussion of art school and its influence on her drag performance. Her famous parting line: 'To the other queens: pick up a book and go read' (Brusselaers, 2017, p. 49) summarised her conflict with the other competitors. Cha Cha's desire to 'elevate' drag isolated her from the other contestants for her perceived elitism and failure to participate in the camp rituals of the show (Brusselaers, 2017, p. 56). Brusselaers concludes that ChaCha's appearance ' ... depicts drag's backlash against accepted arts, and therefore against their respectability and legitimacy' (2017, p. 57). While Velour's similarly legitimised 'high art' background had the potential to alienate her peers and fans, this was negated by workroom discussions with her peers emphasising the vitality of drag community, and knowledge of queer history:

> I think I come off a little bit fancy because I try to write an essay every time I speak. It's ingrained, I'm the child of professors. ... But I believe that all drag is really important and needs to be uplifted – even and especially varieties that aren't featured on the show. I didn't come in with an attitude of superiority or even performative artistic superiority. The challenge was for people not to assume that I do, because of the way that I look and the way that I talk. I think they learned very quickly that I can be a support system (Velour in Malice 2017).

Throughout Season 9, Velour expresses her drag persona through her on stage performance, but also in moments of 'confessional address' (Redmond 2008) in the workroom, where she discussed her struggle with anorexia, and the prevalence of eating disorders in the queer community (S9, E4 & 5). These moments characterise the embodiment of celebrity, where: 'The body becomes the medium through which messages about identity are transmitted' (Benson 1997, 123 in Redmond 2019, p. 109). Velour deployed her unique embodiment of identity and gender performance at moments when they would create maximum impact; her rose petal moment in the Finale episode merging gender performance and a unique interpretation of Houston's song (Moylan 2017) designed to captivate the audience.

Velour's advocacy for transgender inclusion in the drag community, and fundraising for LGBTQIA charities in New York, have been at the forefront of her celebrity image post *RPDR* – alongside other alumni activists such as Bob the Drag Queen. The alignment of her persona with 'selling' a cause, rather than her just own persona and associated products suggests a continued performance of authenticity. As Redmond (2019, p. 87) contends, representations of celebrity are the mode in which ordinary citizens understand their place in the world. This is seen in celebrity endorsements of ' … a range of products, services, and industries that migrate way beyond related enterprises, so that people's consumption and ritualistic lifestyles are inextricably bound up with celebrity'. Fan support for celebrity philanthropy can be mobilised in the same way as celebrity endorsement of a product; the authenticity of the performer is essential. As Jerslev (original emphasis, 2014, p. 175) contends, celebrity philanthropy, is often assumed by audiences to be: 'a media strategy aim[ed] at *impression management* … '. To advocate for causes as part of one's celebrity image requires dedication, given the frequent assumption of insincerity. Further:

> … celebrity do-gooding is basically one way of producing and reproducing celebrity, an instrument for distinction, a means of developing symbolic capital, a means of solidifying the fan base, a means for the continuous reproduction of a sellable, likeable persona. … celebrity goodwill and charity is in many ways risky business as it challenges one of the core parameters in the construction of the celebrity persona – authenticity (Jerslev 2014, p. 175).

Velour's benevolent acts were a central feature of her persona prior to her performance on *RPDR* (Nett 2017); thus suggesting their authenticity. Like Lady Gaga, whose charitable causes and online calls to action are integral to her persona (Bennett 2014), Velour also uses social media to connect with fans and encourage philanthropy. Ellcessor (2018) contends that the effectiveness of social media activism is dependent on the centrality of a celebrity's 'core values' to their persona.

> … connected celebrity activism is a matter of ongoing, seemingly authentic, technologically-facilitated performances that forge connections between a celebrity's persona, projects, interactions, causes, and activist organizations. No longer a distinct enterprise, activism can now effectively structure a star text, acting as a core value through which that celebrity is made culturally meaningful, and knitting together disparate facets of a celebrity's persona and activity (Ellcessor 2018, p. 256).

As I have argued elsewhere (Middlemost, 2019 forthcoming) the power of Velour's activism appears to be more than a cleverly constructed celebrity persona – it is: ' … a politics that employs symbols and associations; a politics that tells good stories' (Duncombe 2007, p. 9). Velour is able to tell good stories by combining her politics with personal narrative, and artistic performance. The intimate address used in her live performance creates a connection with the audience, and allows Velour to direct fans to specific causes in a way that seems authentic to her 'real' self: 'I had a sense of the role that my drag played in my local community, but the biggest challenge was figuring out where I fit on a global scale. I discovered [through winning *RPDR*] that my drag really does speak to people on an emotional level' (Velour, in Nichols 2017).

The final section of this paper considers the specific characterisation of celebrity performed by the queens who have succeeded outside of *RPDR*, and questions how distinction between celebrities might be understood.

Distinctly unique?

'As much as I enjoy trying to define Sasha Velour day to day, in a sense her entire purpose in my life is to remain indefinable ... an ongoing and evolving project, a reminder that reinvention is always possible' (Velour, quoted in Damshenas, 2019a, p. 56).

Throughout this article, I have drawn inspiration from RuPaul's essential virtues of charisma and uniqueness to unpack the post *RPDR* success of Sasha Velour. This section will suggest that a further category – distinction – may assist in reading Velour's celebrity persona, and theorising how she, and other popular *RPDR* alumni distinguish themselves.

Pierre Bourdieu's (1984) *Distinction* offers a framework for interpreting the distinctiveness of individual celebrity personas. Bourdieu outlines three types of capital (economic; cultural; and social) which can be applied to celebrity: 'Social subjects ... distinguish themselves by the distinctions they make ... The science of taste and of cultural consumption begins with a transgression that is in no way aesthetic: it has to abolish the sacred frontier which makes legitimate culture a separate universe' (xxix). Velour combines the 'legitimate culture' of fine art practice with her aim to abolish barriers to participation in drag performance. This merger is realised in her one-woman show 'Smoke and Mirrors', which has been staged in Australia, New Zealand, across the U.S. and Canada, and the U.K. in 2019. Smoke and Mirrors draws on personal narrative, illustrated with art projection – a technique that Velour developed prior to her performance on *RPDR*. Velour contends that:

> ... as an adult I've turned to drag more to deal with real sadness at times, with real suffering, and then translate it through all the glamour and glitter into something that is empowering for me. There were times when coming up with drag performances were the only thing that gave me optimism. ... That's why people connect with drag on such a personal level: it's all that darkness turned into power (Bromwich 2017).

The images of emotional and intellectual power embodied by Velour and reflected in her drag performance suggest star 'magic' that can speak to a number of marginalised groups: ' ... projected through sheer will and talent and charisma, images of emotional and intellectual power' (Dyer 1998, p. 16). By merging art practice with personal (star) power and using this performance to encourage audiences to connect with her activist values, Velour attempts to distinguish herself from other *RPDR* alumni.

Beyond Bourdieu's work on distinction, there has been little research that considers how celebrities distinguish themselves, and their unique brands, from other celebrities. Persona and the issue of celebrity brand distinction requires further analysis that is beyond the scope of this article. As a starting point, I turn to Reeves (1961) marketing concept – the 'Unique Selling Proposition' (USP) to connect uniqueness with the performance of a distinctive celebrity brand. Reeves' stresses the centrality of a USP to consumer products, which may be applied to celebrity persona, branding, and authenticity. The USP can be considered central to celebrity drag persona, as it distinguishes the celebrity performing (and selling) two distinct personas. The USP

emphasises the necessity of creating a 'meaningful way' (Niu and Wang 2016) to stand out when advertising a product, and to offer consumers (fans) something which other products (celebrities) do not. As Niu and Wang assert, Reeves' concept shares the same intangibility as other depictions of 'uniqueness'. Instead they propose a Revised USP (RUSP), which can 'be supported by either rational appeals or emotional appeals to elicit positive consumer feelings' (Niu and Wang 2016, p. 876). Velour's USP centres on her performance of art/drag, coupled with advocacy for the LGBTQIA community – an 'emotional appeal' to foster a feeling of inclusion amongst fans, and distinguish herself as a product/persona. Velour has reflected upon authenticity and celebrity/drag persona while promoting Smoke and Mirrors, which she claims is both an artistic expression, and about 'just being herself':

> I wanted to be so much more honest in this show that it definitely felt like new terrain. … I wanted to give an introduction to me, on my own terms because most people have an introduction to me through a reality show. I wanted to really share with people for the first time (Tirado 2019)

By using an 'intimate register' (Barbour *et al.* 2015) during the Smoke and Mirrors shows, Velour uses her personal narrative to connect with, and mobilise fans towards philanthropic causes – a technique applied by many *RPDR* fan favourites, such as Jinkx Monsoon. Of celebrity brands, van Elven (2018, p. n.p.) has stated: 'The only thing that is unique about your brand is your story. You can make a distinct product, but at the end of the day, it's the story that sells'. Velour's story coupled with the consistent performance of her drag art and activist values allows fans to believe there is a 'genuine', 'authentic' connection between Velour and the causes she advocates.

Velour has also distinguished herself from RuPaul (and by association *RPDR*) by consistently advocating for the transgender community. She has repudiated RuPaul's remarks on a number of occasions, and publicly acknowledged the central role of transgender individuals in drag and LGBTQIA culture (see Velour, in Weaver 2018). Advocacy and activism is a central theme of Velour's Smoke and Mirrors performance where she discusses her desire to champion the trans community, the construct of gender, and her relationship with unexpected drag inspirations, such as Nosferatu (Velour 2019). These moments suggest a transgression, an abolition of the restrictions of 'legitimate' culture – and a move towards a rearticulated drag performance that merges modern art practice (digital art projection), and inclusive politics.

Finally, Velour's distinctive brand is evident in her activity across media platforms; she is a transmedia queen whose reach extends across stage performance (Nightgowns, Smoke and Mirrors); social media channels; art (her commissioned Google Doodle of Marlene Dietrich was featured on Dietrich's birthday); print media (*Velour* magazine); music/music video (*C.L.A.T* performed with Aja, Alexis Michelle, and Peppermint); television (cameo appearances on *Broad City* and *The Bold Type*); and short film (*Pirate Jenny*). In July 2019 Velour announced that she would be producing an eight-part short series of Nightgowns for new streaming service Quibi,[7]to launch in April 2020; thus, giving Nightgowns an international reach. Velour described the series as 'part behind-the-scenes documentary, part lip-sync extravaganza' (Daw 2019, p. n.p.). Velour's Nightgowns series will be screened alongside productions from Jennifer Lopez, Stephen Spielberg, and Chrissy Teigen (amongst others), and will almost certainly expand her profile.

The rapid ascent of Sasha Velour post *RPDR* can be attributed to her unique drag and activist persona, and her transmedia profile. Central to the commercialisation of her endeavours has been the consistent alignment of her celebrity persona with art and activism. While further research is needed to comprehensively analyse how celebrities distinguish themselves, Velour is distinguished by her unique combination of charismatic persona; artistic expression; and activism which she performs as a consistent brand across transmedia platforms.

Conclusion

'*Smoke & Mirrors* is about "illusions," sure, but sometimes illusions are just tools to understand and cope with reality, to uncover the truth of who we are, or to bring some of our dreams into the spotlight.' (Velour in Nolfi 2019).

This article has mapped the career trajectory of Sasha Velour, and her efforts to create positive change for the LGBTQIA community by bringing her unique brand of art and activism to an active, and increasingly, mainstream audience. Drawing inspiration from RuPaul's virtues of charisma and uniqueness, I have argued that Velour manifests these qualities as part of her drag persona, across a variety of transmedia platforms. In particular, Velour's embodiment of a seemingly authentic celebrity persona encourages fans to form an affective connection with her, which can be directed towards charitable causes (Bennett 2014). Velour's acknowledgement of the illusion required to perform both drag and celebrity exposes the complexity of performing celebrity across multiple platforms, while convincing fans she is 'just being herself'.

The timing of Velour's appearance on *RPDR*, coupled with the toxic contemporary political environment is significant. As Eisenstadt (1968) suggests, it is during times of political upheaval that ordinary citizens turn to charismatic leaders to inspire feelings of hope for the future. This is a possibility that Velour imagines for herself and her audience via digital art and drag performance, as seen in her touring show, Smoke and Mirrors. An analysis of charisma and uniqueness as part of a cohesive brand have framed the complicated, and fluid nature of contemporary drag celebrity that Velour embodies. The use of Bourdieu's *Distinction* is intended to extend current readings of celebrity 'uniqueness', and account for Velour's career beyond *RPDR* which engages with politics and activism significant to the queer community. While Sasha Velour describes herself as 'a little strange, and a little weird', her success across art, fashion, and activism reflect her growing status as an emerging transmedia drag icon beyond the boundaries of *RPDR*.

Notes

1. 11 'main' series (at June 2019); plus 4 seasons of *RPDR All Stars* (Season 4 of *All Stars* controversially crowned 2 winners).
2. I have used the feminine she/her pronoun for Velour throughout, as she has specified this as her preference (Velour 2017). I have also used the feminine pronoun for RuPaul for consistency.
3. In addition to previously mentioned spin off series such as *RPDR: All Stars*, and *Drag U, Drag Race Thailand* premiered in 2018, with the premiere of *RPDR: UK* in October 2019, and Canadian, Australian, and Celebrity *Drag Race* announced for 2020 (Bond 2019).

4. Alyssa Edwards (S5; AS2) was famously accused relying on her personality to balance a lack lustre performance by fellow contestant Phi Phi O'Hara in episode 4 of *RPDR: All Stars 2*. In a subsequent episode, judge Carson Kressley also remarks that Edwards just needs to 'make a face' to win him over, much to the displeasure of the other remaining contestants.
5. In comparison to past winners and fan favourites Sharon Needles (1 million followers); Courtney Act (1.2 million); Shangela (1.3 million); Vanjie (1.3 million); Aquaria (1.5 million); Alaska (1.6 million); Katya (1.7 million); Trixie Mattel (1.8 million); Adore Delano (1.9 million); and Bianca Del Rio (2 million).
6. Despite the negative fan response to Ganache, she insists she was just 'being herself'; and her 'authentic self' at various turns. She seemingly 'blames the edit': 'Unfortunately a lot of the moments made it seem that I was shady ... a lot of that came across as me being hateful' (Damshenas 2019b).
7. Quibi ('quick bites') is described by CEO Jeffrey Katzenberg as 'premium, episodic content optimised for pocket-sized screens'; but definitely 'not a substitute or competitor for television' (Sperling 2019).

Disclosure statement

No potential conflict of interest was reported by the author.

References

Associated Press, 2017. *RuPaul's Drag Race* keeps focus on Art, not its impact. *NBC news*. Available from: https://www.nbcnews.com/feature/nbc-out/rupaul-s-drag-race-keeps-focus-art-not-its-impact-n795901 [Accessed 20 April 2019].

Bailey, F., and Barbato, R. (Producers). (2009). RuPaul's Drag Race [Television series]. U.S.A.: Logo TV, Viacom Media Networks

Barbour, K., *et al.*, 2015. Registers of performance: negotiating the professional, personal, and intimate in online persona creation. *In*: E. Thorsen, ed. *Media, margins, and popular culture*. Basingstoke: Palgrave Macmillan, 57–69.

Barsamian, E., 2017. Sasha Velour from *RuPaul's Drag Race* on her style icons and how to be a queen. *Vogue*. Available from: https://www.vogue.com/article/sasha-velour-rupaul-drag-race-karl-lagerfeld-celebrity-style [Accessed 1 Nov 2017].

Bennett, J. and Holmes, S., 2010. The "place" of television in celebrity studies. *Celebrity studies*, 1 (1), 65–80. doi:10.1080/19392390903519073

Bennett, L., 2014. "If we stick together we can do anything": lady Gaga fandom, philanthropy and activism through social media. *Celebrity studies*, 5 (1–2), 138–152. doi:10.1080/19392397.2013.813778

Bergado, G., 2018. Sasha Velour on dressing like queer royalty and how youth can learn about LGBTQ history. *Teen Vogue*. Available from: https://www.teenvogue.com/story/sasha-velour-queer-royalty [Accessed 24 May 2019].

Bernhardt, J., 2018. *RuPaul's Drag Race* is subverting our ideas of mainstream TV. *The Guardian*. Available from: https://www.theguardian.com/commentisfree/2018/feb/08/rupauls-drag-race-subverting-mainstream-tv-lady-gaga [Accessed 15 Apr 2019].

Bond, N., 2019. Hit reality show *RuPauls drag race* coming to Australia. *News.com.au*. Available from: https://www.news.com.au/entertainment/tv/reality-tv/hit-reality-show-rupauls-drag-race-coming-to-australia/news-story/104ef5d0b27dcc82ebed8bd30580da1b [Accessed 9 Sep 2019].

Bourdieu, P., 1984. *Distinction: a social critique of the judgement of taste*. Cambridge, MA: Harvard University Press.

Brennan, N., 2017. Contradictions between the subversive and the mainstream: drag cultures and *RuPaul's Drag Race*. *In*: N. Brennan and D. Gudelunas, eds. *RuPaul's Drag Race and the shifting visibility of drag culture: the boundaries of reality TV*. Cham: Palgrave Macmillan, 29–44.

Bromwich, K., 2017. Sasha Velour: 'drag is darkness turned into power'. *The Guardian*. Available from: https://www.theguardian.com/tv-and-radio/2017/oct/29/sasha-velour-drag-is-darkness-turned-into-power-rupaul-drag-race-interview [Accessed 30 Oct 2017].

Brusselaers, D. (2017) '"pick up a book and go read": art and legitimacy in rupaul's drag race', in Brennan, N. and Gudelunas, D. (eds) RuPaul's Drag Race and the Shifting Visibility of Drag Culture: The Boundaries of Reality TV. Palgrave Macmillan, pp. 45–59. doi:10.1007/978-3-319-50618-0_4.

Cocker, H.L. and Cronin, J., 2017. Charismatic authority and the YouTuber: unpacking the new cults of personality. *Marketing theory*, 17 (4), 455–472. doi:10.1177/1470593117692022

Cooper, B., 2018. *A star is born*. USA: Warner Brothers.

Damshenas, S. (2019a) 'Sasha Velour in conversation with Alok Vaid-Menon', *Gay Times*, pp. 50–57.

Damshenas, S., 2019b. Silky Nutmeg Ganache reveals the abuse she's received since drag race. *Gay Times*. Available from: https://www.gaytimes.co.uk/culture/126510/silky-nutmeg-ganache-reveals-the-abuse-shes-received-since-drag-race/ [Accessed 6 Sep 2019].

Daw, S., 2019. Sasha Velour announces nightgowns docu-series on Quibi. *Billboard*. Available from: https://www.billboard.com/articles/news/pride/8524220/sasha-velour-nightgowns-docu-series-quibi [Accessed 12 Aug 2019].

Deller, R.A., 2016. Star image, celebrity reality television and the fame cycle. *Celebrity studies*, Routledge, 7 (3), 373–389. doi:10.1080/19392397.2015.1133313

Dommu, R., 2019. Watch drag superfan Alexandria Ocasio-Cortez Meet Sasha Velour. *Out*, p. n.p. Available from: https://www.out.com/drag/2019/11/12/watch-drag-superfan-alexandria-ocasio-cortez-meet-sasha-velour [Accessed 20 Nov 2019].

Duncombe, S., 2007. *Dream: re-imagining progressive politics in an age of fantasy*. New York: New Press.

Dyer, R., 1991. *A star is born* and the construction of authenticity. *In*: C. Gledhill, ed. *Stardom: industry of desire*. Oxon: Routledge, 132–140.

Dyer, R., 1998. *Stars*. London: British Film Institute.

Eisenstadt, S.N. (Ed)., 1968. Introduction. *In*: *On charisma and institution building*. Chicago: University of Chicago Press, pp. ix–2.

Ellcessor, E., 2018. "One tweet to make so much noise": connected celebrity activism in the case of Marlee Matlin. *New media and society*, 20 (1), 255–271. doi:10.1177/1461444816661551

Greenhalgh, E., 2018. "Darkness turned into power": drag as resistance in the era of Trumpian reversal. *Queer studies in media & popular culture*, 3 (3), 299–319. doi:10.1386/qsmpc.3.3.299_1

Gudelunas, D., 2016. Culture jamming (and tucking): *RuPaul's Drag Race* and unconventional reality. *Queer studies in media & popular culture*, 1 (2), 231–249. doi:10.1386/qsmpc.1.2.231_1

Gudelunas, D., 2017. Digital Extensions, experiential extensions and hair extensions: *RuPaul's Drag Race* and the new media environment. In Brennan, N. and Gudelunas, D. (eds) *RuPaul's Drag Race and the shifting visibility of drag culture: the boundaries of reality TV*. Cham: Palgrave Macmillan, 231–244.

Hawkins, K., 2017. The *'RuPaul's Drag Race'* season 9 cast is filled with some of the most talented queens the show has ever seen. *Bustle*. Available from: https://www.bustle.com/p/the-rupauls-drag-race-season-9-cast-is-filled-with-some-of-the-most-talented-queens-the-show-has-ever-seen-46587 [Accessed 18 Apr 2019].

Hendriks, E.C., 2017. Breaking away from charisma? The celebrity industry's contradictory connection to charismatic authority. *Communication theory*, 27 (4), 347–366. doi:10.1111/comt.12120

Hobson, J., 2017. Sasha Velour on why drag is a political and historical art form. *wbur*. Available from: https://www.wbur.org/hereandnow/2017/07/24/sasha-velour [Accessed 27 Feb 2019].

Holmes, S., 2005. Starring ... Dyer? Revisiting star studies and contemporary celebrity culture. *Westminster papers in communication and culture*, 2 (2), 6–21. doi:10.16997/wpcc.18

Holmes, S., 2006. It's a jungle out there!: playing the game of fame in celebrity reality TV. *Framing celebrity: new directions in celebrity culture*. doi:10.4324/9780203715406

Holmes, S., 2010. Dreaming a dream: Susan Boyle and celebrity culture. *The Velvet light trap*, 65 (1), 74–76. doi:10.1353/vlt.0.0079

Jenkins, S.T., 2017. Spicy. exotic. Creature. representations of racial and ethnic minorities on *RuPaul's Drag Race. In*: N. Brennan and D. Gudelunas, eds.. *RuPaul's Drag Race and the shifting visibility of drag culture: the boundaries of reality TV*. Cham: Palgrave Macmillan, 77–90.

Jerslev, A., 2014. Celebrification, authenticity, gossip: the celebrity humanitarian. *Nordicom review*, 35 (Special Issue), 171–186. doi:10.2478/nor-2014-0111

LeBesco, K., 2004. Got to be real: mediating gayness on *survivor. In*: L. Ouellette and S. Murray, eds. *Reality TV: remaking television culture*. New York: New York University Press, 271–287.

Malice, M., 2017. Sasha (Is) fierce: *RuPaul's Drag Race star* velour on being a professional queen. *Observer*. Available from: https://observer.com/2017/03/sasha-velour-rupauls-drag-race-interview-logo/[Accessed 12 Oct 2017].

Marshall, P.D., 2014. *Celebrity and power: fame in contemporary culture*. 2nd ed. Minneapolis: University of Minnesota Press.

McIntyre, J. and Riggs, D.W., 2017. North American Universalism in *RuPaul's Drag Race*: stereotypes, linguicism, and the construction of "puerto rican queens". *In*: N. Brennan and D. Gudelunas, eds. *RuPaul's Drag Race and the shifting visibility of drag culture: the boundaries of reality TV*. Cham: Palgrave Macmillan, 61–76.

Megarry, D., 2017. *RuPaul's Drag Race* smashes ratings records with season 9 premiere. *Gay Times*. Available from: https://www.gaytimes.co.uk/culture/67053/rupauls-drag-race-smashes-ratings-record-season-9-premiere/ [Accessed 22 Apr 2019].

Middlemost, R., 2019. "Serving activist realness": the new drag superstars and activism under trump. *In*: M. D'Silva and A. Atay, eds.. *Intercultural communication, identity, and social movements in the digital age*. London: Routledge.pp. 48-65.

Moylan, B., 2017. Sasha Velour reveals what really went down on the *drag race* finale. *Vice*. Available from: https://www.vice.com/en_us/article/ywzyay/sasha-velour-reveals-what-really-went-down-on-the-drag-race-finale [Accessed 1 Jul 2019].

Nett, D., 2017. *RuPaul's Drag Race* winner Sasha Velour cut from a different fabric. *wbur*. Available from: https://www.wbur.org/npr/534313492/rupauls-drag-race-winner-sasha-velour-cut-from -a-different-fabric [Accessed 27 Feb 2019].

Nichols, J.M., 2017. Sasha Velour: A thoughful, intellectual queen for the new era of *drag race. Huffington Post*. Available from: https://www.huffingtonpost.com.au/entry/sasha-velour-new-era -drag-race_n_5952b42fe4b05c37bb7a145b [Accessed 1 Nov 2017].

Niu, Y. and Wang, C.L., 2016. Revised unique selling proposition: scale development, validation, and application. *Journal of promotion management*, 22 (6), 874–896. doi:10.1080/10496491.2016.1214209

Nolfi, J., 2019. *RuPaul's Drag Race's* Sasha Velour reveals smoke and mirror tour dates. *Entertainment Weekly*. Available from: https://ew.com/theater/2019/09/04/sasha-velour-smoke-mirrors-tour-dates/ [Accessed 21 Oct 2019].

O'Halloran, K., 2017. *RuPaul's Drag Race* and the reconceptualisation of queer communities and publics. *In*: N. Brennan and D. Gudelunas, eds. *RuPaul's Drag Race and the shifting visibility of drag culture: the boundaries of reality TV*. Cham: Palgrave Macmillan, 213–227.

Press, Associated (2017) RuPaul's Drag Race keeps focus on Art, not its impact (2017) NBC News. Available at: https://www.nbcnews.com/feature/nbc-out/rupaul-s-drag-race-keeps-focus-art-not-its-impact-n795901 (Accessed: 20 April 2019).

Redmond, S., 2008. Pieces of me: celebrity confessional carnality. *Social semiotics*, 18 (2), 149–161. doi:10.1080/10350330802002192

Redmond, S., 2019. *Celebrity*. Oxon: Routledge.

Reeves, R., 1961. *Reality in advertising. Widener classics*. doi:10.2307/1318113

Richards, J., 2019. Toxic *RuPaul's Drag Race* fans are in danger of ruining the show for everyone. *Junkee*. Available from: https://junkee.com/rupauls-drag-race-toxic-fans/189494 [Accessed 25 Feb 2019].

RuPaul, 2018 Mar 6. Available from: https://twitter.com/rupaul/status/970810822413795328?lang=en [Accessed 28 Aug 2019].

Selva, D., 2016. Social television: audience and political engagement. *Television & new media*, 17 (2), 159–173. doi:10.1177/1527476415616192

Sim, B., 2018. 10 casting decisions that hurt *RuPaul's Drag Race* (and 10 that saved it). *ScreenRant*. Available from: https://screenrant.com/rupauls-drag-race-casting-decisions/ [Accessed 10 May 2019].

Spanos, B., 2018. Sasha Velour meets world: *drag Race* winner talks life before and after Ru. *Rolling Stone*. Available from: https://www.rollingstone.com/culture/culture-features/rpdr-rupauls-drag-race-sasha-velour-drag-queen-nightgowns-744535/ [Accessed 15 Jan 2019].

Sperling, N., 2019. What is Jeffrey Katzenberg's Quibi all about, and why should you care? *Vanity Fair*. Available from: https://www.vanityfair.com/hollywood/2019/06/quibi-jeffrey-katzenberg-streaming-platform-interview [Accessed 12 Aug 2019].

The Council for Global Equality, 2019. *The facts on LGBT rights in Russia*. Available from: http://www.globalequality.org/component/content/article/1-in-the-news/186-the-facts-on-lgbt-rights-in-russia [Accessed 25 May 2019].

Tirado, F., 2019. Sasha Velour's new solo show is a homage to her gender fluidity. *Out*. Available from: https://www.out.com/drag/2019/4/03/sasha-velours-new-solo-show-homage-her-gender-fluidity [Accessed 10 April 2019].

van Elven, M., 2018.*Why does Rihanna's fashion outsell other celebrity collections?* Available from: https://fashionunited.uk/news/fashion/why-does-rihanna-s-fashion-outsell-other-celebrity-collections/2018062930478 [Accessed 16 Oct 2019].

van Krieken, R., 2018. *Celebrity society: the struggle for attention*. London: Routledge. Available from: https://books.google.com.au/books?id=HAF-DwAAQBAJ&pg=PT42&dq=celebrity+individuality&source=gbs_toc_r&cad=3#v=onepage&q=celebrity individuality&f=false

Van Leeuwen, T., 2001. What is authenticity? *Discourse studies*, 3 (4), 392–397. doi:10.1177/1461445601003004003

Velour, S., 2017 April 5. Available from: https://twitter.com/sasha_velour/status/849764817783095296?lang=en [Accessed 17 Jan 2019].

Velour, S., 2019. *Smoke and mirrors*. Sydney, Australia.

Vesey, A. (2017) ' "a way to sell your records": pop stardom and the politics of drag professionalization on rupaul's drag race: Pop Stardom and the Politics of Drag Professionalization on RuPaul's Drag Race', Television and New Media, 18(7), pp. 589–604. doi:10.1177/1527476416680889

Weaver, H., 2018. *Drag Race* winner Sasha Velour is not done addressing those RuPaul comments. *Vanity Fair*. Available from: https://www.vanityfair.com/style/2018/03/drag-race-winner-sasha-velour-addresses-rupaul-comments-at-nightgowns-show [Accessed 27 Feb 2019].

Weber, M., 1968. *On charisma and institution building*. S. Eisenstadt, Edited by. Chicago: University of Chicago Press.

Weber, M. (1968) *On charisma and institution building*. Edited by S. Eisenstadt. Chicago: University of Chicago Press.

Zane, Z., (2018. Swatch Gets a 'Glam' Makeover with Sasha Velour. *Out*. Available from: https://www.out.com/popnography/2018/11/06/swatch-gets-glam-makeover-sasha-velour [Accessed 3 Jan 2019].

'Labouring in the image': celebrity, femininity, and the fully commodified self in the drag of Willam Belli

Rachel O'Connell

ABSTRACT

This essay explores the mediagenic drag style of Willam Belli, a contestant from Season 4 of Ru Paul's Drag Race (2012) and a YouTube performer, as a set of reflections on navigating the 'demotic turn' (Graeme Turner) in contemporary celebrity. I propose that Willam's drag foregrounds the work (labour) and working conditions that lie behind the 'werq' on *Drag Race*. His drag both exemplifies and comments upon the feminised 'labour of visibility' (Brooke Erin Duffy's concept) and practices of self-commodification that the contemporary attention economy demands, particularly of girls, women, and feminine/femme/feminised subjects. Taking up Judith Butler's (1990) suggestion that drag reveals the processes by which gendered identities are constructed, I argue that Willam's drag seems to reveal how the 'labour of visibility' is currently constructing contemporary femininities. His output constitutes an embedded, enmeshed, and complicit commentary on the construction of a commodified, hypersexualised version of femininity in the contemporary economies of reality television, social media, and digital self-entrepreneurship.

[Reality television participants] labour *as* the image of their insecure selves *for* an image, or viable self-brand. They also labour *in* the image, inside the precarious and unstable world of reality television production.

Alison Hearn, "Insecure: Narratives and Economies of the Branded Self in Transformation Television" (p. 502)

Unscripted television is really just a springboard for whatever you want to brand yourself as. Most people figuratively jump off that springboard and are like, 'Ooooh, this water is lovely' and float up to the pool bar. If I were lifeguarding, I'd yell, 'Do laps, bitch. *Swim*. It's time to work.'

Willam Belli, *Suck Less: Where There's a Willam, There's a Way* (p. 52).

Introduction: celebrity's demotic turn and the labour of visibility

Willam Belli, a contestant on Season 4 of *RuPaul's Drag Race* (2012), introduces himself, in the first episode of his season, with the statement, 'I'm an actor. I've done TV, I've done film … I'm a successful drag queen and not some bitch who has to show for a dollar.'[1] This

statement immediately opens up questions of professional status in the entertainment industry and is haunted by anxieties about fame, remuneration, and precarity.[2] It foregrounds the work (labour) that lies behind the 'werq' on *Drag Race*. Following Willam's cue, I explore this theme in this essay. Media scholar Alison Hearn's statement quoted above conjures the idea of an image displayed on a television or computer screen. Within the frame of the screen, the people pictured are struggling and labouring, even if they make what they are doing look nothing like work. They are *labouring in the image*. In this essay I read Willam's drag as an exploration of the way in which contemporary femme/feminine/feminised subjects labour 'in the image,' that is, in the economies of reality television and social media. Judith Butler has argued that drag reveals the processes by which gendered identities are constructed (Butler 1990). I argue here that Willam's drag reveals how a certain feminised 'labour of visibility' (Duffy's coinage; more on this below) is constructing contemporary femininities. Willam's output, I suggest, constitutes an embedded, enmeshed, and complicit commentary on the construction of a commodified, hypersexualised version of white femininity in the current attention economy of social media and digital self-entrepreneurship. His drag reveals how femininities, and feminine/femme subjectivities, are emerging at the nexus of postfeminism, precarity, neoliberalism, and mediation.

Put another way, I read Willam's drag in the context of the 'demotic turn' in celebrity. The 'demotic turn,' as conceptualised by Graeme Turner, describes 'the increasing visibility of the "ordinary person" as they turn themselves into media content through celebrity culture, reality television, DIY websites, talk radio and the like' (2006, p. 153).[3] Importantly, the demotic turn does not constitute a democratisation of celebrity. Rather, Turner argues that it is characterised by a rapid, exploitative 'industrial cycle of use and disposal' of quasi-celebrified individuals who ultimately gain little remuneration or lasting fame. Structurally, the demotic turn is driven by 'the pursuit of profit by large internationalised media conglomerates who ... still control the symbolic economy' (2014, p. 93). While 'positive byproducts' include greater diversity in representation, this diversity seems superficial given the absence of structural change (Turner 2014, p. 92). Similarly, in the realm of digital culture, internet scholar Alice Marwick argues that that 'while social media tools may have opened up spaces of visibility for people outside broadcast media or politics, these opportunities are typically limited, fleeting, and unaccompanied by the financial resources available to the traditionally famous' (2015b, p. 141). Ultimately, then, despite the demotic turn, 'celebrity remains an hierarchical and exclusive phenomenon' (Turner 2014, p. 94).

I read Willam's drag as a performance that comments on the dilemmas of navigating the demotic turn, that is, of navigating the precarious economies, both material and representational, of contemporary reality television and digital culture. The central concept through which I approach Willam's drag is *visibility*. Marwick, in her analysis of self-branding in digital economies, argues that in contemporary society, 'status is predicated on the cultural logic of celebrity, according to which the highest value is given to mediation, visibility and attention' (2015a, p. 14). The attention economy of social media has produced a context in which subjects strive for mediated visibility as an entrepreneurial investment in themselves, under neoliberal conditions of precarity. Moreover, this imperative for visibility weighs in a specific way on girls and women (and, I would add, all feminine/feminised/femme subjects), as scholars such as Shields

Dobson, Banet-Weiser, and Duffy argue. The 'ascension of social media' interlocks seamlessly with 'post-feminist logics of self-branding and entrepreneurialism' that 'recast self-expression and mediated visibility as conduits to female empowerment' (Duffy 2015). Thus the contemporary digital economy becomes the locus of a feminised 'labour of visibility' (Duffy 2015). Like much of the 'free labour' that drives the digital media economy (Terranova 2000), this labour of visibility is largely precarious and uncompensated. Thus, according to Duffy, the labour of visibility is a new form of 'gendered unpaid work' that 'increasingly structures activity in the social media imaginary' (2015). I read Willam's drag *as a performance of the feminised labour of visibility*. His drag, in this sense, seems to be *about mediation* – about reality television, social media, and their central problem of visibility. As such, his performance constitutes an archive of some of the pathologies of both contemporary neoliberalism and postfeminist discourse.

In so being, his drag ultimately becomes an exploration of self-commodification, self-objectification, and abjection. These central themes of Willam's drag are best captured, perhaps, by his identificatory responses to certain abject feminine/femme/feminised subjects in his YouTube video series 'The Beatdown.' In this series, Willam is filmed watching other YouTube videos and commenting on them; this humour format is known as the 'reaction video.' Due to Willam's dedication to 'ironically' phobic humour (more on this below), 'The Beatdown' is at the harsher end of the reaction video spectrum, and Willam has himself described it as 'cyber-bullying' (2016a, p. 223). Interestingly, though, he expresses identification with some of the most abjected subjects that he views. For instance, in 'Beatdown' S3E26 (27 November 2016), he watches reportage footage of a 22-year old woman named Maria Louise Del Rosario, who is naked except for crosses taped over her breasts, getting her butthole tattooed in public at a crowded South Florida Tattoo Expo. Reporter Liz Tracy discusses the spectacle with a woman onlooker; they laugh. Willam takes exception to the exclusivity of these two, less marginal women. He states, 'Oh no, I don't like this. Jill's being a bitch.' (It is unclear here if he means the reporter, whom he has perhaps misnamed, or the woman she is speaking to; or if he is using slang.) He continues, 'Like, I love this girl and she's trash and she's me. But Jill's like, "ha, no." Fuck you, Jill. Don't judge my butt tattoo.' Here Willam identifies with Del Rosario, taking on her tattoo as his own. He further states, 'She's looking for her big break. I see her. I've been her and we have all been her. Need anything else from me for the camera? Oooh [he makes a sexual groan].' Identifying with Del Rosario's struggle for visibility, a struggle that she is waging on the territory of her own body, femininity, and sexuality, Willam seems to reveal here, I would suggest, the kernel of his own drag. His seems to be a drag rooted in identification with the femme/feminine/feminised subjects whom he embodies: *subjects abjected in/by mediation*.

In the first section below I offer some context about Willam's drag and career. I then explore, in the second section, Willam's exposés of exploitative production practices in reality television and consider how, in his performances and commentaries, the sexual positionality of the 'bottom' becomes a figuration of the precarious predicament of the reality television participant. In my third section, I discuss Willam's exploration of femininity, showing how we can trace, in his work, the ways in which the precarities of mediation and digital culture are generating new, hyper-sexualised and hyper-commodified, femininities and femme/feminine subjectivities. In my final section, I consider some of the implications of Willam's performance of a commodified, self-

objectified femininity through Ros Gill's (2007) frame of 'sexual subjectification,' suggesting that his figuration of femininity expresses the terror of contemporary digital precarity.

'Not a Ru-girl': the career and works of Willam Belli

Willam participated in Season 4 of *Drag Race* and, notoriously, was disqualified in Episode 8 for, according to the show, breaking the rules by having his spouse visit him when the contestants were meant to be secluded. His disqualification was in line with the show's presentation of him as a 'villain' figure. He is the only queen ever to be disqualified from the American version of the show, until the disqualification of season 12 queen, Sherry Pie. An exiled and rejected *Drag Race* daughter, Willam sings, in 'Read Her,' the promotional video for his parodic self-help book *Suck Less*, 'You tried to make me behave/You shooshed and shushed all the fun away/But fuck you, I'm not a Ru-Girl who's some cliché/ In here [his book] I'll make it clear/Why I'm a superstar that will go far/On my own, suck my bone as I walk away.' However, Willam does not walk away. Rather, he has engaged in an ongoing feud with the *Drag Race* franchise ever since he appeared on the show, frequently criticising its production practices.[4] Willam has, however, managed to 'go far' independently of *Drag Race*. As his quote at the head of this article suggests, he was one of the earliest media-savvy queens to use the short-lived spike in visibility provided by a reality television appearance to move into digital content creation, in an entrepreneurial attempt to generate a sustained and materially remunerative celebrity status for himself. He parlayed his appearance on *Drag Race* into a YouTube career focusing on humour ('The Beatdown'), makeup videos, and parodies of pop songs (such as 'Read Her,' a parody of Sia's 'Reaper'). He has, at the time of writing, over 900,000 subscribers on YouTube. Outside of YouTube, his ventures include his book *Suck Less*; an international schedule of live performances; and acting appearances including Netflix's *Eastsiders* and the Lady Gaga vehicle *A Star is Born*.

Willam's 'fishy,' sexy, glamorous drag (which has developed significantly since his stint on *Drag Race*) falls outside the twin poles that dominate *Drag Race*: 'pageant' on the one hand, and 'comedy' or 'freak' on the other.[5] His drag aesthetic zones in on a Playboy Bunny/softcore porn ideal of feminine 'hotness,' referencing Hollywood starlets and the Spring Break fantasy of the show *Girls Gone Wild*. He typically presents himself sporting tousled blonde hair, revealing clothing, and youthful fashion styling, his white skin lightly tanned and his body slim and toned. Staple wardrobe items include mini-skirts, hot-pants, midriff-revealing tops, and a lot of denim. He very faithfully reproduces a certain softcore allure, symptomatising a wider 'pornification' of culture, in which 'texts citing pornographic styles, gestures and aesthetics ... have become staple features of popular media cultures in Western societies' (Paasonen et al 2007, p. 1).

In terms of content, Willam's oeuvre constitutes a space of rage, abuse, and contumely – a zone of multidirectional verbal and representational violence. He is notorious for his controversial humour – a kind of humour often described as 'ironic,' which essentially involves repeating misogynistic, transphobic, racist, classist, and ableist tropes. Two incidents have been particularly notorious. He performed in blackface in the 2011 film *Blubberella*, and in 2017, on his internet Q&A show *Suck Less* (named after, but different from, his self-help book), he made a series of blatantly transphobic comments. He has apologised for both incidents, for whatever this is worth.[6] Willam also routinely abjects

himself, although I am not suggesting that this justifies his phobic humour in any way. One obvious example of this is his song, *Boy is a Bottom*, performed with fellow drag queens Detox and Vicki Vox (Belli 2013c). This parody of 'Girl On Fire' by Alicia Keys mocks a fictional gay man for being sexually receptive. Willam sings, 'This boy is a bottom/A gutbucket bottom/He's a ratchet-ass bottom.'[7] And yet Willam defines himself as sexually receptive as part of his self-brand and humour. For instance, he states in *Suck Less*, 'there's no bigger bottom than me,' and includes a whole section on 'How to Suck Less at Anal' (2016a, p. 52; pp. 131–139). His constant stream of objectifying self-characterisations implicate both his gay male identity and his pornified drag persona, establishing the defiantly self-abjecting position that he adopts throughout his oeuvre.

'I'm just like WikiLeaks/but my dick is up in my ass cheeks': revealing the work behind the 'werq' on *RuPaul's Drag Race*

Alison Hearn, in her analyses of reality television, asks, 'What is the nature of the labour performed by the individuals whose bodies and senses of self are fodder for [reality television] programmes?' (2008a, p. 495). This is a question that I explore in this section, by considering Willam's *Drag Race* related materials – both his appearance on the show, and his subsequent commentaries about it. Willam's ambivalent and uncomfortable participation in reality television, I suggest, tends to reveal reality television as a *scene of labour*, indeed, as 'the paradigmatic productive post-Fordist workplace' of the entertainment industry (Hearn 2008a, p. 498) – and he reveals this against the grain of the show itself, as reality television always wants to erase participants' labour. Willam's *Drag Race* materials reveal and critique the 'shafting' to which those involved with reality television are subjected, ultimately linking the 'bottom line' that drives reality television to the defiant abjection of the sexually receptive 'bottom.'

In the 'Career' section of *Suck Less*, Willam states:

> Finding out what you're good at and then figuring out how to get paid to do it is the easiest way to a solvent and happy future. (I took that from a magazine with Oprah on the cover.) ... The proper job will allow you growth while at the same time self-discovery. That sounds right, right? (p. 186).

Willam here mocks neoliberal ideology's strategic intertwining of work and self-actualisation. This neoliberal sleight of hand is a central strategy within reality television. Reality television persistently presents participation in its shows as self-actualisation, not labour – that is, as therapy, apotheosis, transformation, and 'doing what you love,' rather than as performing on a television show. This erasure of participants' labour is ultimately a strategy to 'escape from labour' by de-realising it (Hearn 2008a, p. 503). That is to say, 'reality television is a representational expression, and ideological legitimation, of television's own economic rationalisations' (Hearn 2014, p. 450). Reality television generates an image-world in which 'producers and networks position themselves as benign corporate benefactors' (not employers) and participants are expected to receive their exploitation 'as a gift' (2008a, p. 503). To put this another way, to the extent that reality television constitutes a legitimation of precarity and labour intensification under neoliberalism, it requires its contestants to participate in the obscuring of their own work.

However, subsequent to his *Drag Race* appearance, Willam has persistently highlighted the material labour practices entailed in producing the show – to the chagrin of the *Drag Race* franchise, according to him. For instance, in 'Read Her,' his promotional song for *Suck Less*, he sells the book by describing it as an exposé in which he will 'spill some tea' about *Drag Race* and describes himself as 'just like WikiLeaks.'[8] *Suck Less* does deliver on this promise, as it includes a 'pop quiz' entitled 'Are you right for a reality show?' (2016a, pp. 56–7). This quiz presents a series of questions and multiple choice answers that, while avoiding open accusations, hint at practices that Willam alleges were used by *Drag Race* during the filming for his season. A show is invoked in which production staff are paid 'salaries that, after taxes and divided by the sixty hours a week they worked, come to be less than minimum wage and thereby technically illegal' (2016a, p. 56). In this show, a contestant might get restive due to his/her unsatisfactory treatment, for instance 'refusing to get into a van at ten p.m. after a fourteen-hour day and after being handed 75.00 USD for you and eleven other contestants to eat ($6.25 each)' (2016a, p. 56). Willam also invokes exploitative practices regarding intellectual property, suggesting that if this hypothetical show were to invite a past contestant back on, she/he might choose to 'have a lawyer review the contract in case it gave the production company 100 percent career control over all media, future works, and licensing' (2016a, p. 57).

Willam here describes run of the mill labour and intellectual property practices in reality television, which, Hearn argues, is essentially a euphemistic name for 'a set of cost-cutting measures in mainstream television production enacted by management' as an 'attempt to extract as much unregulated labour as possible from workers,' by which she means both performers and production staff (2014, pp. 439–440). These measures involve 'lowering production costs by producing programming "just in time" – quickly, cheaply, and avoiding unionized actors and writers in favour of flexible, low-paid, multi-tasking workers' (2014, p. 439). Production staff on short-term contracts work long hours without breaks, overtime pay, or workplace benefits (2014, p. 440). Meanwhile, on-screen participants' appearances on the shows as (some version of) themselves means that their labour can be excluded from the category of acting, thus avoiding unionised labour contracts in favour of 'minimal "appearance fees"' (2014, p. 440). Ultimately reality television's participants and production workers are bound into 'a capitalist logic that actively extracts value wherever it can in whatever way possible' (2014, p. 449).

Of particular relevance to reality television is the category of affective labour, a form of immaterial labour. Immaterial labour produces intangible phenomena such as knowledge, images, and feelings, and requires the worker to bring her creativity, communicative capacities, and sense of self into the work (see Hardt and Negri, 2006, pp. 108–113). Immaterial labourers include, for instance, 'software designers to waitresses and sex-trade workers to academics' (Hearn 2014, p. 445). A subset of this, affective labour produces an experience or emotion in the consumer (in the case of reality television, the viewer). Reality television participants perform affective labour by being themselves for the camera, presenting themselves for the viewer's consumption. This requires them to perform to the format. Their display of personality is 'closer to the fulfilment of a task specification than a process of expression' (King, qtd in Hearn 2014, p. 448), as any display of self is 'highly disciplined, anticipating the demands or expectations of its producers' (Hearn, p. 448). Willam himself notes this in *Suck Less*, stating, 'You won't be shocked to know that in eight seasons of *RuPaul's Drag Race*, Pisces, Cancers, and Sagittariuses

showed up with the most frequency because those signs frequently are emotional and like attention' (2016a, p. 54). Importantly, in affective labour, such as that performed by reality television participants, the distinctions between working and nonworking life, between existence and capital, between self and service, collapse, such that '"being" *is* labour' (Hearn 2014, p. 444).

Willam's refusal or perhaps inability to contribute the required affective labour on *Drag Race* means that his presence on the show is notably awkward, inharmonious, and destabilising of the show's representational equilibrium. The most notable instance of this takes place on the runway – the culminating moment of each episode, in which it is revealed which contestant will be eliminated. In Episode 5, during the runway review, judge Michelle Visage requests that Willam reveal his personality more openly, stating 'I feel like I don't know you yet.' Here Visage performs the role of the judge, which, in reality television, is that of extracting a specific kind of affective labour from the participant: the money shot. The money shot, as Laura Grindstaff has argued in her work on talk shows, is the emotional breakdown: a climactic moment of heightened emotion, 'joy, sorrow, rage, or remorse expressed in visible, bodily terms' (2002, p. 19).[9] Grindstaff, through her use of the term 'money shot,' analogises the talk show's climactic moment to that of pornography. The most notorious example on *Drag Race* would be Roxxxy Andrews' 'bus stop' breakdown in Season 5. When Visage requests a money shot from Willam, his much-memed response is, 'I tend to think that emotions are for ugly people.' In deflecting her request, Willam engages in a behavioural non-sequitur that, in the reality television context, is equivalent to a porn star refusing to climax for the camera.

Later in the same episode, however, just before the cast will be told who will be eliminated, Willam suddenly starts to cry, as though to belatedly deliver the requested money shot. However, his delayed compliance turns out to be even more disruptive than his initial refusal. Weeping, he states:

> I've never had, like, girlfriends. I've never really been friends with other drag queens. I've always been an actor on television. I was on *Boston Public* with you [addressed to guest judge Loretta Devine] and um I'm getting to know these girls and they're awesome and it sucks to know that one of them is going to have to go home so I can win. It's hard ... So yeah. That's it ... And I'm not acting. Swear to god.

In this excruciatingly awkward moment, Willam presents a statement that starts as an expression of affection for the other contestants but rapidly switches direction, turning into an insult to the other queens and an expression of his own self-aggrandisement and competitiveness. Moreover, he inserts, into this supposedly disinterested outburst, a self-promoting gesture of connection to Loretta Devine and *Boston Public*. He concludes his jarring lament with a perky full stop, 'That's it,' abruptly switching off the emotion as though to flaunt its inauthenticity. This inauthenticity is further emphasised by his closing claim, 'I'm not acting,' which of course raises the possibility that he is.

We could read this confusing and unstable moment through James C. Scott's concept of the 'weapons of the weak.' This concept excavates the agency of subjugated populations, arguing that resistance can take form in everyday activities that are not always read politically, for instance, at work, foot-dragging, evasion, and false compliance (1985, pp. xv-xxii). Willam complies here, but only partially and sullenly; he drags his feet in the affective labour demanded of him. In so doing, he disrupts the smooth surface of the

representation, a representation that, when it is working fluently, renders participants' work invisible, that is, renders their affective labour of emotionally breaking down on camera as spontaneous and as therapeutic.

In his subsequent parody songs about the show, Willam generates a sexual register of discourse that seems to speak to the impasse of the reality television participant in this situation. This sexual register revolves around the figure of an unnamed executive producer with whom Willam claims to have had a sexual encounter during the filming of the show. The shadowy figure of this producer appears repeatedly in Willam's statements about the show. The pop up quiz in *Suck Less*, for instance, has a whole question devoted to him. The multiple choices answers constitute, seemingly, a list of rageful things that Willam would like to say to him. Response A, for instance, is, 'I sucked your dick from the back, raw-dogged AND kept my mouth shut about it, and you're gonna act like how your work buddies try to treat me and others is OK?' (2016a, p. 56). Moreover, Willam repeatedly emphasises the producer's apparently prodigious penis size. Response C, for instance, is, 'How is it you have the backbone of a scoliosis patient when it comes to doing what's right but you're able to support that two-hander of a cock?' (2016a, p. 56).

In reality television, the one figure that is understood to enjoy power and material gain is the executive producer. Thus this producer, with his huge penis and his power to sexually use Willam, seems to be both an actual person, and also an image, a figure that gives Willam a vocabulary to speak about the position of the reality television participant. In another of Willam's protest songs about *Drag Race*, 'Too Late to RuPaulogize' (Belli 2013b, a parody of Timbaland's "Apologize"), all the various kinds of 'shafting'[10] to which Willam feels he has been subjected by the show seem to coalesce when he sings the lyric, 'Whose dick I gotta suck to get my ass back on the tube?' Here he directly links sexual service with media visibility. Making the same link, Willam has elsewhere stated that 'getting to the top of the fame game is a race to the bottom, and there's no bigger bottom than me' (2016a, p. 52). In the sexual register through which Willam describes the predicament of the reality television participant - that of being shafted by the executive producer - the participant, in search of fame, comes to inhabit precisely the ambivalently abject, defiantly ironic position of the 'ratchet-ass bottom' that Willam has elsewhere immortalised in song. In his presentation of his own sexuality, Willam has styled himself as the 'poster girl' for the bottoming 'movement.' Meanwhile, Gill and Pratt have stated that creative workers 'have been identified as the poster boys and girls of the new "precariat"' (2008, p. 3). Within the complex of associations developed in Willam's oeuvre, these two very different 'poster girls,' for bottoming, and for the creative precariat, begin to merge.

'Thigh gaps are a currency where I'm from': contemporary femininities and 'entrepewhorial endeavours'

In a 'Beatdown' episode from 2014, Willam pours contempt on fellow YouTuber Levi Bernhardt's body positivity video. Bernhardt, in this video, takes it upon himself to tell women how to feel about our bodies, in a clumsy attempt to combat body-shaming. Willam reacts to Bernhardt's video by defending normative body standards. For instance, when Bernhardt states that women don't need to shave our forearms, Willam responds, 'Nobody wants to fuck a hairy girl,' and calls Bernhardt's comments 'dangerous propaganda' and 'hate speech.' When Bernhardt proposes that women shouldn't worry

whether we have gaps between our thighs, Willam reaches a climax of outrage and states, 'Thigh gaps are a currency where I'm from in Hollywood.' He continues, as though to substantiate this claim, 'You must not be on Instagram because there's a tag for it.' Willam's conception of thigh gaps as 'currency' because there is a 'tag' for them signals an interconnection between labour, gender, embodiment, and the digital economy, and it is this that I unpack in this section. I explore here the type of femininity that shapes Willam's drag: his commitment, that is, to a glamorous, 'hot,' fishy drag. I read 'hot' femininity in relation to the feminised labour of visibility that drives the digital economy, largely moving away from Willam's *Drag Race* material to consider his work as a YouTuber. Willam's drag, I suggest, reveals how the labour of visibility generates a hypersexualised, commodified version of white femininity that is optimised for the attention economy of social media and digital self-entrepreneurship. Occupying the space where femininity and mediation intermesh, his drag presents a 'cyber-femininity,' as defined by Abidin and Thompson: 'the portrayal and performance of female gender as mediated via the Internet and digital technologies' (2012, p. 467). In showing how digital precarity is generating new femininities, and new feminine/femme subjectivities, Willam's drag explores, as Shields Dobson puts it, 'the conditions and experience of inhabiting femininity in the digitally mediated post-feminist context' (p. 97).

The economic structures of digital content creation do indeed shape the impasses of femininity that form the subject matter of Willam's drag. Duffy has coined the term 'aspirational labour' to describe the 'forward-looking, carefully orchestrated, and entrepreneurial form of creative cultural production' (2016, p. 446) in which digital content creators such as YouTube performers engage. Producing a range of often feminised YouTube content such as makeup tutorials, vlogs, product reviews, and shopping haul videos, these 'emotional laborers for the social media age' (2016, p. 449) engage mostly in uncompensated work, taking on risk and investment themselves, in the hope of getting 'discovered.' This 'manic rhetoric' of getting 'discovered,' Duffy claims, fuels the digital economy's 'vast system of unpaid internships, freelance work, and user-generated content' (2016, p. 454). Media scholars have argued that this 'visibility culture' (Duffy 2017, p. 229) is ultimately disciplinary, in the Foucauldian sense: it forms the self along the lines designed by neoliberalism, moulding the subject in a process that Wendy Brown has described as 'neoliberal governmentality' (2003). Thus, Alice Marwick argues, Web 2.0 'idealise[s] and reward[s] a particular persona: highly visible, entrepreneurial, and self-configured to be watched and consumed by others' (2015a, p. 13). Ultimately, Web 2.0 forms as much as it reflects behaviours and subjectivities: it is 'a neoliberal technology of subjectivity that teaches users how to succeed in postmodern American consumer capitalism,' thus forming the user into neoliberalism's 'ideal subject' (Marwick 2015a, p. 14).

The demands of this visibility culture fall in specific ways on girls, women, and feminine/feminised/femme subjects in the context of contemporary postfeminism. Banet-Weiser argues that the girl internet performer/entrepreneur is an exemplar of how the postfeminist subject is entangled with the interactive subject of contemporary media (2012, p. 56–7), proposing that 'a desire to be noticed or recognized is perhaps the quintessential element to the branded postfeminist self' (2012, p. 77). Moreover, Banet-Weiser notes how 'self-production online can position girls and women as specific kinds of products for consumption' (2012, p. 80), as their projects of self-branding collapse the distinction between self and brand, self and labour, leading to the commodification of

self, and the infiltration of business models into all areas of life. Thus both reality television and social media are sites where the whole self is consumed by, and made to be the material of, entrepreneurial labour. This is the essence of the femininized 'labour of visibility.'

This labour of visibility is reproduced in Willam's drag, which generates a representation of a world in which the female body is relentlessly scrutinised, the pursuit of visibility is paramount, and public and private continuously collapse into one another – a world populated by blonde, white starlets clad in yoga pants and huge sunglasses, struggling with substance abuse problems and having nervous breakdowns on social media (see for instance his YouTube song 'Blurred Bynes, Belli 2013a, performed with Detox and Vicki Vox, which lampoons the former child star Amanda Bynes). The kind of labour that his drag explores is most exactly defined, perhaps, by Wissinger's concept of 'glamour labour': aspirational labour as it manifests itself in the work of models, who are increasingly expected to brand themselves on social media. Wissinger argues that the speeded up attention economy, which she refers to as 'the regime of the blink' (2015, p. 16–19), combines with neoliberalism to create a context in which models become 'manic workers' that 'traffic the volatile forces of affectivity and total self-maximization' (2015, p. 5). 'Glamour labour,' Wissinger states, emerges 'when life, work, and body management bleed together' (2015, p. 3); it encourages 'an embodied entanglement with technology,' combining 'bodily potential and connectivity' (p. 5).

Wissinger's emphasis on embodiment is particularly useful here, as Willam is heavily invested in the bodily aspects of feminised visibility labour. Banet Weiser, discussing self-branding in social media, notes that 'the hypersexualiazed female body is particularly brandable in the current economy of visibility' (2012, p. 85). In this context, the emergent category of 'hotness' can come to represent a 'right' to visibility' (Banet-Weiser 2012, p. 83). It is important to note the restrictions here: the postfeminist sensibility that frames this 'hot' female body is 'by definition a reinstatement of white femininity as the ideal' (Banet-Weiser 2012, p. 84). In the 'Beatdown' video in which Willam lampoons fellow YouTuber Bernhardt's body positivity message, Willam's blonde wig, slim, white body, and exposed midriff, all conform to precisely this exacting body culture of 'hotness' (precisely the body culture Bernhardt is trying to critique). Willam's choice of top in this video is also telling. It bears the slogan 'more tequila.' This evokes the Spring Break party fantasy showcased by the television show *Girls Gone Wild*, in which young women in alcohol-fuelled nightlife venues are encouraged to reveal their bodies for the camera; Willam's look here is exactly on brand for *Girls Gone Wild*. As a contestant on *Drag Race*, Willam also signals his expertise in performing to this format. In Season 4, Episode 6, the queens are tasked with participating in a wet t-shirt competition, in a parody of *Girls Gone Wild*. Willam confidently describes this challenge as 'money in the bank.' He adeptly performs the required porn-aesthetic moves, showing up on stage in huge sunglasses, blonde wig, and a tiny skirt that he then strips; 'ejaculating' sun lotion all over himself; and kneeling on the floor, head thrown back, guzzling streams of water poured on him from above by muscled male models. Gaining the 'biggest reaction' from the shouting crowd, Willam wins the wet t-shirt competition.

Girls Gone Wild mimics, in grotesque fashion, the feminised labour of visibility, turning it into the image of an inebriated girl raising her top for the camera. But *Girls Gone Wild* is also part of the network of visibility. Pitcher states that the 'potential for one's famous 15 minutes is an effective tactic the series uses to perpetuate itself' (2006, p. 208–9). Thus,

'one young woman ... explained her rationale for flashing a crowd at a *GGW* event: "We're looking to be famous!"' (2006, p. 209). Further, in the digital world, this kind of pornographised/reality femininity has an algorithmic advantage in the struggle for visibility. Carah and Dobson, in their article 'Algorithmic Hotness,' study the labour of young women employed to promote night life venues via 'ambient marketing' on social media, by posting images of themselves in the venues. Carah and Dobson point out that social media platforms' content is structured by algorithms 'based on predications of value generation,' and that particular kinds of bodies are most likely to be prioritised by these algorithms (2016, p. 3). These bodies are 'mostly female' and are described as 'hot.' 'Hot' body presentations aim to generate 'affective engagement' – to create zones of attention on social media, spikes in connectivity that Carah and Dobson refer to as " 'body heat.' Willam's drag, then, replicates the kind of femininity that is optimised to produce online 'body heat,' the kind of femininity that, in Wissinger's terms, brings together 'bodily potential and connectivity' (2015, p. 5).

In this sense, to return to Willam's rant about Bernhardt, thigh gaps genuinely do, where Willam comes from, operate as a kind of currency – a currency of visibility. As Willam's comment on thigh gaps suggests, Willam's drag does offer its own internal theorisation of the feminised labour of visibility that it both embodies and caricatures. Willam, who has stated that he has taken part in sex work, appears to view drag on a continuum with stripping and pornographic performance.[11] He refers to the two interchangeably, for instance when he states: 'a lot of audience members want to have their favourite porn star's or drag queen's attention for that one second and a brief skin-on-skin dollar exchange' (2016a, p. 183). In an even more expansive melding of different occupations, he states that, 'When people tip a stripper, bartender, performer, or bouncer, they're not tipping for their health. They're tipping to buy someone's undivided attention for a split second, whether it's to lightly graze a taint with a dollar or to communicate "There's more where that came from" to a security guard to overlook the giant line and let you in' (2016a, p. 181). While clearly these forms of labour are varied, Willam identifies a link between them in their quality of being *affective labour*: labour that provides a consumer with the experience of 'undivided attention,' the 'graze' of communication, the real or metaphorical 'skin on skin exchange,' which produces a sensation or feeling in the consumer. All of these forms of work present themselves, in the context in which Willam places them, as service work (often denigrated or abjected), as labour that is determined by 'the rise of what some scholars term an "affect economy," in which the circulation of bodily, interpersonal, emotional and affective energies is being calibrated for profit' as a result of 'the shift from a product-based economy to an experience-based one' (Wissinger 2015, p. 165).

We could, by this logic, describe Willam's entire oeuvre in terms of his own coinage, 'entrepewhorial endeavours' (2016a, p. 104). He means sex work by this, but I am suggesting the phrase has a wider application in his work. It is striking that Willam's coinage 'entrepewhorial' plays on the keyword of neoliberalism, 'entrepreneurial.' I would argue that what 'entrepewhorial endeavours' comes to denote, in his performance, is the idea of a *fully commodified self* that emerges under neoliberalism. Hearn argues that the forms of self-branding demanded by neoliberal entrepreneurialism, 'illustrate the erosion of any meaningful distinction between notions of the self and capitalist processes of production and consumption' (2008b, p. 197). Through his allegiance to/fascination with sex work (a

form of labour that has often been stigmatised because it is perceived to transgress the supposed boundaries between private and public, personal and commercial) Willam seems to allegorise the 'entreprewhorial'/entrepreneurial femininity that emerges where the whole self is consumed by capitalist processes. Tsianos and Papadopoulos (2006) suggest that 'new social subjectivities do not so much mirror the characteristics of immaterial production but the precarious modes of exploitation proliferating in them.' Willam's drag, I suggest, reveals how digital precarities are generating this feminine fully commodified self. A staple of Willam's wardrobe, he says, is the 'chicken bucket dress' (2016a, p. 213). This is any dress that 'displays all of one's legs and breasts like that of a KFC Family Meal' (2016a, p. 213). Here he reads his body as joints of meat, precisely inasmuch as he perceives his body as having or presenting (through drag) feminine parts. This 'self as meat' conception proposes a contemporary 'thigh gap femininity,' a fully commodified self that emerges at the nexus of the interlocking forces of precarity, postfeminism, entrepreneurial neoliberalism, digital economies, and social media.

This whole scenario seems to be captured visually by a sequence in the video for Willam's song 'Read Her.' The video includes footage of Willam's image being edited in Photoshop. In the Photoshop editing window, Willam sings the lyrics, 'I might just spill some tea/About this dude [RuPaul] who's on TV/His producer's dick is huge/And I know because I tasted his splooge.' As he sings about his troubled encounter with reality television, a mouse cursor, operated by an invisible hand, moves across his image, adjusting and manipulating it. The alterations made by the cursor suggest hyper-feminisation and hyper-sexualisation, as they increase the size of the lips and the hair. The moving image of his singing mouth appears to have been enlarged and floats slightly above the visual surface. This Photoshop footage is intercut with shots of Willam walking up and down a night-time street, styled in a typical *Girls Gone Wild* look, waving at passers-by that catcall him. These shots clearly characterise him as a streetwalker. He calls out, 'Wanna cum on my tits?' This sequence of the 'Read Her' video thus interlaces images of feminine sexual availability and embodied self-commodification with footage that explicitly references mediation, conjuring the idea of a fully commodified self that emerges in and through digital mediation.

'Wanna cum on my tits?': concluding thoughts

Willam declares in *Suck Less*, 'I credit a lot of hard work along with hundreds of pounds of hair, makeup, and tape for truly making me a "thing"' (2016a, p. 52). By making himself a 'thing,' he means, becoming notable or current, becoming famous. Given the nature of his drag, though, his phraseology queries the distinction between being *a thing* (visible, current, a celebrity) versus being a *thing* (an object) – and are they both the same thing? That is, when Willam describes his career in this way, we could read him not only as stating that he has pursued visibility and celebrity, but also as stating that he has rendered himself as an object; and there may, in this context, be little distinction between the two. Indeed, they seem to fold together when he states that in order to be visible you must, 'stay current and stay cunt' (2016a, p. 54). Rosalind Gill coins the phrase 'sexual subjecti-fication' to refer to self-imposed sexual objectification – making oneself a thing/perceiv-ing oneself as a thing. 'Sexual subjectification,' she argues, describes a postfeminist process in which 'women are not straightforwardly objectified but are portrayed as active,

desiring sexual subjects who choose to present themselves in a seemingly objectified manner because it suits their liberated interests to do so' (2007, p. 151). Gill does not see this as a successful reversal or reframing of objectification, but rather as another ruse of power. Sexual subjectification constitutes 'a shift in the way that power operates: from an external, male judging gaze to a self-policing, narcissistic gaze' (2007, p. 151). In his drag Willam seems to embody one subjected to such power, to ostentatiously partake of and explore the subjectivity of sexual subjectification. I explore, in this final section, the dynamics of self-objectification in Willam's performance, framing my discussion through Gill's concept of sexual subjectification.

As Gill points out, the culture of sexual subjectification presents dilemmas for the feminist critic. How are we to come to terms with Del Rosario's butthole tattoo, with the way in which participants on *Girls Gone Wild* 'revel as objects of a consuming gaze' (Pitcher 2006, p. 208)? Shields Dobson, analysing young women's 'heterosexy' selfie culture, has turned to the work of Rebecca Schneider, who theorises women's explicit bodily performance art. Shields Dobson states, 'Schneider's work suggests that a purposeful construction by a female artist of her specific, individual body in the object's role can be understood as disruptive to object-subject binaries by making visible the object's own "eye" and "showing the show" of her own objectification and commodification' (2015, p. 58). What is helpful here in the case of Willam is not the rather predictable, recuperative suggestion that the object might return the gaze, turning the tables on the viewer and thus claiming her own agency. Rather, what is useful is the idea of the 'showing of the show' of objectification. Willam's performances do indeed foreground the showing and the show, endlessly indulging and exploring the self-objectifying subject's desire to be seen and consumed. What occurs when this desire is repeatedly, obsessively represented, as in Willam's drag? We could say that what Willam achieves – as Schneider suggests women's explicit bodily performance art can do – is 'marking the historical terms of her commodification across her own body' (Shields Dobson 2015, p. 58, paraphrasing Schneider). Regardless of who 'she' is (Maria Del Rosario, Willam, any/all femme/feminine/feminised subjects labouring in the image and/or abjected in/by mediation), the 'historical terms' that Willam's drag marks are the contemporary gendered contexts created by postfeminism, precarity, neoliberal self-entrepreneurialism, and the digital economy. His drag is in a sense an artefact of this moment.

Banet-Weiser asks, 'What, exactly, does it mean to be free in the current moment, amid the market-driven promises of postfeminism, within the seemingly limitless spaces of media interactivity?' (2012, p. 58). If we seek an answer to this question through Willam's drag of sexual subjectification, I suspect that this answer would be an intimation of freefall, terror, and disaster. Susan Lepselter, discussing reality television shows about hoarders, argues that we can read 'public spheres as "affective worlds," worlds that express "public feelings"' that could include, for instance, 'depression, free-floating disturbance, or an ambience of apprehension and nervousness' (2014, p. 260). She thus finds that the meanings of reality television hoarding narratives "extend far beyond the crises of the individuals they feature; they are 'symptomatic of a public feeling: a feeling of disaster' (2014, p. 260). Might Willam's performance communicate a feeling about femininity in the struggle for visibility, about femininity as train wreck, as celebrity damage, as party disaster? Throughout this essay I have neglected to touch upon Willam's most notorious action on *Drag Race*. He vomits on the runway at the moment when he is to be told that

he has been disqualified – an experience that is likely to be particularly traumatic for somebody that has publicly disclosed that he struggles with bulimia. Willam has offered an explanation for this incident, stating that his corset was too tight; but when I watch this footage I'm reminded of something Sara Ahmed says about queer lives in *The Promise of Happiness*. She talks about 'moments where it is all "too much," when a body, a life, a world becomes unbearable' (2010, p. 97). This moment of vomiting on the runway strikes me as an example of too muchness, a kind of throwing up of the disgrace of disqualification; of the precarious struggle for visibility that emerges from the conditions of mediation and neoliberalism; of the unbearable requirements placed on the femme or feminine body.

In 'RuPaulogize,' Willam describes his complaints about *Drag Race* as 'white girl problems' (Belli 2013b). To the extent that his drag focuses on the impasses of a specific media-optimised white femininity, they are indeed white girl problems. To consider how race intertwines with the struggle of 'labouring in the image' for racialised femme/feminine/feminised subjects, we could turn to The Vixen, a far more explicitly political figure than Willam, but one whose presence on Drag Race is equally rageful, non-compliant, and excessive, and whose trajectory, like Willam's, is deeply entwined with digital culture and social media. Debra Ferreday, in this special issue, explores the Vixen's embodiment of rage and her strategic withdrawal from the show, which exposes the racialised frames of *Drag Race*. In the meantime, I have suggested that Willam's drag presents us with a set of insights about celebrity's demotic turn and the feminised labour of visibility. Ridout and Schneider pose the question, 'How do we pay attention to precarity – economic precarity, neoliberal precarity – through a close reading of the performing body?' (2012, p. 6). I propose that reality television and digital content creation are key forms in which precarity is profoundly embedded in the bodily performance of participants. Under neoliberal precarity, Ridout and Schneider argue, 'creativity and terror, art and structural insecurity, become structural affiliates' (2012, p. 8). As Willam prowls down a darkened street calling out, 'Wanna cum on my tits?', I certainly find that his performance tends to point to the 'terror' and 'structural insecurity' in the art – if the art is, the performances that reality television and social media elicit.

Cristina Morini, discussing the feminisation of labour under cognitive capitalism, has stated that 'the figure of social precariousness today is woman' (2007, p. 43). When we imagine the many images of female precarity that might attend this statement, Willam probably isn't our go-to example; and I don't want to trivialise the material struggles that Morini foregrounds. But I would suggest that Willam's drag generates figurations, not exactly of 'woman,' but of a femininity that emerges in response to the demands of the 'blink economy,' as Wissinger calls it. His is a drag of digital precarity. In tracing the contours of the fully commodified self, he reveals how contemporary femininities and femme/feminine subjectivities emerge through the feminised labour of visibility, at the troubled nexus where postfeminism, neoliberalism, precarity, and mediation interlock.

Notes

1. Willam has stated that his pronouns are he/him. By 'bitch who has to show for a dollar' he refers to drag queens that perform live in clubs for tips.

2. These anxieties surface more openly in later comments about his career. In his book *Suck Less*, he describes his acting career in Hollywood as 'a decade of obscurity' and declares that he 'didn't even make has-been. I'm a never-was' (p. 52).
3. By 'ordinary person' Turner means, not people who are 'normal' or 'average,' but people who do not have access to the circuits of traditional fame.
4. In *Suck Less*, see pp. 56–7, 'Pop Up Quiz! Are You Right for a Reality TV Show?', which I discuss below. Willam's complaints about Drag Race have been widely reported online; for one example, see https://www.gaystarnews.com/article/willam-tells-all-drag-race-disqualification/#gs.149my4.
5. 'Fishy' is a drag slang term that means extremely feminine and/or passing as cis-female.
6. There is a wealth of online and media reportage and comment on these incidents, particularly the 2017 one. See, for instance: https://www.gaystarnews.com/article/willam-apology-transphobic/; https://www.out.com/news-opinion/2017/9/30/willam-belli-transphobic-shocking-no-one; https://www.pinknews.co.uk/2017/09/28/rupauls-drag-race-star-willam-belli-shocks-fans-with-transphobic-comments/.
7. 'Ratchet' is a slang term with racialised and feminised connotations; it suggests something is despised, tacky, or low.
8. 'Tea' or 'T' is drag slang for 'truth,' often meaning gossip or frank opinion.
9. Here I quote Grindstaff's book about daytime television talk shows; however she extends the concept of the money shot to reality television in Laura Grindstaff and Susan Murray (2015), 'Reality Celebrity: Branded Affect and the Emotion Economy,' *Public Culture*, 27(1), pp.109–135.
10. Willam was (according to him) excluded from the official *Drag Race* tour. Thereafter he developed a solo performance that showed after the *Drag Race* show at venues that the *Drag Race* tour visited. He named his tour 'Shafterparty.'
11. Strikingly, *Girls Gone Wild* also straddles the boundary between reality television and pornography. Mayer has stated that it is 'a video series that its observers call "soft-core pornography" and its producers call "reality television"' (2005 p. 303), suggesting the emergence of a 'reality pornography/documentary industry' (2005 p. 310). Seen in this context, the proximity of Willam's drag to pornography also suggests an implicit commentary on reality television.

Disclosure statement

No potential conflict of interest was reported by the author.

References

Abidin, C. and Thompson, E., 2012. Buymylife.com: cyber-femininities and commercial intimacy in blogshops. *Women's studies international forum*, 35 (6), 467–477. doi:10.1016/j.wsif.2012.10.005

Ahmed, S., 2010. *The promise of happiness*. Durham, NC: Duke University Press.

Banet-Weiser, S., 2012. *Authentic: the politics of ambivalence in a brand culture*. New York: NYU Press.

Belli, W., 2013a. Blurred Bynes. Available from: https://www.youtube.com/watch?v=mr51afj7eJY.

Belli, W., 2013b RuPaulogize. Available from: https://www.youtube.com/watch?v=JKbHCi5rBpl.

Belli, W., 2013c. Boy is a bottom. Available from: https://www.youtube.com/watch?v=s0kqobQRcUo.

Belli, W., 2016. Read her. Available from: https://www.youtube.com/watch?v=B-euRmG1PuM.

Belli, W., 2016a. *Suck less: where there's a Willam, there's a way*. New York: Hachette Book Group.

Belli, W., 2016b. The Beatdown, Season 3, Episode 26. Available from: https://www.youtube.com/watch?v=UY7lo9G7eLY.

Brown, W., 2003. Neoliberalism and the end of liberal democracy. *Theory and event*, 7 (1).

Butler, J., 1990. *Gender trouble: feminism and the subversion of identity*. New York and London: Routledge.

Carah, N. and Dobson, A., Oct-Dec 2016. Algorithmic hotness: young women's 'promotion' and 'reconnaissance' work via social media body images. *Social media + society*, 2016, 1–10.

Duffy, B.E., 2015. The labor of visibility: gendered self-expression in the social media imaginary. *Paper presented at Internet Research 16: The 16th Annual Meeting of the Association of Internet Researchers*, 21–24 October. Phoenix, AZ: AoIR. Available from: https://spir.aoir.org/ojs/index.php/spir/article/view/9040.

Duffy, B.E., 2016. The romance of work: gender and aspirational labour in the digital culture industries. *International journal of cultural studies*, 19 (4), 441–457. doi:10.1177/1367877915572186

Duffy, B.E., 2017. *(Not) getting paid to do what you love: gender, social media, and aspirational work*. New Haven, CT: Yale University Press.

Gill, R., 2007. Postfeminist media culture: elements of a sensibility. *European journal of cultural studies*, 10 (2), 147–166. doi:10.1177/1367549407075898

Gill, R. and Pratt, A., 2008. In the social factory? Immaterial labour, precariousness and cultural work. *Theory, culture & society*, 25 (7–8), 1–30. doi:10.1177/0263276408097794

Grindstaff, L., 2002. *The money shot: trash, class, and the making of TV talk shows*. Chicago: University of Chicago Press.

Hardt, M. and Negri, A., 2006. *Multitude: war and democracy in the age of empire*. London: Penguin.

Hearn, A., 2008a. Insecure: narratives and economies of the branded self in transformation television. *Continuum: journal of media & cultural studies*, 22 (4), 495–504. doi:10.1080/10304310802189972

Hearn, A., 2008b. Meat, mask, burden: probing the contours of the branded self. *Journal of consumer culture*, 8 (2), 197–217. doi:10.1177/1469540508090086

Hearn, A., 2014. Producing 'reality': branded content, branded selves, precarious futures. *In*: L. Ouellette, ed. *A companion to reality television*. Hoboken, NJ: John Wiley & Sons, 437–455.

Lepselter, S., 2014. Intimating disaster: choices, women, and hoarding shows. *In*: B. Weber, ed. *Reality gendervision: sexuality and gender on transatlantic reality television*. Durham, NC: Duke UP, 259–281.

Marwick, A., 2015a. *Status update: celebrity, publicity, and branding in the social media age*. New Haven: Yale UP.

Marwick, A., 2015b. Instafame: luxury selfies in the attention economy. *Public culture*, 27 (1 (75)), 137–160. doi:10.1215/08992363-2798379

Mayer, V., (2005). Soft-core in TV time: the political economy of a 'cultural trend'. *Critical studies in media communication*, 22 (4), 302–320. doi:10.1080/07393180500288428

Morini, C., 2007. The feminization of labour in cognitive capitalism. *Feminist review*, 87, 40–59. doi:10.1057/palgrave.fr.9400367

Paasonen, S., Nikunen, K., and Saarenmaa, L., 2007. Pornification and the education of desire. *In*: S. Paasonen, K. Nikunen, and L. Saarenmaa, eds. *Pornification: sex and sexuality in media culture*. Bloomsbury: London, 1–20.

Pitcher, K., 2006. The staging of agency in girls gone wild. *Critical studies in media communication*, 23 (3), 200–218. doi:10.1080/07393180600800759

Ridout, N. and Schneider, R., 2012. Precarity and performance. *The drama review*, 56 (4), 5–9. doi:10.1162/DRAM_a_00210

RuPaul's Drag Race, 2012. Season 4. Logo TV. Jan 30-Apr 30.

Scott, J.C., 1985. *Weapons of the weak: everyday forms of peasant resistance*. New Haven: Yale UP.

Shields Dobson, A., 2015. *Postfeminist digital cultures: femininity, social media, and self-representation*. London: Palgrave Macmillan.

Terranova, T., 2000. Free labor: producing culture for the digital economy. *Social text*, 63 (18: 2), 33–58. doi:10.1215/01642472-18-2_63-33

Tsianos, V. and Papadopoulos, D., 2006 Precarity: a savage journey to the heart of embodied capitalism. *Transversal*. Available from: https://transversal.at/transversal/1106/tsianos-papadopoulos/en.

Turner, G., 2006. The mass production of celebrity: 'celetoids', reality TV and the 'demotic turn'. *International journal of cultural studies*, 9 (2), 153–165.

Turner, G., 2014. *Understanding celebrity*. 2nd ed. Thousand Oaks, CA: Sage Publications.

Wissinger, E., 2015. *This year's model: fashion, media, and the making of glamor*. New York: NYU Press.

'No one is trash, no one is garbage, no one is cancelled': the cultural politics of trauma, recovery and rage in *RuPaul's Drag Race*

Debra Ferreday

ABSTRACT

Historically, Drag Race has mobilised stories about homophobia, family violence, racism and femmephobia that produce drag as a technology of recovery: a means of rising above trauma, in line with media scholarship on the centrality of personal trauma narratives in reality TV. Queer scholars have argued that this imperative to tell positive stories silences more melancholic, 'negative' voices; of the tension between the need to speak of 'damage', and a 'related and contrary desire to affirm queer existence'. Seen as the embodiment of the histrionic, dramatic drag queen villainess and dubbed 'the whistle-blower of the season', Season 10 queen The Vixen subverted familiar trauma narratives, engendering an opening up around narratives of trauma, racism and transmisogyny. This paper examines The Vixen's absence and her re-emergence on social media, reading her viral tweet declaring 'no-one is cancelled' as a provocation that unsettles dominant accounts of mental health, survival and trauma. I argue that in speaking up for the 'trash, garbage and cancelled' subject, The Vixen speaks to Heather Love's call for a queer politics that consider injury as something that might be 'lived with, not necessarily fixed'. In this sense, her flawed star persona resonates with a mad scholarship that constituting a productive mad and queer politics of vulnerability.

Introduction

Widely seen as the embodiment of the histrionic, dramatic drag queen villainess and – more interestingly – dubbed 'the undisputed instigator of the season' (Dry 2018) as well as 'the whistle-blower of the season' by fellow African-American contestant Monet X-change, Season 10 queen The Vixen subverted this familiar trauma narrative when, after refusing to tell her story in the accepted way, she 'stormed' offset – the show's interpretation of a rather dignified and low-key exit – leaving an absence which, I argue, constitutes a literal and figurative opening up around narratives of trauma, racism and recovery and their relationship to drag and celebrity culture. As a contestant on Season 10 of *RuPaul Drag Race*, The Vixen gained attention for her politically engaged persona: on the runway and off, her performance invoked the controversial cultural figure: that of the 'angry black woman' (Griffin 2012). Arriving on *Drag Race* with her own considerable

following for both her activism and her show *Black Girl Magic*, she set out her stall as a fierce critic of intersectional oppression in queer communities (Hawbacker and Tucker 2016). Yet although her raw performances captured the attention of fans and judges, she was constantly embroiled in contrived conflict with white contestants, especially favourite and eventual winner Aquaria, attracting much censure after an episode of the backstage show *Untucked* where she was accused of 'making Aquaria cry'.[1]

In Season 10 of *Drag Race*, the 'problem' of Vixen's excessive black rage became a central narrative arc, coming to a head in the show's reunion episode when she walked offset. This premature exit was greeted by RuPaul with an extraordinary attack that recalled Banks' infamous, and meme-worthy, 'we were all rooting for you' speech to a black contestant in Season 4 of *ANTM*, an intertextual reference that was not lost on the show's media-savvy fandom. Dispensing with the stately, proper 'mama Ru' persona that underpins RuPaul's celebrity image (Dry 2018), she berated the remaining contestants:

> But look at me, look at me, goddamnit! I come from the same goddamn place she comes from! And here I am! You see me walkin' out? No, I'm not walking out. I fucking learned how to act around people and how to deal with shit. I'm not fucking walking out and saying, 'Fuck all y'all!' That's disrespectful. To each of you [the other contestants]

It was left to a weeping Asia to challenge this narrative by invoking the values of queer pride for which *Drag Race* purportedly stands: but RuPaul rejected this, concluding that the Vixen was 'beyond help'.

In storming offset, The Vixen enters into the long line of feminine celebrities, and wannabe celebrities, positioned as 'beyond help': her 'disrespectful' behaviour is implicitly tied to notions of madness and of black rage that are understood as outside the show's understanding of appropriate black celebrity. Predictably, the show attempts to manage this through the discourse of the celebrity feud – pitting The Vixen firstly against Aquaria's blonde white 'good girl', and ultimately against Ru's figuring of a black drag femininity that is represented as desirable through its flexibility in both embodying tropes of ideal whiteness and in its ability to cover over black rage. What is dynamic and exciting about the Vixen, though, is that she refuses to be silenced: that her exit from the show, and triumphant return on social media, opens up the possibility for a new form of drag celebrity that incorporates the very tensions within queerness, femininity and blackness that are suppressed in RuPaul's version of black drag celebrity. As such, she operates as a queer celebrity who also queers the fantasies of postraciality and post-madness that are always at stake in celebrity media. Following her alleged 'flounce', The Vixen's return on social media created an important space for this critique of *Drag Race's* recovery politics. As she famously declared: 'No one is garbage. No one is trash. No one is cancelled. Everyone can be wrong and learn from it and grow. People are not disposable'. In both playing with and critiquing cultural tropes of the celebrity feud, the Vixen is thus able to mobilise her own lived experience of trauma and racialisation on her own terms, building her already considerable celebrity platform to ask trenchant questions about the compromises at stake in *Drag Race's* translation of queer performance for a mainstream audience.

On one level, this is standard *Drag Race* drama, comfortably familiar in its repetition of favoured practices: throwing shade, reading, 'realness' and of the bad girl/good girl tropes that have always circulated in celebrity culture. But Aquaria's white tears also need to be read in the context of wider debates about who gets to display emotions,

and whose emotions are taken seriously. As The Vixen herself astutely commented: 'you have created a narrative of I am an angry black woman who has scared off the little white girl'. This skirmish, I argue, dramatises wider debates about gender, racialisation, and the boundaries of appropriate celebrity, as well as invoking questions about whose drag counts as 'authentic'. As feminist scholars Elizabeth Cole and Alyssa Zucker argue, 'the concept of femininity has long been fraught for Black American women in particular' since 'they have historically been treated as though they exist outside of its boundaries as they faced economic exploitation, virulent stereotyping, and lack of legal protection by virtue of their race' (2007, p. 1). In the context of a culture that already positions Black women's bodies as the constitutive outside of the feminine ideal, Black queens are already disadvantaged. After all, RuPaul himself is presented as a figure of aspiration for other queens of colour, who are told they must work harder than white contestants to produce an ideal femininity that is not only a parody of femininity but of black parodies of white beauty ideals. Like his counterpart, Tyra Banks on *America's Next Top Model* – of which Drag Race started life as a parody and has become an increasingly unironic facsimile – RuPaul has often treated Black queens who fail to achieve this rigid standard of racially ambiguous beauty to a disproportionate dose of tough love. Presented as a star whose evolution from genderqueer club queen to global celebrity to international star is intimately bound up with her adoption of Jane Fonda's iconic *Barbarella* look – and hence with white, retro ideals of feminine glamour – RuPaul defines the limits of drag celebrity, I argue, in ways that often work to exclude and marginalise black queens who exceed those limits. The spat between RuPaul and The Vixen is therefore not simply part of the familiar battle between host and performer, as seen on *ANTM*, but a struggle over ownership of Black queer celebrity: and especially over who gets to speak about queer and racialised trauma, and how.

Recent scholarship in media studies has drawn attention to the centrality of personal trauma narratives in popular television and the role of reality stars in enabling and exploiting public displays of trauma (Biressi and Nunn 2005, Ouellette and Hay 2008). As Anita Biressi and Heather Nunn have argued, the consumption of personal trauma narratives is one of the pleasures of reality television (2005, p. 5); 'the exposure and, more particularly, self-exposure of psychological and bodily trauma' has become 'the central feature of our post-documentary culture' (2005, p. 7). TV formats produce narratives of 'personal pain, injury and loss'; the use of techniques of 'confession, video diary, interview, observational techniques' indicates 'the embedding of the revelation of trauma and psychological damage in post-documentary formats and its relationship to the broader psycho-social realm of an established therapeutic culture' (2005, p. 8).

In his work on trauma, Roger Luckhurst examines how Oprah Winfrey's celebrity centres on a sense of intimacy with the mass audience. While the wealth, fame and cultural influence of the celebrity host mark her as exceptional, he argues, her trajectory embodies the neoliberal therapeutic narrative that 'psychological disadvantage can be superseded by the exercise of the will' (2008, p. 133). For Eva Illouz (2003), the trauma narratives at stake in Winfrey's celebrity performance 'embody modern tragic narratives of the suffering self'; recovery culture engenders a 'deep narrative of the self through suffering', 'a powerful identity narrative that provides a "centre" to the self by stitching together past and present' (cited in Luckhurst 2008, p. 134).

RuPaul engages in just such 'trials of authenticity' yet also paradoxically satirises them. Drag has long been regarded as revealing the instabilities at stake in normative expressions of femininity. Yet ironically, as a celebrity matriarch of colour in the Tyra or Oprah mould and who aspires to build an equally dominant brand identity, 'mama Ru' plays a policing role, providing closure for contestants who demonstrate the ability to appropriately perform and commodify their trauma, while expelling those who fail to do so – not matter how productive that failure might be. How, then. Might these theoretical voices be brought into dialogue with multi-media responses to the 'Vixen controversy', and the way, this incident as a skirmish that speaks to wider debates about mental illness and fantasies of postraciality?

In this paper, I examine how The Vixen's fracturing of the preferred *Drag Race* story arc resonates with queer scholarship, which has been attentive to the imperative to tell positive stories, and the way, this silences melancholic, 'negative' voices. Heather Love writes of a tension in queer studies between the need to speak of 'damage', and a 'related and contrary desire to affirm queer existence' (2007, p. 2). Seen in this context, the Vixen's 'flounce' and return reveal the tensions at stake in queer media that operate at the intersection of these two conflicting and entangled imperatives. Further, Drag Race needs to be situated within a wider history in which madness and black rage have paradoxically been positioned as outside culture through regimes of hyper-visibility as well as in relation to current neoliberal narratives of stigma and 'recovery' (Costa 2014). Drawing on critical mental health scholarship, I argue that a mad reading of The Vixen's arc within the series and her refusal to complete that arc – and by extension of the show's treatment of other 'difficult' queens of colour – enables new understandings of the ways in which mad subjectivities intersect with racialised and gendered oppression, and the way these are struggled over in celebrity culture. In this sense, The Vixen's exit from Drag Race can be read as the culmination of a mad, queer and antiracist critique of the show's recovery politics, both in itself and in the fan and critical responses it engenders, and that opens up new ways of living with the difficult, ugly emotions that popular recovery narratives demand we relegate to the past.

Screening trauma

During its 10-year run, *Drag Race* has attracted hyperbolic praise for its support of the marginalised and outcast within society and in the drag community, preaching a gospel of self-love and self-care through the mantra: 'if you can't love yourself, how in the hell are you gonna love somebody else?', a phrase always greeted with mandatory cries of 'amen' and joyful dancing. Historically, it has mobilised individual stories about homophobia, family violence, racism and femmephobia, encouraging participants to speak out about these experiences in order to overcome them. The show has been described as 'much like drag itself ... reality TV's limit case, maximising the entertainment value of its contestants' personal histories' whose 'added layers of performance (on camera and on stage) and the salient LGBT issues make these moments ring all the more true, in a refreshingly direct way' (Betancourt 2016). Contestants have spoken about mental illness, HIV, gender transition, racism, Islamophobia and homophobic violence, usually in a supportive environment that celebrates queer survival above all else. This celebration of the weird, marginal and outcast is central to fan accounts of Drag Race, as exemplified in Season 4

when the show's audience were invited to help choose the winner, overwhelmingly voting for Gothic drag weirdo Sharon Needles. As cultural critic Domenick Scudera argues:

> '[in voting for Sharon Needles] People were actively engaged in supporting the weirdo, the victim, the vulnerable one. Hopefully, this outpouring of love managed to find its way to the kids out there who are being bullied right now. The message to these kids is loud and clear: ... RuPaul loves you; the nation loves you' (Scudera 2016)

Drag Race's runway, workroom and wider community are hence presented as a holding space, a site of queer kinship that fulfils contestants' historically unmet need for love and acceptance. This is reinforced by RuPaul's role as a symbolic mother whose star persona invokes a kind of eternal, idealised queer femininity rooted in ballroom, with its tradition of drag mothers, but also in tropes of ageing female celebrity. In mentoring exchanges, Ru appears as a therapist figure, dispensing often highly simplistic soundbites whose often victim-blaming content is at odds with their performative warmth and kindness, as in Season 7 when she tells Katya – who has struggled with substance abuse issues, anxiety and depression – 'you seem to be addicted to anxiety'.[2] The creation of drag celebrity, then, is deeply entangled with a confessional imperative; in order to achieve (albeit reduced) star status, contestants must consent to be broken down and rebuilt in RuPaul's own image.

This means Drag Race demands the constant production of personal trauma narratives in order for its narrative arcs to function. In Season 2, fan favourite Pandora Boxx movingly recounted how her experience of homophobia drove her to attempt suicide. Most notoriously, Season 5 queen Roxxxy Andrews recounts how her mother abandoned herself and her sister at a bus stop when she was three: as she collapses into tears, she is told, 'we love you, and you are so welcome here. You know we as gay people, we get to choose our family, we get to choose who we're around. We are a family, we are family here. I love you. I love you[3]' as judges Michelle Visage and Ru are shown delicately dabbing at tear-filled eyes, their performance of ladylike grief in stark contrast to Roxxxy's uncontrolled ugly-crying. To soaring, emotional music she is told, 'what you did on this runway is the passion I am looking for', the production of personal pain equated with winning in an almost parodic performance of neoliberal accounts of recovery. This is the 'money shot of emotional collapse' described by Luckhurst; the attainment of celebrity turns on this moment of confession 'expertly steered by [the host's] empathic identification with virtually any manner of suffering' (2008, p. 133). The episode ends – of course – with a group hug, signalling the re-incorporation of the traumatised subject back into the group 'family'. This is an ambiguous moment, inviting empathy but at the same time reminding us that in reality TV, 'confession, exhibitionism and emotional revelation [are] the conspicuous watermarks of authenticity and ethical commitment to audiences' (Biressi and Nunn 2005, p. 7).

To understand how The Vixen's fracturing of this happy family narrative opens up the potential for a more radical discussion of queer trauma, it is productive to turn to recent scholarship in Mad Studies. Lucy Costa defines this fluid an open field as 'an area of education, scholarship, and analysis about the experiences, history, culture, political organising, narratives, writings and most importantly, the PEOPLE who identify as: Mad' psychiatric survivors; consumers; service users; mentally ill; patients, neuro-diverse; inmates; disabled -to name a few of the 'identity labels' our community may choose to use' (Costa 2014). As such it is not simply a product of academic research but a wider

'project of inquiry, knowledge production and political action' (LeFrancois *et al.* 2013, p. 13) which draws on histories of survivor activism and on methods and conceptual frameworks from women's studies, queer studies and critical race theory, among others, mad studies suggest a radical critique of the 'recovery model' of mental illness at stake in contemporary anti-stigma campaigns and in celebrity media.

To this end, mad scholars have been critical of the voyeuristic nature of reality TV and celebrity culture, with its relentless demand for more horror stories, more coercively performed 'authenticity'. Seen through this lens, *Drag Race* feels uncomfortably close to what Costa et al. term 'survivor porn', in which 'some people reveal their most intimate personal details, [while] others achieve relief through passive watching, while still others profit from the collaboration of those on the front lines in compromised positions' (2012, p. 86). Drag Race's recovery stories, then, are part of a more general cultural shift in which 'telling stories' about mental health and trauma becomes a way of reinforcing rather than challenging neoliberal models of recovery, labour and social governance. 'Telling your story', usually with the nebulous aim of 'reducing stigma', becomes a way of individualising experiences of mental distress, making some forms of social inequality hyper-visible and concealing others. Ideas about recovery and self-expression are central to the show's ethos, which produce drag as a technology of recovery: a means of standing up, making up, walking tall and rising above trauma, embodying the notion that 'it gets better' (Scudera 2016). The progression from local celebrity to Hall of Famer is depicted as an individual journey of self-discovery that leads away from pain: as Alyssa Edwards puts it, 'don't get bitter, just get better'.[4] Favoured stories 'feature the uplifting message that with a little hard work and perseverance, you too can be cured' (Costa *et al.* 2012, p. 89). And yet the familiar tropes of reality TV – zooming in on crying faces, the use of sentimental music to heighten particularly emotive scenes, the deliberate provocation of conflict in order to profit from distress – sit in uneasy tension with this optimistic narrative. To continue to be traumatised under such scrutiny marks contestants as beyond help: that is, as mad. As Simon Cross notes, 'mad' subjects are represented as the constitutive outside of culture (2004, p. 199). In this instance, they threaten both the happy queer postracial family the show invokes, and the boundaries of appropriate drag celebrity itself, echoing Lisa Blackman and Valerie Walkerdine's analysis of the way madness threatens the limits of the unitary subject: 'having lost the ability to distinguish self and other' such that the mad subject is 'viewed as a danger to both himself and the public at large' (2001, p. 126).

As Cross reminds us, representation is central to discourses of madness: the mad subject is overwhelmingly represented through the idea of 'visible differences of appearance and behaviour that demarcate a symbolic boundary between 'us' and 'them' (Cross 2004, p. 199). Celebrity culture has historically been concerned with the delineation of this boundary: it is often through celebrity figures that anxieties around trauma and madness are negotiated and struggled over. As such, it operates within a wider history in which mad bodies have paradoxically been positioned as outside culture through regimes of hyper-visibility (Gilman 1976, Showalter 1987, Cross 2004). In particular, the current antistigma discourse has been critiqued for its oppositional framing of the redeemable subject suffering distress versus the irredeemably mad, an opposition which both obscures and reproduces social inequality: or as Brigit McWade argues, 'representing mental health as everyone's business belies the significant inequalities inherent in our current system' (2018, p. 158). The overdetermination of stigmatised bodies in celebrity culture matters,

since it works to silence questions of actual social inequality 'with the promise that once we understand the facts of mental illness, stigma will be eradicated' (McWade 2018, p. 158).

This resonates with fan responses to *Drag Race*, in which 'somewhere along the line people accepted the values of *Drag Race* as universal, moral fact; that the way to overcome is to pull yourself up by your bootstraps', as one critic put it (Flores 2017). Although the show overtly takes its responsibility to LGBTQ+ audiences seriously in a context where queer subjects are disproportionately likely to suffer from mental distress (McDermott and Roen 2016), it is less willing to reflect on its own complicity with the conditions that cause or intensify distress. Thorgy Thor, who appeared in Season 8 and has depression and anxiety, has spoken of how the emotional labour involved in drag celebrity contributes to the severity and frequency of symptoms, noting that drag queens 'never sleep, we perform, people expect us in the subway to "turn on the fun" when we don't feel like it or we're just shopping at the grocery store' (Nichols 2018). Sharon Needles tells of the emotional and physical toll taken by 'being in drag from 7.30 in the morning until 11.30 at night', at the mercy of continual attempts by producers to stoke conflict (Fossum 2014). These experiences suggest something messier, less linear, than the stories of recovery we see onscreen. Yet 'winning' is always figured as a process of becoming-sane that refuses the more creative – and also more difficult – affordances at stake in mad subjectivity, and in drag as an art form. In representing mental distress as something to be discarded on the road to fame, *Drag Race* risks closing down radical possibilities for queer solidarity, repeating the tired and oppressive celebrity tropes that position the 'hot mess' outside the boundaries of appropriate celebrity. At the same time, its very mainstream visibility, together with the intersection between different media spaces, platforms on which the show depends, mean that this closure is never complete. In order to understand how this struggle plays out in practice, I want to examine how narratives of queer and Black rage play out across their very different celebrity platforms.

Refusing black rage: RuPaul's cruel optimism

The Vixen's constant destruction-testing of the narratives of queer and postracial optimism at stake in Drag Race's ethos, her pushing at the boundaries of acceptable behaviour for a celebrity queen, can be seen as a dramatisation of Lauren Berlant's theory of cruel optimism, defined as 'how we are bound to desired futures that prevent us from flourishing in the present' (2011) in 'something you desire is actually an obstacle to your flourishing' (2011, p. ix). Optimism is doubly cruel, she writes, when 'the very pleasures of being inside a relation have become sustaining regardless of the content of the relation, such that a person or a world finds itself bound to a situation of profound threat that is, at the same time, profoundly confirming', a formula which precisely speaks to the attachment to fame embodied in *Drag Race* (2011, p. 2). This speaks to the drama of the reality TV celebrity who must constantly relive trauma: because this reliving is presented helpful to others, both in providing a point of identification for fans and in challenging stigma, its potential to re-traumatise is never acknowledged. Paradoxically, contestants are made to relive trauma over and over again, a relation which looks less like therapy and more like the dynamic of trauma itself, which precisely binds us to abusive pasts through emotionally charged repetition. Contestants are trapped in these stories even as they are urged to move forward into a future in which freedom is envisaged as one where individual self-love is reinforced and mirrored by the love

of the audience. After all, 'if you can't love yourself, how in the hell are you gonna love anyone else' – a feelgood phrase which invalidates the actual capacity of traumatised subjects to love alongside living with their wounds. If we focus on the show's use of trauma narratives, we see in action Berlant's argument that it is the very pleasure and investment in therapeutic cultures by participants and fans alike that prevent actual connection through the articulation of more painful, difficult, contingent relations to trauma than the show's format allows. Focussing on drag – and the way that flounces, absences, critiques and breakdowns are enfolded into and extend drag performance – it is possible to find more creative approaches to survival which resonate with performers and audience alike. In fact drag itself – where the dazzling and seamless illusion we see on the runway is achieved only through intense labour, discipline and creativity – represents a more progressive model of survival, and of self-care, than the show's actual discussions of mental health.

Further, Drag Race shows us that optimism perhaps is most cruel when we invest it in celebrities and forms of popular entertainment that appear to provide a place of safety, because they so often disappoint us. This is starkly clear when we examine the show's racial politics, which, far from delivering on this promise of queer optimism, suggest a more ambivalent relationship to structural violence. If, as I argue, drag can be read as a complex technology of survival, Drag Race's performances of racial identity doubly fail to achieve this potential. In producing drag as a means of soothing social anxiety through containment and closure, and especially in producing drag celebrity as a pyramid scheme in which trauma exists only in order to showcase one's ability to overcome it, the show forecloses possibilities for less hierarchical queer solidarity. This is never more visible when it gestures to a postracial future that operates by ascribing 'sensitivities' about racism to a past which, paradoxically, constantly erupts in the present.

This is evident in Season 9, where one of the story arcs between episodes was that of Nina Bo'Nina Brown, whose uncompromisingly confrontational drag and struggles with depression led to a narrative of white queens' resentment at having to 'deal with Nina'. Brown was constantly criticised for her low self-esteem: as one white contestant put it, 'we can't stop cheering for her [sic] when she isn't even willing to cheer for herself'. Another contestant, in full command of Drag Race's lexicon of neoliberal recovery discourse, insisted that in terms of depression 'you are fully in control of what sort of day you're going to have'. Nina's storyline, with its tragic narrative of failed potential, reveals a tension in which the show both invokes therapeutic discourse, and yet is unable to reflect on its own complicity in reproducing ableist and racist narratives. As one critic summarises,

> At the end of the day, Nina isn't given the same autonomy that white queens are given ... No one wants to embrace the complexity, the good and badness of being a queer person on a violent, hateful planet. They just remind us that it's not "RuPaul's Therapy Race" (Flores 2017)

The narrative of queer family as welcoming and supportive home, and of transcendence through fame, fractures at the moment when a queen is unable to 'recover' from depression at a pace compatible with cliché character arcs. Persistent depression breaches the established boundaries of confessional storytelling, stubbornly refusing conventional resolution; it can be messy, unattractive and nonlinear: worse, the cruel optimism at stake in the notion that 'it gets better'[5] can be traumatising in itself for subjects whose attempts to manage and overcome their distress are inevitably read as failure, a notion that can be actively dangerous when internalised. That Nina's drag continued to push

creative boundaries *in spite of* her obvious despair and alienation failed to save her: instead – remarkably in a format that celebrates the creativity, artifice and adaptability of oppressed subjects – Nina's 'madness' negates and cancels her spectacular performances on the runway. Not only is continuing to be depressed a choice; winning contestants are defined as such precisely by their ability to internalise the notion of all emotion as a personal choice and to incorporate this into their drag. This is nowhere more visible than in the show's approach to racial pastiche.

Throughout *Drag Race*'s run, black and minority ethnic contestants have been urged to resolve racial trauma by engaging in self-conscious parody of racialised tropes, often resulting in highly offensive performances based on racist, classist and orientalist stereotypes (Han 2015, Garvin 2019). As with RuPaul's own persona – not so much a parody of white femininity as of black female stars' adaptability in incorporating white beauty ideals – the requirement to 'laugh off' the pain of racist stereotypes is inextricably stitched into *Drag Race*'s notion of ideal drag celebrity. This double requirement – that black queens both embody white beauty ideals, while also demonstrating the ability to perform racist tropes – is particularly difficult for the Vixen, whose own celebrity involves recognising racial politics and celebrating black identity. In a parody of cis black feminine celebrity, black queens must avoid appearing too political, too 'messy', and above all too angry; Black bodies are hence repeatedly prioritise the need to manage the fears and anxieties of the white audience over any responsibility they may feel to fans of colour. Queens of colour have been praised for stereotypical racialised performances, such as Stacey Lane Matthews' embodiment of the fried chicken eating 'Welfare Queen' image, a figuration of grotesque, excessive femininity that is deeply gendered, racialised and classed. Through this labour, racism is 'made safe' for performer and audience alike, suggesting that drag celebrity must manage and conceal its distress to connect with an audience that needs to be comforted and protected from the painful reality of white supremacy.

This became starkly clear when Asia O'Hara told Twitter about a childhood incident when her neighbours attempted to set her on fire for being gay; explaining that trolls had recently threatened to set her on fire again, this time because she is Black, an experience that re-traumatised her (Damshenas 2018). Far from being left behind, Asia's trauma re-surfaces because it is intrinsically linked to the structures and politics of the present, as a result of her new visibility as a celebrity of colour. In mad spaces, much attention has been paid to the cult of toxic positivity, and the ways in which it operates to invalidate negative feeling, discourage structural critique, silence real experiences of distress. It is impossible not to hear its echo in RuPaul's own remarks about what he sees as the unattractive and unsaleable nature of black rage and the extent to which *Drag Race*'s appeal lies in its avoidance of those aspects of the African-American experience that white audiences find least palatable:

> People have always been threatened by me as an African-American man, because of the inherent black rage that all black people have in our culture, the underlying black rage because of what happened to us in this country. It's always there … one of the ways that I've been able to dilute that perception is to dress as a character that says, 'Look I'm fun, I can have a sense of humour about life because I'm in drag. … So then people are like, 'Oh, OK, so we can laugh together, we don't have to address the black rage.' (Aitkenhead 2018)

Not speaking about black rage thus becomes a way of maintaining star status and securing the attention of a white supremacist audience: the creation of positive

connection turns on the marginalisation of subjects who are not able to leave their experience of racial inequality at the door. In this light, the show's constant reproduction of racist tropes begins to look less like an attempt to rid these tropes of their power to hurt, and more like the visible symptom of rage turned inward. In other words, the performance of an appropriate celebrity is intrinsically tied up with the labour of internalising and reproducing toxic positivity. Fame itself, then, is a kind of labour of toxic positivity that is most visible in representations of the damaged celebrity.

Again, this echoes mad critiques of the white supremacist values inherent in recovery discourse. As Dom Chatterjee argues, in order for the recovery journey to make sense we are supposed to accept that trauma is in the past, even as it is constantly dragged out for public consumption. But when trauma is tied to systemic oppression, leaving it in the past is both impractical and politically undesirable: 'Given that safe spaces are an ideal, not a reality for most of us, these kinds of statements are invalidating. If feeling safe is a required condition for healing, that makes any kind of recovery inaccessible to those of us enduring chronic trauma from the world around us'. He concludes, "we are expected to get well, [but] nobody asks if the picture of wellness that's supposed to be the end goal is even good for us' (2017). The lack of safe spaces is made even more stark in celebrity culture, where intimacy and accessibility are key.

I should say, here, that all this is emphatically not to say that there is no hope, that healing is impossible; nor am I denying the importance of these queer life stories being told in such a popular format or of their power to move. It would be a detached critic who managed not to weep along with Michelle, Ru and Alyssa during such moments of high drama. Nor am I suggesting that testimonies of abandonment, trauma and loss are necessarily deprived of their power when presented in a highly dramatic, emotionally charged way. Whatever our justifiable scepticism towards the 'it gets better' narrative, there is something deeply distasteful about criticism which seeks to police the way in which survivors get to speak about and profit from their stories. As the show's fan spaces demonstrate, contestants' testimonies can be a lifeline for viewers experiencing similar pain. Many have written of the show's importance as part of an assemblage of self-care: those of us who live with depression, for instance, might recognise ourselves in Melanie McFarland's moving account of 'Ru ... calling people – calling me – to lip-sync for my life. To wake the hell up and be gorgeous again' when 'the very concept of gorgeous was altogether forgotten, a memory as garbled and scratchy as an old club track' (2016). This deeply camp version of what it means to live with mental distress – the idea that the show must go on, hiding broken hearts behind sequins and greasepaint – has always been entangled with queer and femme celebrity. As a way of coping with mental distress, it has its advantages over the dour self-discipline, the earnest mindfulness, the white bourgeois back-to-nature, anti-culture tropes that the contemporary recovery ethos all too often involves. Through affective identification with drag celebrities, it seems, a different way of living with trauma might be possible. Far from mere reality TV exploitation, *Drag Race*'s constant exhortation to love oneself (and through doing so, to become more open to loving others) is grounded in queer practice: as Manuel Betancourt (2016) writes, the 'rhetoric of self-love as a form of self-care has always been essential in the world of drag'.[6]

Yet we need to remember that this identification, this weeping along, takes place in a world where Aquaria's white tears are culturally valued, where they enhance her celebrity capital in a way that The Vixen's anger, or Nina's continuing pessimism and

negativity, are not: where we are encouraged to identify with Roxxxy's pain but to disavow The Vixen's rage. RuPaul's ultimate inability to understand, to hold space for queer black rage, is disappointing precisely *because* of drag's origins in spaces of queer and racialised trauma, as a way of living-as marginal subject. In his parody of Oprah and Tyra-like figures, RuPaul proposes a new way of doing celebrity: one which recognises the freaky, the marginal, the different. Yet his failure to embrace The Vixen's drag, which takes up the figure of the angry black woman in a genuinely exciting way that exceeds the boundaries of accepted Drag Race celebrity, producing a moment of productive mad and queer failure, reveals this as cruel optimism. In the reunion episode, RuPaul's angry monologue turned on the Vixen's perceived negativity, her frustration at being silenced, and ultimately her use of silence and absence as the only remaining forms of protest available to her. In choosing the established tropes of celebrity culture over a more open-ended and honest resolution, the show misses an important opportunity to speak differently about queer trauma – whatever that might mean.

In suggesting that trauma narratives are constructed and artificial, finally, I am not suggesting that they are necessarily inauthentic or that there is some 'truly authentic' form of survival narrative that reality TV formats conceal; nor am I proposing that the Vixen's performance is 'more authentic', since to do so would be to reproduce problematic discourses that have always constructed black bodies as Other. But in acknowledging the power of self-care discourse, it becomes all the more critical to pay attention to what it excludes: to what happens when perceived 'madness' threatens to exceed the boundaries of socially permitted trauma narratives – when drag itself becomes a performance of black distress, black rage: when it questions the value of contrived redemption arcs in a world that literally wants to set you on fire. Refusing the melancholic reproduction of racial stereotypes the show typically demands, The Vixen's performance of excessive black femininity speaks both to the reality of oppressive social structures *and* to the intimate and personal experience of distress that living within such structures entails. Importantly, in opening up this space, she enables a refiguring not just of the way we think about queer trauma, but of the way trauma is implicitly represented, contained and struggled over in celebrity culture as a whole.

Conclusion: being irredeemable

In refusing containment, Vixen resists the desire to consolidate a sense of one's self in a culture seemingly devoid of meaning' that reality TV demands (Biressi and Nunn 2005, p. 100). If therapeutic discourses provide a language through which to make sense of subjective experience in a world where 'power structures and decision-making processes appear to alienate and exclude the individual' (Biressi and Nunn 2005, p. 104), in becoming irredeemable, she opens up a space to affirm the very queer trauma and black rage which *Drag Race* attempts to resolve. In the exhortation to 'just get better', the popular image of the mad 'as aggressive, out of control, and unable to normalise their behaviour' (Cross 2004, p. 205) is not disrupted, but is instead displaced on to participants who – whether for reasons of ongoing distress or a political commitment to refuse incorporation – are unable or unwilling to 'normalise their behaviour'. In becoming absent, she reveals the limitations of popular trauma narrative: to speak of the mental distress occasioned by trauma thus requires a commitment to recovery which is precisely a disavowal of mad identity. Hence, the mad subject cannot

speak, since the very conditions of speaking entail a commitment to becoming not-mad. To refuse such a commitment is to be positioned as both difficult and dangerous. The conversations she engenders, through her willingness to embody the 'trash, garbage and cancelled', demonstrate Judith Butler's argument that it is wrong to conceive of individual bodies as completely distinct from one another, that 'we cannot imagine the political meaning of human body without understanding those relations in which it lives and thrives': that 'the body, despite its clear boundaries, or perhaps precisely by virtue of those very boundaries, is defined by relationality' (2014). 'Making connections' here becomes not simply a matter of incorporating culturally scripted conversations into our everyday practice, but of producing new social frameworks that allow subjects to speak from a space of trauma, and to question the very conditions of labour and spectatorship that structure those conversations. They make visible the ways in which institutions, nations and communities secure complicity with normalised regimes of violence through techniques of silencing and shaming, and they do this all the more powerfully since they provide spaces for acknowledging histories of shame without immediately demanding an individual commitment to overcoming. To quote Sara Ahmed, emotions 'create the very effect of the surfaces or boundaries of bodies and worlds ... emotionality involves movements or associations whereby "feelings" take us across different levels of signification, not all of which can be admitted in the present'; they are hence 'bound up with the "absent presence" of historicity' (2004, p. 117–119). This has implications for our understanding of some subjects, feelings or behaviours as disordered; our dominant framing of madness precisely turns on the production of some emotions as both excessive (causing distress to the subject) and insufficiently internalised (causing distress to others). Madness hence threatens the boundary between self and other, carrying a danger of social disruption that demands containment. This threat is both denied and implicitly acknowledged in the currently fashionable exhortation to 'speak out' about mental distress.

For Love, there is power in those things that cannot be redeemed, or whose redemption cannot be accomplished through worn-out cultural scripts available to us. As she argues, 'Texts or figures that refuse to be redeemed disrupt not only the progress narrative of queer history but also our sense of queer identity in the present. We find ourselves deeply unsettled by our identifications with these figures: the history of queer damage retains its capacity to do harm in the present (2007, p. 8–9)'. Above all, The Vixen poses the question: what if it doesn't get better – or gets better only in contingent and messy ways? And how might surviving precisely *as* a body-in-distress in itself constitute a radical act? This not only challenges dominant ways of thinking about mental health and trauma but allows us to rethink the ways in which media exploits the notion of the celebrity 'hot mess' through cycles of repression and excess.

In this context, the 'angry black woman' as multimedia drag persona becomes a focus of productive failure: failure to produce idealised white femininity, to appropriately manage emotion, and to deny and internalise black rage. Seen in this light, The Vixen does not 'fail' at drag celebrity on the show's terms, but rather expands our sense of what drag celebrity can be and do. This resonates with Rachel Alicia Griffin's powerful reclaiming of the 'angry black woman' as a figure who can 'do the very things that Black women are discursively disciplined not to do. I will rant without a hint of regret ... with my head held high believing that I am worth standing up for in a world that crudely tells me otherwise' (2012, p. 138). In taking herself literally out of the limited frame that *Drag Race* allows black queens, Vixen is able to take control of her narrative through a critical moment of fragmentation in the cruelly

optimistic fantasy of recovery at stake in Drag Race's version of drag celebrity. In a context where celebrity culture increasingly functions as a way of thinking through the ways in which historical trauma survives in the present, her dramatic exit and return constitute a powerful refusal of celebrity damage narratives that insist on dominant notions of recovery. In refusing erasure, she shows us a creative and fiercely celebratory way of affirming damage. If we resist the idea that particular identities, bodies, emotional orientations are in need of correction and containment, what newer, more radical forms of connection might be possible? Further, how might this require us, as audiences and critics, to examine our complicity with the violence inherent in such narratives of correction, and the disproportionate demands such narratives make on contestants with marginalised identities? As critic Matthew Rodriguez (Rodriguez 2018) asks 'what, then, does it mean to show love for the Vixen'?

Notes

1. *RuPaul's Drag Race: Untucked!* Season 10, episode 3, Diva Worship. VH1: 14 March.
2. *RuPaul's Drag Race*, 2015 Season 7, episode 7, Snatch Game. Logo TV, 13 April.
3. *RuPaul's Drag Race*, 2013 Season 5, episode 7, RuPaul Roast. Logo TV, 11 March.
4. *Rupaul's Drag Race*, 2013 Season 5, episode 2, Lip Synch Extravaganza Eleganza. Logo TV, February 4.
5. See Puar (2012) for a more detailed critique of the ways in which Dan Savage's 'It Gets Better' project reproduces neoliberal values, and how this might be productively challenged.
6. More recent reality TV productions have foregrounded self-love to an even greater extent than *Drag Race*, to equally problematic yet moving effect: see, for example, the rebooted Queer Eye, whose 'fab five' embodies this version of queer celebrity as self-love guru.

Acknowledgments

I am grateful to Paul Byron for the Facebook conversation that inspired this article, and to Tom Brassington for reminding me about the bus stop incident.

Disclosure statement

No potential conflict of interest was reported by the author.

References

Ahmed, S., 2004. Affective economies. *Social Text*, 22 (2), 117–139. doi:10.1215/01642472-22-2_79-117
Aitkenhead, D., 2018. RuPaul: 'Drag is a big f-you to male-dominated culture'. *The Guardian*, 3 Mar. Available from: https://tinyurl.com/y22urx66
Berlant, L., 2011. *Cruel Optimism*. Durham: Duke University Press.

Betancourt, M., 2016. RuPaul's Drag Race and the art of self-love. *The Atlantic*, 14 May. Available from: https://tinyurl.com/y372asz5

Biressi, A. and Nunn, H., 2005. *Reality TV: realism and revelation*. London: Wallflower Press.

Blackman, L. and Walkerdine, V., 2001. *Mass hysteria: critical psychology and media studies*. London: Palgrave.

Butler, J., 2014. Rethinking vulnerability and resistance. *In*: J. Butler, Z. Gambetti, and L. Sabsay, eds. *Vulnerability in resistance*. Durham, NC: Duke University Press, 12–27.

Chatterjee, D., 2017. Mental health is different for people of color in these 3 ways. *Mad in America*, 17 May. Available from: https://tinyurl.com/yykxrfbv

Cole, E. and Zucker, A., 2007. Black and White Women's perspectives on femininity. *Cultural Diversity and Ethnic Minority Psychology*, 13 (1), 1–9. doi:10.1037/1099-9809.13.1.1

Costa, L., *et al.*, 2012. Recovering our Stories: a small act of resistance. *Studies in Social Justice*, 6 (1), 85–101. doi:10.26522/ssj.v6i1.1070

Costa, L., 2014. Mad Studies – what it is and why you should care. *Mad Studies* (blog). Available from: https://tinyurl.com/y59cos65

Cross, S., 2004. Visualizing madness: mental illness and public representation. *Television and New Media*, 5 (3), 197–216. doi:10.1177/1527476403254001

Damshenas, S., 2018. Asia O'Hara "threatened to be burned alive" by racist Drag Race fans. *Gay Times*, 20 June. Available from: https://tinyurl.com/y3x67dcw

Dry, J., 2018. RuPaul's outburst on the 'Drag Race' reunion is the most powerful moment of season 10. *Indiewire*, 21 June. Available from: https://tinyurl.com/y5x2jpk2

Ferreday, D., 2017. Like a stone in your stomach: articulating the unspeakable in rape victim-survivors' activist selfies. *In*: A. Kuntsman, ed. *Selfie citizenship*. London: Palgrave MacMillan, 127–136.

Flores, B., 2017.We still need to talk about how Drag Race treated Nina Bo'Nina Brown. *Pride*, 29 June. Available from: https://tinyurl.com/y629a86x

Fossum, M., 2014. Sharon needles on RuPaul's Drag Race: "they took away our booze and terrorized us". *New Times*, 20 May. Available from: https://tinyurl.com/y3vy6caa

Garvin, K., 2019. Sorry — love you': Asian Americans on 'RuPaul's Drag Race. *Clyde Fitch Report*, 23 Mar. Available from: http://tinyurl.com/yywxxrwl

Gilman, S., 1976. *The face of madness: hugh diamond and the origins of psychiatric photography*. New York: Palatine.

Griffin, R.A., 2012. I am an angry Black Woman: black feminist autoethnography, voice, and resistance. *Women's Studies in Communication*, 35 (2), 138–157. doi:10.1080/07491409.2012.724524

Han, C.W., 2015. *Geisha of a different kind: race and sexuality in gaysian America*. New York: New York University Press.

Hawbacker, K.T. and Tucker, S., 2016. Chicago's black drag queens are upholding a radical gender-bending tradition. *Chicago Tribune*, 11 Aug. Available from: https://tinyurl.com/ybhqm3w8

Illouz, E., 2003. *Oprah Winfrey and the glamour of misery*. New York: Colombia University Press.

LeFrancois, B., Menzies, R., and Reaume, G., eds., 2013. *Mad matters: a critical reader in Canadian mad studies*. Toronto: Canadian Scholars' Press.

Love, H., 2007. *Feeling backward*. Cambridge, MA: Harvard University Press.

Luckhurst, R., 2008. *the trauma question*. London: Routledge.

McDermott, E. and Roen, K., 2016. *Queer youth, suicide and self-harm: troubled subjects, troubling norms*. London: Palgrave MacMillan.

McFarland, M., 2016. RuPaul gave me life: how Drag Race pulled me back from the depths of depression. *Salon*, Mar 22. Available from: https://tinyurl.com/y436pfso

McWade, B., 2018. Madness, violence and media. *In*: P. Beresford, A. Daley, and L. Costa, eds. *Madness, violence and power: a critical collection*. Toronto: University of Toronto Press, 150–163.

Nichols, J.M., 2018. RuPaul's Drag Race stars open up about mental health and the toll of super-stardom. *Huffington Post*, 18 Jan. Available from: https://tinyurl.com/y3w5yobt

Ouellette, L. and Hay, J., 2008. *Better living through reality TV: television and post-welfare citizenship*. Malden, MA: Blackwell.

Puar, J., 2012. The cost of getting better: suicide, sensation, switchpoints. *A Journal of Lesbian and Gay Studies*, 18 (1), 149–158. doi:10.1215/10642684-1422179

Rodriguez, M., 2018. How 'RuPaul's Drag Race' makes room for Queer Black trauma. *Into*, 10 May. Available from: http://tinyurl.com/y6g468nz

Scudera, D., 2016. It gets better: drag edition. *HuffPost*, 2 Feb. Available from: https://tinyurl.com/y36zmgau

Showalter, E., 1987. *The female malady: women, madness and English culture, 1830–1980*. London: Virago.

Fifteen Seconds of Fame: Rupaul's drag race, camp and 'memeability'

John Mercer and Charlie Sarson

ABSTRACT

In this article, we argue that the campy affectations of contestants of *RuPaul's Drag Race* (*RPDR*) serve as the perfect vehicle through which GIFs and memes can be created and have the potential to go viral online. *RPDR* relies heavily on social media for its success, and we claim that the queens who go on to establish a celebrity persona beyond the show are often the ones who fully exploit this relationship by condensing themselves into self-branded caricatures. These simplified personas, with their distinctive phrases, quirks and idiosyncrasies, can be easily captured and expressed in short GIFs, clips and memes. We argue that memeability – that is, having a persona that lends itself to becoming a meme that in turn acts as a mechanism in the production of stardom – is the online celebrity's equivalent of charisma in the social media age. In this article, by drawing on queens from *RPDR* such as Miss Vanjie and Alyssa Edwards, we assert that virality and memes have become part of the celebrity-making process, as well as a vehicle to enable brand collaborations and capitalisation.

Introduction

Episode 1, season 10 of *RuPaul's Drag Race* (*RPDR*) culminated, as usual, with a runway show and elimination of a queen according to a format that had been refined and established over a decade. This, however, was not to be like other seasons as the first queen to exit the show, Vanessa Vanjie Mateo, better known as Miss Vanjie, was to quickly become one of the most memorable of any of the contestants during the previous decade of programming. In a rare moment when the expression *coup de théâtre* might accurately be applied to a staged event, Miss Vanjie after failing the lip sync challenge, exited the stage walking backwards, intoning her name 3 times; 'Miss Vanjie … Miss Vanjie … Miss Vanjie … '

Almost everything about this incident, lasting a mere 15 seconds, was remarkable; from the camp excess of Vanjie's outfit, festooned with pink and purple silk flowers, further adorned with plastic dolls and fish, her inch-long eyelashes and blonde wig that she chose to run her gloved fingers through in a gesture of languorous glamour, to the disparity between the hysterical vision of femininity that she presented to the judges that were underscored by her gravel-voiced incantation of her name as she appeared to retreat ghost-like and somnambulant, offstage and into obscurity.

Viewers already understand that being the first queen to be eliminated from *RDPR*, just as being the first contestant to leave any reality TV show, is to be showered with ignominy. Indeed, the competitors of such programming are routinely positioned as unready and unfit for celebrity status and therefore supremely forgettable and disposable. However, Miss Vanjie's social media afterlife meant that she was not destined to disappear so quickly. In the hours after her departure viral clips of the exit rapidly circulated on Youtube, Facebook and Twitter.[1] A subsequent extract from the following episode showing RuPaul and fellow judge Michele Visage suppressing laughter at the extraordinary exit was to further consolidate the camp hysteria and therefore viral potential of Miss Vanjie.[2] In the following weeks, the clip became one of the most talked about moments from season 10 circulating as a GIF and transformed into an especially popular and pervasive meme.[3] Such was the success of the Miss Vanjie meme that it has found its place into the Urban Dictionary summed up thus:

Gay culture is exiting a room backwards and saying "Miss Vanjie Miss Vanjie ... "[4]

Vanjie's subsequent rise to fame and victory in the midst of her seeming defeat, ostensibly based on 15 seconds of televised footage appropriated, and circulated as a meme, seemed to shatter the generic conventions of the reality TV competition show and the trajectory of celebrity that it promulgates. Rather than a therapeutic struggle against adversity to ultimate victory within the televised *RDPR* diegesis, Vanjie instead became the star of season 10 and a fully fledged celebrity in her own right (returning to the show in the following season) due to the viral online success of her televised failure. Whilst Miss Vanjie was exhorted to 'sashay away' at the end of the first episode, the manner (and mannerism) of her exit meant that she became an ever-present absence throughout the season, her departing lines repeated, revised and revisioned by the judges and other contestants alike.

In this essay, we suggest that the celebrity of Miss Vanjie tells us something about both the narratives of celebrity in the digital age and the ways in which viral clips, GIFs and internet memes circulated on social media have become imbricated in the construction of a celebrity persona.

Chris Rojek has previously argued that celebrity status belongs to one of the 3 orders; ascribed, achieved and attributed. Ascribed meaning born into fame, achieved through talent and attributed through 'the concentrated representation of an individual as noteworthy or exceptional by cultural intermediaries' (2001, p. 18). Notwithstanding reservations about the rather rigid demarcations that Rojek suggests, almost 20 years later it is possible to see the ways in which celebrity in a reality TV format show like *RDPR* can be constructed as simultaneously existing at the intersection of the axes of these vectors of fame. For instance lineage (specifically matrilineage) is of crucial importance within drag culture and it is established by being adopted by a drag mother as a young queen into her drag family (Hopkins 2004). Miss Vanjie, for instance, is the drag daughter of Alexis Mateo who was a contestant in season 3 and part of the line up for season 1 of *RuPaul's Drag Race All Stars*. Queens become contestants through their reputation as skilled drag performers (singers, comedians, hostesses, pageant queens) in their locality gaining fame or a following via Instagram (based on the skills that go into their drag looks and consolidating that fame through media attention via social media).[5] Consequently, we suggest that Rojek's categories of celebrity are blurred in the contemporary media landscape.

So in this essay, we are looking at several related issues; the extent to which the construction of celebrity in *RDPR* (and more generally) relies on social media in the twenty-first century, the textual qualities and camp affordances of virality, GIFs and memeability that enable the creation of a drag race superstar persona and the extent to which fan investment via the circulation of memes is critical in the construction of contemporary celebrity and the extent to which this resists (or queers) the image management strategy of the entertainment industries.

Notes on mainstreaming drag and camp

At the most quotidian level, we need only acknowledge the evolution of the production and distribution history of *RPDR* to make a case for the mainstreaming of drag alongside a concomitant broadening out of camp as a system of meaning-making. *RDPR*, since the first season in 2009, has been produced by *World of Wonder*, known for programming (largely reality and documentary formats) that focuses on sexuality and sexual subcultures. As such, their content has a tendency to attract small but dedicated fanbases and to become associated with what might be considered cult television. The channel that first hosted the show, *Logo TV*, further fomented this initial sense of a niche and specific audience. This American channel – one that comes as part of a paid subscription to a specific provider – originally targeted gay and lesbian audiences, showing repeats of shows that have since become 'gay classics' (such as the British sitcom *Absolutely Fabulous*), and commissioning other originals such as *RPDR*. However, as of season 9 that first aired in 2017, the show moved to *VH1*, a sister channel of *MTV*. The demographic for this channel is far broader than that of *Logo TV*, and as of 2016 (the year before it began hosting *RPDR*), the channel was received in over 90 million US households – 40 million more than *Logo TV*. In addition, as of season 11, the streaming site *Netflix* acquired distribution rights of *RPDR* to the UK, meaning the show could become branded a 'Netflix Original'. The easy online accessibility to *RPDR* via *Netflix*, coupled with its dedicated fanbase sharing clips, stills and quotes on social media, opened the show to a wider audience. Away from the cameras, many of the most popular queens from across seasons have toured with the *Werq the World* tour, performing to sold-out venues across the USA and Europe. What this demonstrates is an exponential growth in audiences for *RPDR* and a trajectory towards a wider public consciousness. Whereas RuPaul himself may argue that drag will never become mainstream,[6] *Drag Race* seems destined to move in exactly that direction. As such, the camp pleasures that the show offers have become open to, and *made open to*, a far wider constituency than what could be termed the 'LGBTQ+ community'.

Notwithstanding the expanding audience share for *RDPR*, the connections between the mainstreaming of drag performance and a wider investment in camp humour and celebrity culture are already strong. Indeed, it's virtually impossible to disentangle any discussion of particular forms of stardom from camp as one of the principle mechanisms for the circulation of celebrity meaning across popular culture. As we will note later on in this essay the potential for a camp reading is part of the ways in which a celebrity persona is constructed more generally and is axiomatic to the construction of a drag persona. Therefore, the extent to which RuPaul and the queens of *RPDR* have become enmeshed

within, rather than ironically commenting on, celebrity culture deserves some consideration and has been consolidated by the serendipitous circumstance of the 2019 MET Gala.

Since the early 1970s under Diana Vreeland's control, the MET Gala has been regarded as one of the most glamorous of New York social events. In recent years, with a celebrity guest list presided over by Anna Wintour and the staff of *Vogue* and tickets costing 30,000, USD it is an event synonymous with exclusivity, glamour, extravagance and prestige. Each year the MET Gala is themed to reflect that this lavish spectacle is ostensibly a fundraiser for the Costume Institute of the Metropolitan Museum of Art. In 2019 the theme of the MET Gala was 'Camp: Notes on Fashion'.

It was perhaps an inevitability given the international success of *RDPR* and RuPaul's celebrity status and regular appearance on syndicated US TV shows like *Saturday Night Live* (*SNL*) that he would be on the guest list for the MET Gala. We choose the pronoun 'he' advisably here as given the limitless potential for camp excess the event offered, instead RuPaul appeared on the red carpet (albeit in a pink sequined zebra print tuxedo accessorised with a feather boa) as his male self. This choice was to raise some eyebrows and was rationalised, rather tenuously, on the basis that RuPaul never drags up unless he is being paid to do so.[7] It perhaps makes more sense to think about the choice in terms of the pragmatics of managing a career as a mainstream celebrity and clearly establishing RuPaul Charles' celebrity persona alongside that of Mama Ru who now resides within the controlled *Drag Race* universe. Charles' career ambitions demonstrably exceed the world of drag and he is repeatedly touted as a potential guest host of shows like *SNL*. Whilst, on the one hand, this might suggest a disavowal of the very subculture that has afforded RuPaul fame, drag is always in one way or another about transformation, becoming and moving beyond even when that transition is to move past a drag persona.

Perhaps to compensate for RuPaul's sartorial restraint, two queens from *RDPR* also appeared on the MET Gala red carpet. The first being season 10 winner Aquaria, in an outfit inspired by Julie Andrews in *Victor/Victoria* (a camp classic about cross-dressing) and season 7 winner Violet Chachki, whose 1950s haute couture references have meant that she is courted by the fashion establishment as a model.[8] It's notable that none of the more extravagantly camp queens made an appearance. The queens allowed to wear drag on the red carpet at this prestigious event were instead what might be described as fashion queens or 'convincing' female impersonators and their outfits understood as intertextual 'translations' of camp for a mainstream media, referencing the history of Hollywood cinema. That is to say, Aquaria and Violet Chachki's appearance and ensembles at the MET Gala were aligned with a highly polished and visually stunning standard of camp, the camp that Susan Sontag says is 'often decorative art, emphasizing texture, sensuous surface, and style at the expense of content' (Sontag 2009, p. 278). In essence, both queens become exemplars of Sontag's summation of camp as being 'a woman walking around in a dress made of three million feathers' (p. 283).

Indeed, what was strikingly absent at the MET Gala (and a similar criticism might be levelled at *RPDR* more broadly) was the version of camp located within the extremes of excess, vulgarity and poor taste. This is a version of camp that Matthew Tinkcom notes have been most vividly represented in cinema, by the director John Waters and drag queen and character actor Divine; Waters, rather surprisingly given the theme, was not invited to the MET Gala and his absence was picked up by media outlets (Waters contends that, despite the MET owning a number of items of his clothing, he has never received an

invitation to attend, and that it is not just this year despite the fact that, to many, it seems an oversight to have not asked the 'King of Camp').[9] Perhaps this exclusion is not so difficult to fathom however as Waters' camp epitomises what Tinkcom characterises as a 'trash aesthetic' that takes pleasure in 'mocking many of the most cherished institutions of contemporary life (marriage, domesticity, work, glamour)' (2002, p. 156). We note that the same institutions are reified by *RPDR* in its frequent endorsement of same-sex marriage, its focus on a work/werk ethos, and normative ideals of feminine glamour. Although Waters himself featured in season 7, episode 9 of *RPDR* (entitled 'Divine Inspiration') as a guest judge, even then the more shocking and distasteful elements of his earlier 'trash aesthetic' oeuvre (*Pink Flamingos, Female Trouble*) became subsumed into the more polished, straight-friendly camp of *RPDR*. Whereas the MET Gala and *RPDR* have the capacity to host the trashy camp of Waters, a mainstream and fundamentally *palatable* version of the camp is proffered instead, ever mindful that while both the MET Gala and *RPDR* enjoy a committed LGBTQ+ audience, there is also a large non-LGBTQ+ audience to cater to. Camp's assimilation into the mainstream of popular culture, however, is neither new nor is it unproblematic. As Shugart and Waggoner note, camp is often

> Anchored in conventional notions or "discourses" of gender and sexuality, and [...] questions circulate around whether and, if so, how camp may function as a key strategy by which those discourses might be renegotiated. [...] Perhaps camp's popularity in contemporary culture says more about the ability of dominant media interests, invested in preserving conventional discourses, to appropriate and defuse potentially threatening strategies and sensibilities. (2008, p. 2)

The MET Gala then illustrates celebrity culture deploying a very particular type of camp that can include RuPaul and a carefully selected coterie of his queens but excludes the kitsch and subversive camp of John Waters. Consequently, camp in this luxurious and rarified setting loses much of its countercultural bite and instead becomes a style or sensibility or even a marketing strategy to facilitate a celebrity's conspicuous display of wealth; camp as in effect an alibi. On reflection, perhaps the campest thing about the 2019 MET Gala is the choice of camp as a theme at all. Camp in this context is appropriated as what might be described as a performative register by celebrities, including RuPaul and his queens. Camp enables a (more or less) ironising distancing of the celebrity from their persona through extravagant display that reminds us of the constructed nature of celebrity at the same time as reifying its constructedness.

However, to argue that camp is evacuated of all of its subversive power in this context or to suggest that RuPaul and his queens appearing at the MET Gala are little more than an assimilation of queer culture into the mainstream would be too facile. Instead, we are suggesting a negotiation that takes place here between mainstream and marginal cultures at such highly publicised and promoted occasions and that this negotiation progressively takes place in the realm of social media.

For example, the MET Gala and comparable 'glamorous' events are designed to provide venues for such conspicuous displays of extravagance and luxury that they are frequently susceptible to satirical humour often circulated via social media.[10] This practice has developed pace during the course of the past 20 years. Recent media reportage has reminded us that the online search for photographs of Jennifer Lopez in a revealing Versace gown at the Grammys in 2000 is routinely attributed to the development of

Google Images and to the virality of the striking red carpet appearance.[11] In 2012 Angelina Jolie's much-mocked Oscar carpet pose with her right leg extended at an unusual angle from her Versace gown was circulated and recycled endlessly in the days that followed.[12] Publicists are of course increasingly attuned to the PR collateral to be gained on social media from such photo opportunities with some clearly contrived to provoke mockery as in the case of UK reality TV personality Gemma Collins who has claimed the title of 'queen of memes' largely as a result of a 'misjudged' wardrobe decision that was the subject of a subsequent social media campaign.[13]

In each of these cases, mediated 'moments' of excessive glamour (or a perceived failure to achieve glamour) which we would caution can easily be read as misogynist in their implicit valorisation of idealised models of appropriate femininity, have also opened themselves up to a camp appreciation and re-appropriation. As Shugart and Waggoner note:

> Style of the exaggerated, ostentatious, outrageous sort constitutes camp, rendering it a spectacle. [...] Incongruence must be made visible, however, in particular, typically excessive, ways for it to be coded as camp. There is a passionate, exuberant quality to the extravagant aesthetic of camp. (2008, p. 34)

Additionally and fundamentally for our purposes in this essay, the virality that such images achieve and their potential transformation into memes (a process we will describe subsequently) are mechanisms that enable the contestants of *RuPaul's Drag Race* to insert themselves into these new social media-driven discourses of celebrity.

A short history of the meme

In *The Selfish Gene* (1976) Richard Dawkins defines a meme as the cultural and social equivalent to the biological gene. The distinction made by Dawkins between the two is that genes reproduce by inheritance whereas memes do so via imitation, and as such memes are forms of knowledge exchange that can become transformed, added to and enhanced over time through processes of learning. Memes are social phenomena that represent behaviours, ideas and abilities, and they become passed on from person to person and imitated and embellished in the process. Everyday examples of memes that have existed for centuries can include recipes, stories and folklore, songs and fashion (Burgess *et al.* 2018). However, with the advent of the internet, digital memes have come to warrant their own definition and cultures separate to those examples that pre-date the online arena (Shifman 2014a). Patrick Davison argues that an internet meme is *'a piece of culture, typically a joke, which gains influence through online transmission'* (2012, p. 122, original italics). Early examples of internet memes include emoticons, while later examples from the early-to-mid 2010s tended to include photos distinct to their respective meme. These photos often feature an easily identifiable emotion with varying text – usually typed in Impact font (Brideau and Berret 2014) – superimposed to communicate a relatable situation or message, often for humorous effect (Davison 2012). Specific examples include 'Grumpy Cat'[14] and 'Success Kid'.[15] Limor Shifman regards digital memes as sharing common characteristics of form and content; common awareness among those forms and contents; and as being reproduced, transformed and circulated in quick succession via multiple users of the internet (2013). As Paasonen, Jarrett and Light note, 'memes, in general, live off their participatory possibilities of remix and alteration, and their appeal is centrally dependent on their ability to amuse' (2019, p. 80). The

humour of memes has a tendency to become ironic, surreal or offensive (Davison 2012) and to apply to specific subgroups of people based upon cultural markers such as age, gender, sexuality, race and ethnicity, and occupation (Shifman 2014a). However, as noted by Dobson and Knezevic (2018), the spread of memeable material on social media can often become framed by reductionist readings and reinterpretations of such cultural markers as race, gender, sexuality and social class. This can lead to the production of memes that further stigmatise those from lower socioeconomic backgrounds (Dobson and Knezevic 2017). Similarly, a frequent recourse towards memes featuring black people and black celebrities has drawn the criticism that this practice might be regarded as a form of 'digital blackface' (Jones 2018). It is important therefore to note that the politics of memes and meme sharing are far from unequivocally progressive. Notwithstanding these reservations, recently the links between memes and celebrity have been discussed in this journal. Using the example of Nicolas Cage (McGowan 2016), ironic humour and the sharing of memes can be seen as a driver behind the reinterpretation of Cage's resurgent celebrity status for example.

Shifman argues that the speed with which digital memes can become replicated, circulated and accessed separates them from their offline counterparts (2014a), and this also accounts for the quick turnaround in a meme's shelf life. For instance, recent examples that follow the still-image-with-changeable-text format include the 'Distracted Boyfriend'[16] and the 'Is This A Pigeon?'[17] meme, but shifts in style (such as the infrequent use of Impact font, a greater reliance on stock photos, and the appropriation of film/television stills) help to differentiate these later memes from those of 5 to 10 years ago, which now appear out-dated to those who circulate them. In addition, increased access to video-recording technology and digital platforms for video sharing sparks the potential for amateur, user-generated content to become memes but also for individuals to contribute to the process by imitating the original (Shifman 2014a). Shifman frames this through the concept of 'networked individualism' (Wellman *et al.* 2002), in which users who imitate or edit their own versions of popular memes demonstrate their own creativity and individual wit, while at the same time offering their contribution to the wider network of other memes within that same genre. Digital memes in their broader definition exist as 'enormous groups of texts and images', then (Shifman 2014b, p. 341).

In discussing the rapid process of circulation afforded by digital technology it is also important when defining terms of reference to note that there are distinctions between memes and digital content that 'goes viral'. Hemsley and Mason define 'going viral' and 'virality' as comprising three main elements: (1) the dispersal of a media text occurs on an individual-to-individual basis, (2) the spread of the media text happens at a high speed and (3) it spreads across a number of networks and is accessed by a broad range of people (2013). Virality then encompasses both the 'viral video' and the 'viral ad'. There are evident similarities between virality and digital memes; the speed of transmission and a wide outreach are certainly features of memes that have gained traction within wider popular culture. However, to become the subject of a viral video clip, for example, is not enough. It may provide the necessary foundation to become a meme, but Shifman outlines the additional requirements for that process to happen:

> The main difference between Internet memes and virals thus relates to variability: whereas the viral comprises a single cultural unit (such as a video, photo, or joke) that propagates in many copies, an Internet meme is always a collection of texts. [...] A single video is not an

Internet meme but part of a meme – one manifestation of a group of texts that together can be described as the meme. (2014a, p. 56)

Memes are the next stage on from virality, then. Burgess *et al.* (2018) note the potential for memes and virality to interact through 'viral challenge memes', where a specified task is set and those who partake regularly nominate others to follow suit. Individual creativity, or the higher-profile celebrity involved, increase the likelihood of virality and subsequent embellishment.[18]

Individual digital platforms also provide their own affordances for the creation, recreation and spread of memes (Shifman 2014a). For example, Twitter allows users to retweet the memes of others, but they also offer the option to 'retweet with comment', meaning the original tweet (which may include an image or video clip) becomes embedded in a new tweet that users can add their own comments to thus transforming the original and embellishing it with their own content, contributing to the process of becoming-a-meme. In addition, Twitter allowed users to start tweeting GIFs in 2014, and Facebook added the same functions in 2015 for comments and posts, and installed a GIF toolbar for posts and Messenger in 2017. Dean theorises GIFs as 'animated memes, often consisting of short-looped video clips shared for the purposes of conveying emotion or a reaction to an event or an utterance' (2019, p. 258). The use of GIFs is pervasive within online communication: indeed, they are regarded as a form of communication in social media (Jiang *et al.* 2018). Jiang et al. outline the ways in which GIFs have become integral to much online communication, used as a means of conveying emotion; of substituting text when a GIF more effectively conveys a situation or feeling; as being able to convey more nuanced feelings than emojis; to start, and sustain, conversations; and to inject humour and personality (2018). These short-looped video clips are often taken from television, film or viral videos, with subtitles regularly added, and become widely circulated in open online spaces or in closed online conversations. This commonly leads to a decontextualisation from their original material source that grants GIFs a polysemic quality where interpretations are made differently based upon the audience viewing or receiving it (Miltner and Highfield 2017). This can regularly lead to a *mis*communication of intent and context of messages when GIFs are shared online (Jiang *et al.* 2018). However, GIFs that comprise looped footage from television or film are commonly shared among the fanbases of their respective media, which helps to establish fan identities, transform and repurpose narratives, share in-jokes and support arguments or fan fiction (Hautsch 2018). This is of particular significance to *RuPaul's Drag Race*, where there is an established fanbase largely comprised of LGBTQ+ people or people aware of LGBTQ+ culture regularly making GIFs that go viral and become memes online. These contribute to and sustain the celebrity status and unique identities of the queens while simultaneously decoupling them from their original cultural context and flattening their performances into short-repackaged messages, the meanings of which consistently alter and evolve.

'Memeability' and celebrity culture

The creation and circulation of GIFs and viral clips that might become memes predicated on a condition that we describe as 'memeability' is critical to the development of this specific strand of contemporary celebrity culture which perpetuates itself online. At the

most instrumental level, this is attributable to the pragmatics of celebrity in the social media age. The queens of *RPDR*, even whilst they might appear in the same promotional venues at points and have been to a greater or lesser degree integrated into celebrity culture, are not direct equivalents of the Hollywood A List who populate the red carpets supported by a highly developed infrastructure of publicity and marketing. Having neither the financial resources nor the social and cultural capital of these stars, instead, they are often their own publicity machine and sustain their celebrity statuses online through Instagram, Twitter and associated social media. In this regard, the *RDPR* queens are not only contestants on a TV programme; they are simultaneously becoming part of a celebrity culture that exists online. In *Status Update: Celebrity, Publicity, and Branding in the Social Media Age* Alice Marwick describes the particularities of online celebrity:

> Online celebrities are not traditional celebrities, they do not have teams of agents and managers to protect them from the public, and they lack vast sums of money. Moreover, they are working within a different milieu, that of the internet, which idealizes transparency and thus expects a certain amount of exhibitionism. (2013, p. 114)

Whilst we might take issue with the increasingly anachronistic dichotomy that Marwick draws between 'online' and 'traditional' celebrities, in this social media-driven environment that we are discussing in this essay virality and memeability become central strategies in the establishment and sustenance of a media profile at the same time as they become markers of celebrity status; in short, a queen's memeability has an analogue in pre-digital discourses of 'star quality' and charisma.

Though virality and memeability are not phenomena that emerge from gay or queer culture and are by no means always camp in intention, they have been enthusiastically adopted because of their rich expressive potential as vehicles for ironic (and thereby camp) positionality. We would argue that many memes are therefore inherently camp due to the ironising and potentially subversive strategies that lie at the heart of this form of cultural appropriation and distribution. The meme is always ostensibly an expressive rather than an instructive or directive form of communication. Memes and memeability work on the basis of a facility to summon up a mood, an attitude or shared cultural sensibility. In this respect, we are reminded of Sontag's much quoted (and much criticised) 'Notes on Camp' (Sontag 2009) and her description of a 'certain mode of aestheticism' and 'what camp taste responds to is "instant character."'

Through their demonstration of memeability the queens of *RDPR* can infiltrate an online discourse of fame populated by a pantheon of celebrities who provide memeable riches unintentionally, such as Mariah Carey, Britney Spears or Celine Dion.[19] At least some, if not all, of these celebrities are those associated with what Grindstaff and Murray call 'branded affect':

> Dramatic outbursts of emotional expressivity are "branded" [...] as they are taken up, circulated, replayed, and recycled as indexes of a celebrity persona. Consequently, some reality television stars exist not only as the concrete embodiment of heightened emotion on-screen but also as brands in relation to the spectacular emotion or affect they produce/evoke. (2015, p. 111)

This branded affect is promulgated via virality and memeability on social media and celebrities who are associated with it (such as Gemma Collins who we have already

mentioned) provide a performative register and blueprint for the self-conscious meme-ability of an *RDPR* performance that is then duplicated and circulated online.

One of *RuPaul's Drag Race*'s most notable exemplars of memeability is Alyssa Edwards, queen of season 5 and *RuPaul's Drag Race All Stars 2*. Famed for her staccato tongue-pops (a sort of audible exclamation mark), shady reads and put-downs, and her plosive outburst of the word 'beast' to refer to unconvincing drag, Edwards is one of the earliest queens who became easy to caricature and therefore easy to imitate, lending herself towards virality and memeability. GIFs of Edwards are ubiquitous online, owing to her ability to condense her character into seconds-long catchphrases and reactions, recirculated by others online to demonstrate their own affective relationship to a given situation or event. As such, Edwards might be regarded as the embodiment of Grindstaff and Murray's 'branded affect' (ibid.), and consequently has been able to leverage her own personal brand as a promotional/marketing tool of value to corporations with some degree of success. Recently, for instance, Edwards has collaborated with *Cosmopolitan*[20]; a 5-minute video produced by the media outlet features Edwards giving advice on how to be petty, replete with tongue-pops, shady 'advice', and a large hand-held fan and cosmetic mirror both of which are emblazoned with the word 'Beast'. The video is used as a vehicle for Edwards to promote her eye shadow palette made in collaboration with the make-up brand *Anastasia Beverly Hills* (indelibly linked to *RPDR*, as it offers a lifetime supply of its products to the eventual winner of each season). Other collaborations have seen Edwards star in commercials for *Pepsi* in which she teaches fellow *RPDR* alumnus Plastique Tiara how to tongue-pop.[21]

In the case of the *Cosmopolitan* video, Edwards's branded affect coupled with her virality and memeability, based on her glamour as a drag queen renowned for her perfected makeup, is capitalised upon by a relationship with the media outlet and with a global makeup brand. The rhetoric of the video is clearly designed with social media in mind, containing a succession of instances in which Edwards performs the recognisable and repeatable aspects of her celebrity persona, perfect for turning into GIFs to be circulated online. In turn, this raises awareness of, and drives traffic to, *Cosmopolitan* and *Anastasia Beverly Hills'* respective publications and products. So, this self-conscious memeability becomes a means through which to expand brand awareness, develop a celebrity profile, and to capitalise upon one's performative register. 'Branded affect' and memeability is evoked through the virality of GIFs and memes of Alyssa Edwards, Gemma Collins, Mariah Carey and Britney Spears, however, the difference between Edwards/Collins and Carey/Spears is that the former's celebrity statuses have developed within the age of memes and virality and have relied upon them for sustenance. The celebrity status of Mariah Carey and Britney Spears has not. As such, memes and GIFs shared of the latter tend to come from moments that were less self-aware (and certainly less self-referential). We might draw a parallel here with the contentious point that Susan Sontag makes in 'Notes on Camp' about distinctions between camp's naïve or deliberate form (Sontag 2009).

The meme and memeability in this context work as mechanisms through which the aspiring celebrity can establish their status whilst fans and followers can consolidate their affective relationship with them through repetition and imitation and simultaneously claim ownership of the meaning-making potential of celebrity. What is clear at least in the present moment is that memeability is an important contributor to the ability to sustain a career as an *RDPR* superstar. Virality and memeability enable the queens to situate

themselves into the discourses of online celebrity where Miss Vanjie's notorious exit or Alyssa's tongue-pop are of equal cultural significance to any meme generated from the extravagances or idiosyncrasies of Mariah Carey or Britney Spears.

Conclusion: what does this meme?

RuPaul and the most successful queens of *Rupaul's Drag Race* are now assimilated into the patterns and discourses of mainstream celebrity culture. Celebrity in the age of social media is increasingly predicated on, and in fact demands, virality and memeability; a compression, simplification and multiplication of messages and this tendency has become a feature of the discourse of celebrity more broadly. In the particular case of reality television celebrities, a social media profile based around virality is essential and the ability to produce content that might generate memes is key to the maintenance of a celebrity persona. The viral video and memes have become part of celebrity making and indexes of celebrity status. Whilst meme production sits alongside industrialised image management and therefore has the potential to be resistant to or even destabilise the brand identity of an individual celebrity it is progressively being deployed in a more self-aware manner, drawing on irony and camp and becoming part of the image-making strategy of celebrities. The queens of *RPDR* are at the vanguard of this new form of image construction as we have illustrated.

As a popular cultural phenomenon, *RuPaul's Drag Race* relies on paratextual discourse amongst emotionally invested audiences and especially on a vibrant social media engagement with the programme and its contestants for its success. We have argued here though that most of the queens who ultimately have a sustained success both during their appearance on the programme and afterwards are those who understand and are able to exploit social media and the memeability of their personas. This demands distinctive iconographic characteristics of the queens' drag image that includes memorable and humorous catchphrases or gimmicks and performative idiosyncrasies. Whilst a queen may be a talented performer, singer, comedian, this in itself is rarely a sufficient qualification to sustain a career.

Memeability in this context then might be understood as a particular marker of what in the predigital media landscape has been described variously as charisma or star quality. Indeed, it is our contention that memeability is the charisma of the social media age; a form of algorithmic charisma that crystalises the intangibility of star quality into compressed, shareable, reproducible, 'GIFable' content.

The extent to which memeability is more than a passing moment in the development of celebrity meaning-making in the digital age is of course uncertain. For instance, the controversy around article 13 of the 'European Union Directive on Copyright in the Digital Single Market' making online platforms liable for infringements may well curtail the viral spread of copyright material on which many of the *RPDR* memes are based.[22] For now, though the meme and memeability represent metaphors for the nature of celebrity in the digital age; a point in celebrity culture when the more truncated the 'message' is the better and where the plasticity of an isolated moment transformed into a meme creates and sustains a celebrity persona. By exiting the runway of *RuPaul's Drag Race* backwards, Miss Vanjie was sashaying towards her new celebrity career.

Notes

1. https://www.youtube.com/watch?v=kHUz0Z_xFXw.
2. https://www.youtube.com/watch?v=m5277YS1ptU.
3. https://www.bustle.com/p/miss-vanjie-memes-have-taken-over-rupauls-drag-race-star-vanessa-vanjie-mateo-isnt-even-mad-8692513
4. https://www.urbandictionary.com/define.php?term=Miss%20Vanjie.
5. We note that drag queens have been enthusiastic adopters of social media as a mechanism in constructing and maintaining a fanbase at a local level as illustrated by Jessa Lingel and Adam Golub's research in the essay *In Face on Facebook: Brooklyn's Drag Community and Sociotechnical Practices of Online Communication* (2015).
6. https://variety.com/2019/tv/news/rupaul-drag-race-emmys-1203336127/.
7. https://www.wmagazine.com/story/rupaul-met-gala-2019-red-carpet-drag.
8. https://www.vogue.com/vogueworld/article/violet-chachki-paris-couture-fashion-week-fall-2019-shows-photo-diary.
9. https://www.papermag.com/john-waters-met-gala-2638357067.html.
10. https://www.cosmopolitan.com/style-beauty/fashion/a9578084/funny-met-gala-memes/.
11. https://www.businessinsider.com/jennifer-lopezs-grammys-dress-inspired-google-image-search-2015-5?r=US&IR=T.
12. https://www.marieclaire.co.uk/news/celebrity-news/angelina-jolie-s-leg-takes-over-the-internet-210607.
13. https://www.dailymail.co.uk/tvshowbiz/article-4715668/Gemma-Collins-shows-curves-edgy-outfit.html
14. https://knowyourmeme.com/memes/grumpy-cat.
15. https://knowyourmeme.com/memes/success-kid-i-hate-sandcastles.
16. https://knowyourmeme.com/memes/distracted-boyfriend.
17. https://knowyourmeme.com/memes/is-this-a-pigeon.
18. The 'Ice Bucket Challenge' of 2014 is a good example here of a viral clip, associated with a fundraising campaign for *ALS Association* that became a popular meme: http://www.alsa.org/fight-als/ice-bucket-challenge.html.
19. As we have previously noted not all memeable celebrities are pop divas. The rapper Drake, for example, is often regarded as the epitome of memeability. https://www.vice.com/en_uk/article/rq5e7r/understanding-drakes-meme-appeal.
20. https://www.cosmopolitan.com/entertainment/celebs/a28468477/alyssa-edwards-petty-video/.
21. https://www.youtube.com/watch?v=jsXevbn6Cjc We note that Edwards' tongue-pops have been adopted as lingua franca for the queens of *RPDR*. For instance amongst the queens in the first season of *RuPaul's Drag Race UK*, Cheryl Hole has adopted the tongue-pop as her own gestural signature.
22. https://www.wired.co.uk/article/what-is-article-13-article-11-european-directive-on-copyright-explained-meme-ban.

Disclosure statement

No potential conflict of interest was reported by the authors.

ORCID

John Mercer (iD) http://orcid.org/0000-0002-8969-2626

References

Brideau, K. and Berret, C., 2014. A brief introduction to impact: 'The meme font'. *Journal of visual culture*, 13 (3), 307–313. doi:10.1177/1470412914544515

Burgess, A., Miller, V., and Moore, S., 2018. Prestige, performance and social pressure in viral challenge memes: neknomination, the ice-bucket challenge and smearforsmear as imitative encounters. *Sociology*, 52 (5), 1035–1051. doi:10.1177/0038038516680312

Davison, P., 2012. The language of internet memes. *In*: M. Mandiberg, ed.. *The social media reader*. New York: New York University Press, 120–134.

Dawkins, R., 1976. *The selfish gene*. New York: Oxford University Press.

Dean, J., 2019. Sorted for memes and gifs: visual media and everyday digital politics. *Political studies review*, 17 (3), 255–266. doi:10.1177/1478929918807483

Dobson, K. and Knezevic, I., 2017. 'Liking and sharing' the stigmatization of poverty and social welfare: representations of poverty and welfare through internet memes on social media. *Triple C: communication, capitalism & critique*, 15 (2), 777–795. doi:10.31269/triplec.v15i2.815

Dobson, K. and Knezevic, I., 2018. "Ain't nobody got time for that!": framing and stereotyping in legacy and social media. *Canadian journal of communication*, 43 (3), 381–397. doi:10.22230/cjc.2019v44n3a3378

Grindstaff, L. and Murray, S., 2015. Reality celebrity: branded affect and the emotion economy. *Public culture*, 27 (1), 109–136. doi:10.1215/08992363-2798367

Hautsch, J., 2018. The rhetorical affordance of GIFs by Tumblr's *supernatural* fandom. *In*: L. Morimoto and L.E. Stein, eds.. Tumblr and Fandom, special edition, *Transformative works and cultures*. Vol. 27. doi:10.3983/twc.2018.1165

Hemsley, J. and Mason, R.M., 2013. The nature of knowledge in the social media age: implications for knowledge management models. *Journal of organizational computing and electronic commerce*, 23 (1–2), 138–176. doi:10.1080/10919392.2013.748614

Hopkins, S.J., 2004. Let the drag race begin. *Journal of homosexuality*, 46 (3–4), 135–149. doi:10.1300/J082v46n03_08

Jiang, J., Fiesler, C., and Brubaker, J.R., 2018. "The perfect one": understanding communication practices and challenges with animated gifs. *Proceedings of the ACM on human-computer interaction*, 2, 1–20.

Jones, E.E., 2018. Why are memes of black people reacting so popular online? *The Guardian*, 8 July. Available from: https://www.theguardian.com/culture/2018/jul/08/why-are-memes-of-black-people-reacting-so-popular-online [Accessed 17 October 2019].

Lingel, J. and Golub, A., 2015. In face on Facebook: Brooklyn's drag community and sociotechnical practices of online communication. *The journal of computer-mediated communication*, 20 (5), 536–553. doi:10.1111/jcc4.12125

Marwick, A.E., 2013. *Status update: celebrity, publicity, and branding in the social media age*. New Haven, CT: Yale University Press.

McGowan, D., 2016. Nicolas cage – good or bad? Stardom, performance and memes in the age of the internet. *Celebrity studies*, 8 (2), 209–227. doi:10.1080/19392397.2016.1238310

Miltner, K.M. and Highfield, T., 2017. Never gonna GIF you up: analyzing the cultural significance of the animated meme. *Social media + society*, 3 (3), 1–11. doi:10.1177/2056305117725223

Paasonen, S., Jarrett, K., and Light, B., 2019. *NSFW: sex, humor and risk in social media*. Cambridge, MA: MIT Press.

Rojek, C., 2001. *Celebrity*. London: Reaktion.

Shifman, L., 2013. Memes in a digital world: reconciling with a conceptual troublemaker. *Journal of computer-mediated communication*, 18, 362–377. doi:10.1111/jcc4.12013

Shifman, L., 2014a. *Memes in digital culture*. Cambridge, MA: MIT Press.

Shifman, L., 2014b. The cultural logic of photo-based meme genres. *Journal of visual culture*, 13 (3), 340–358. doi:10.1177/1470412914546577

Shugart, H. and Waggoner, C., 2008. *Making camp: rhetorics of transgression in U.S. popular culture*. Tuscaloosa: The University of Alabama Press.

Sontag, S., 2009. *Against interpretation and other essays*. London: Penguin.

Tinkcom, M., 2002. *Working like A homosexual: camp, capital, cinema*. London: Duke University Press.

Wellman, B., Boase, J., and Chen, W., 2002. The networked nature of community: online and offline. *IT & society*, 1 (1), 151–165.

Index

Abidin, C. 11, 73
affiliate programmes 6
Algorithmic Hotness' study 75
America's Next Top Model 1
Andrews, Hannah 2
Ang, L. 29
ascension of social media 67
A Star is Born (2018) 14
authentic celebrity 51–2
authenticity 22, 51–2

Banet-Weiser, S. 73, 74, 77
Belgrave, L. 41
Bell, Erin 23
Belli, Willam 65; entrepewhorial endeavours
72–6; 'I'm just like WikiLeaks/but my dick is up
in my ass cheeks' 69–72; 'Not a Ru-girl', career
and works of 68–9
Bennett, J. 52, 55
Berkowitz, D. 41
Berlant, Lauren 88
Billboard's Hot Dance Music/Club Play chart 10
Biressi, Anita 84
Bourdieu, Pierre 58
brand ambassadorship 6
'Brand Me!' (2016) panel 13
Brennan, N. 1, 21, 51
Broad City (2019) 14
Brusselaers, D. 56
bulletin board systems (BBS) 6
Burgess, A. 104
Butler, J. 39, 66

capitalist cultural production 8
caricature 37–40; and comedy 41–3
celebrification: arthouse documentaries 5;
defined 4; fame, support of political causes
5; gender norms/anti-capitalist politics
5–6; homonormative narratives 5; internet,
professionalisation, capital 6–7; modes of
drag 7; non-commercial niche amateurism 5;
social media platforms 5
celebrity culture 87
celebrity do-gooding 57

celebrity management 22
celetoids 22
charisma, defined 53
The Cockettes (2002) 5, 7–8
Cole, Elizabeth 84
Collie, Hazel 2
comedic drag performance 41–2
Commane, Gemma 2
commercialisation 7
commodification 2, 26–8
Comolli, Jean-Louis 44
contemporary postfeminism 73
conventional notions/discourses 101
Core, P. 36
Costa, Lucy 86
Cross, Simon 87
cruel optimism 88–92
cyber-bullying 67
cyber-femininity 73

Davison, Patrick 102
Dawkins, Richard 102
democratisation 6
Dentith, Simon 39
digital agencies 6
direct social media communication 52
disclosure 29–30
Dobson, K. 103
Dobson, Shields 73, 77
Downton Abbey (ITV 2010–2015) 35
drag and camp 99–102
drag culture 1; *see also* celebrification
drag mothers 21
drag queens 8
Drag Race phenomenon 1
Duffy, B. E. 73
Dyer, R. 51–3

Edgar, E. 21, 23
editing, role of 42
Eisenstadt, S. N. 60
Elevator Girls in Bondage (1972) 8
Ellcessor, E. 52, 54, 57
Estranja, Laganja 13

INDEX

Feldman, Zeena 2
Ferreday, Deborah 3
Ferris, K. O. 44

gay culture 98
Gill, R. 69, 72, 77
Glee (2012) 14
'good' citizenship 9
Gopnik, A. 41
Gray, Ann 23
Gudelunas, David 1
Gunn, Gia 39–40

Hakim, Jamie 2
Hamad, Hannah 21
Hamilton, S. 45
Hearn, Alison 11, 65, 66
Hemsley, J. 103
Holmes, S. 51, 52, 54, 55
Hoyle, David 8

Illouz, Eva 84
I'm A Celebrity: Get Me Out of Here (ITV1, 2002-present) 23
Internet Relay Chat, proto-social networking site 6

Jarrett, Paasonen 102
Jerslev, A. 57
Jolie, Angelina 102
Journey to the Centre of Uranus (1972) 8

Khamis, S. 29
Knezevic, I. 103

Leary, T. 7
Leibovitz, Annie 1
Lepselter, Susan 77–8
Logo TV, queer network 1, 21
Luckhurst, Roger 84

mainstreaming of drag culture 2
Marshall, P. D. 27, 29, 37, 44, 51, 53
Marwick, Alice 66
Mason, R. M. 103
Masters, Jasmine 12
matrilineage 98
McMichaels, Morgan 13
McWade, Brigit 87
meme: defined 102; emoticons 102; going viral and virality 103; individual digital platforms 104; lower socioeconomic backgrounds 103; remix and alteration 102–3; short-looped video clips 104; video-recording technology

and digital platforms 103; memeability and celebrity culture 104–7
MET Gala and comparable glamorous events 101–2
Metzger, Megan 23–4
Meyer, Moe 36
Michelle, Alexis 40
micro-celebrities 7
Middlemost, Renee 3
Miller, V. 104
Monsoon, Jinkx 36
Moore, S. 104
Morini, Cristina 78
Morrison, Josh 23
Mother Camp (1972) 9
Muñoz, José Esteban 26
Murdoch, Rupert 6
Murphy, Ryan 8

neoliberal entrepreneurialism 75
networked individualism 103
Newton, E. 13, 36
Niu, Y. 50
Nunn, Heather 84

O'Connell, Rachel 3
online celebrity activism 54
O'Reilly, T. 6

Papadopoulos, D. 76
Paris Is Burning (1990) 5, 7–9
Patel, Karen 31
Pitcher, K. 74–5
Pose (2018–2019) 8
Pratt, A. 72

"queer parody" drag impersonations 2

Reagan's America (1981–1989) 8
reality television participants 65, 69
reality television programmes 55
Redmond, S. 57
Reeves, R. 50, 58
Revised USP (RUSP) 59
Rhodes, G. 37
Ridout, N. 78
Rock of Love with Bret Michaels (VH1, 2007–2009) 23
Rojek, Chris 98
Royale, Latrice 14
RuPaul's Drag Race (RPDR) 5; competitive, hard-werqing self-brands 12–14; drag and social media convergence 10–11
Rupp, L. 43

Sasha Velour: *American* (2017) album 50; America's Next Drag Superstar 50; authentic celebrity 51–2; charisma 52–5; transphobic language and race representation 49–50
Saturday Night Live (SNL) 100
Schneider, R. 78
Scudera, Domenick 86
self-branding method 11–13, 30
sexual objectification 76–7
Shifman, Limor 102, 103
Shugart, H. 102
Smith, Maggie 41, 42
The Snatch Game 2; caricature 37–9; celebrities 37; commonalities 36; conventional television personality 36; impersonating celebrities, queering celebrity 43–5; international viewership 35; Lady Gaga impersonation 37–8; show's talent contest 13
social media influencers 7
social media platforms 51
Social Security Administration 2019 9
Sontag, Susan 38, 100
Strictly Come Dancing (BBC, 2004-present) 23

Taylor, V. 43
Teen Vogue Summit 54
'The Business of Drag' (2016) 14
The Osbornes (MTV, 2002–2005) 23
The Selfish Gene (1976) 102
Thompson, E. 73
Thor, Thorgy 88
Tinkcom, Matthew 100
Tinsel Tarts in a Hot Coma (1971) 8
Tracy, Liz 67
transformational narratives 29
Trilling, Lionel 21–2

Tsianos, V. 76
Turner, Graeme 66

'Ultimate Queen': achieved and attributed celebrity 21; commodification, brand and exposure 21, 26–8; drag mother, role of 21; format and celebrity 21–2; history and self-commemoration 22–6; illusion, authenticity and disclosure 28–31; older queens 24
Unique Selling Proposition (USP) 50, 58–9
unscripted television 65
Usenet, proto-social networking site 6

van Elven, M. 59
van Krieken, R. 56
Van Leeuwen, T. 51
Vesey, A. 22, 26, 56
VH1 channel 1
Viva Glam campaign 10
The Vixen: Black women's bodies 84; feminine celebrities 83; personal trauma narratives 84; RuPaul's cruel optimism 88–92; screening trauma 85–8; on social media 83

Waggoner, C. 102
Wang, C. L. 50
Waterss, John 101
weapons of the weak concept 71–2
Web 2.0 buzzword 6
Weber, M. 53
Welling, R. 29
The WELL, proto-social networking site 6
Werqin' Girl (2012) 14
Weschler, J. 38
West Coast counterculture 8
Wissinger, E. 74

Zucker, Alyssa 84